# Lili Kraus

With gratitude
for your kind
words and
remembrances —

*[signature]*

# Lili Kraus

Hungarian
Pianist

Texas
Teacher

Personality
Estraordinaire

*by*
Steve Roberson

TCU Press • Fort Worth

Library of Congress Cataloging-in-Publication Data

Roberson, Steven Henry, 1949-
Lili Kraus : Hungarian pianist, Texas teacher,
and personality extraordinaire / by Steve Roberson
p.cm.
Includes discography (p. ), bibliography (p. ), and index.
ISBN 0-87565-216-6 (alk. paper)
1. Kraus, Lili, 1903-1986. 2. Pianists—Biography. I. Title

ML417.K76R632000
786.2'092—dc21

[B]                                                      99-046975

*Design/Margie Adkins Graphic Design*

*To Lili Kraus*
*whose spirit continues to inspire and teach*
*and*
*Bea Roberson*
*whose energy and love have given me life and vision.*

# CONTENTS

# $\mathcal{A}$CKNOWLEDGMENTS

The author gratefully acknowledges the invaluable advice and support from Ruth Pope, Lili's daughter, who now resides in Hill House in North Carolina with her husband, Fergus.

Frans Schreuder, Dutch piano teacher living in The Hague, first heard Kraus play in an internment camp in Java where they were both prisoners during World War II. Subsequently he maintained a friendship with her for forty years. Mr. Schreuder was tremendously helpful in providing information, insights, and encouragement, all of which the author prizes.

Also, the author wishes to thank the Indiana Humanities Council and Butler University for underwriting various research efforts in the production of this manuscript. Finally, the author is deeply appreciative of the advice and guidance provided by his editor, Judy Alter, and her assistants at the TCU Press.

Steve Roberson
Indianapolis, 1999

# PRELUDE

Lili Kraus continues to play an extraordinary role in my life. Recollections of her musicianship, intelligence, remarkable energy, and charisma still dazzle me, just as they did when I studied under her at Texas Christian University in Fort Worth as I worked on my master's degree from 1972 to 1975. Those recollections of an impressionable youth seem now almost an intermingled blur of excitement and anxiety. Madame Kraus would jet in from some distant location, having just played a concert, and for me the associated glory of the latest tour was thrilling. That she was also a superstar in the local community added to the aura of greatness. Among the music elite of Fort Worth society, she was a diva to be coveted and courted. At TCU she was distinguished artist-in-residence and the only permanent jury member of the Van Cliburn Competition held on campus every four years. How stimulating to be a disciple of this great woman!

Kraus was unlike anybody else I have known. She was glamorous and brilliant. She could talk about any topic: music, literature, politics, you name it. On the political front, by the way, she was a staunch liberal. She was absolutely beautiful. Her prominent cheekbones and dark, luminous eyes were crowned by long hair pulled into a bun on the back of her head. She was eternally tanned and vivacious. Her concert gowns were

fabulous concoctions of imported silks, cut to designs she sketched herself. Her way with words was nothing short of fantastic. She used the English language with ravishing sweep, mesmerizing us all with an accent that reminded me of Zsa Zsa Gabor's. Whether she was on the stage or with a group of students at the nearby pancake house, her regal bearing and radiance were like a beam of pure white light. Her manner of dress was striking; when I knew her she usually wore a white pants suit with a white ruffled blouse every day, accented by three strands of pearls, sparkling earrings, and a large diamond ring.

In no way was she ordinary. Lessons, for instance, were seldom at a predictable time; Kraus might have her teaching assistant call you unexpectedly at 2:00 P.M., announcing your lesson that evening at ten. From those lessons I have two dominant memories. First, I vividly recall how magnificently Kraus could demonstrate anything. You might have worked on a piece for days, yet she could sit down at the piano and magically transform the same notes into a thing of rare beauty. She would play with tonal voluptuousness and passion, the same two musical qualities that drew me to her in the first place.

But the lessons almost always had—at least for me and most of the students I knew—some notes of discord, the basis of my second remembrance of them. Madame Kraus could become tactless in a flash, saying biting things. During my tenure at TCU I heard several such tales from fellow students: She told a friend of mine the night before his senior recital that it was hard for her to believe he was supposed to be a musician;

in a public master class she let a fourteen-year-old German girl know that she had just murdered Mozart, and the girl burst into tears; when one of her students was playing the Beethoven Concerto no. 3 with the TCU orchestra in Ed Landreth Auditorium, Kraus suddenly stood and shouted, "Stop; I won't have the audience think it's supposed to sound that way"; somehow the student managed to continue after a brief consultation with Kraus. Along with others, I was devastated by this kind of treatment—by the look in those penetrating eyes—too many times.

Lessons became events to be cherished and feared. Complicating the matter was her insistence that we all learn a specific technical system, one that I now believe was flawed in the way she taught—not played—it. In fact, she knew her limitations in this area, having struggled all her life to overcome technical deficiencies in her own training. In my case (and I gather that mine was not unique) she urged me not to play a piece in its entirety for the first several months, directing me instead to spend most of my practice time in painstakingly slow work, analyzing the movement of wrists, fingers, shoulders, and so forth, while studying just a measure or two. We had one lesson where we spent the entire time examining how my facial muscles reacted while I played. This type of work is actually brilliant, the only way to make the most sophisticated progress; the downside in Madame Kraus's system was that all aesthetic fulfillments were put aside during prolonged physical retraining. In fact we never got beyond the opening phrase of Bach's *Italian Concerto* during the first

semester. I remember vividly her comment to me in the initial lesson (I had already finished an undergraduate degree in piano and thought I had a fairly decent concept of how to play the instrument): "My dear child, you must start over. You must become an infant again." That is rather deflating news for any serious adult.

After one semester, I decided that I could not survive the lessons and made the fateful decision to transfer to another piano teacher at TCU. Over the Christmas break I wrote Madame Kraus, sending the letter to California where she was performing. I told her, essentially, that I was not up to the task of doing what she wanted and had sought a spot in another piano studio. She did not respond to me but called the music department chairman at TCU, Dr. Michael Winesanker, to say that I had two choices: to apologize and come back to her or to leave TCU. Dr. Winesanker relayed that message to me, adding that "we are all subject to Madame Kraus's whims." How true those words were. I chose option one, waiting outside her studio door one February afternoon until she had finished teaching. I fumbled my apology and offered to buy her dinner at her favorite nearby cafeteria (Jetton's was the establishment, where she often ordered macaroni and cheese, which she doused with sugar) as a gesture of reconciliation. On the way home, she said, "I hope you have learned a lesson." I responded that I had but could not quite put it into words. She articulated it for me: "You've learned not to be so impetuous!" From that moment, Madame Kraus was in my life to stay, no matter what.

What I learned from her is too complex to describe. Over

the years, in my own teaching, I have used her name with great pride. I have made "discoveries" about playing, only to realize, "That's what Kraus meant!" I learned that music, teaching, and life must be infused with drama and passion to be maximally effective. I also learned that genius can have many faces, because Kraus manifested it in her playing, in her demeanor, in her drawings, and even in her musings. I remember the fabulous conversations she would have with us over dinner, about music, politics, philosophy, religion, and so forth. I am also inspired by her warmth, sincerity, and graciousness, recalling how she would engulf a student in her embrace if she happened upon one of us on campus. I learned, too, that the other side of greatness is insecurity. Once, after having had a disastrous memory slip in Schubert's G-flat major Impromptu during a recital in Dallas, she summoned all her students the next day to a classroom in the music building. Without saying a word she walked into the room at the appointed hour, went straight to the piano, and played that Impromptu as gorgeously as it has ever been played. At the conclusion of the final chord, she left as quietly as she had entered.

In some ways it is ironic that I am the one to write her biography. Neither of us would have thought it likely. There are other students who were closer companions. I think, though, that no one else had stronger reactions to her, on both ends of the continuum. I found her to be a great personality, a great artist, and greatly difficult, but I always wanted to be in her presence. I chauffeured her around Fort Worth and was frequently in her little duplex a few blocks from campus. I even had a

lesson once in that tiny place while she reclined in bed (the piano was in her bedroom, and she was ill with a viral infection). Being with Madame Kraus was like being part of this bigger-than-life fairy tale. I have written the biography because I am infatuated with her. I have done it because she was an extraordinary musician and a stunning human being. Her life was lived fully, richly, and deeply, eclipsing everything else in my experience. I have done it because her story deserves to be told.

I have done it with great difficulty, spending sixteen years, on and off, working on this project. It took so long because I needed time to try to understand this woman, and now I am glad I allowed the work to mature. In the beginning I viewed Kraus as a sensational pianist and interesting personality. In the end, I have come to see her as a sensational human being and interesting musician. For me, the scale has been tipped toward the woman rather than the artist because of her triumphs against long odds. She had to overcome a childhood beset with a dysfunctional family and poverty. She struggled with oppressive discrimination leveled against her because she was a Jew. She battled protracted separations from her young children, thirty years of widowed life, and a horrific imprisonment that demolished her career in its prime. Yet through it all she laughed and loved and played on. That, for me, is her most enduring legacy. The passage of years dims the recollections of the occasional tactless moments and the drama in her playing, but the memory of her majestic spirit endures.

Finally, I have frequently chosen to let her tell her story in

her own words, inserting her thoughts in her inimitable style, idiosyncratic grammar and all. Those who did not know Madame Kraus might be surprised at her artistry with language, suspecting that I have chosen only the spectacular quotes. Let me assure all readers, though, that her manner of speaking was equally glamorous and compelling whether she was talking to a large audience or ordering her macaroni and cheese. ✳

# ACT I—THE DEBUT

In humble circumstances that belied—and illuminated—her eventual success, Lili Kraus was born on March 4, 1903, in Budapest, Hungary. Her parents were Victor and Irene Bak Krauss. The spelling "Krauss" instead of "Kraus" was the Czech rendering of the surname "Krausz." With the blossoming of her international career, Kraus dropped the original "ss" in exchange for the Germanic form of "Kraus." Victor, a Czech who spoke rough Hungarian, was a gentle, gregarious man who eked out a meager living by selling and sharpening knives and scissors in his small cutlery shop. Though a blood relative (probably his grandfather) had been mayor of Prague, his own socioeconomic standing had declined markedly. He was charming, charismatic, and outgoing. He was also a wonderful raconteur with beautiful eyes and a positive outlook. Irene, a proud Hungarian with aristocratic aspirations and peasant realities, was beautiful and willful. She possessed a wonderful singing voice that never found professional fulfillment, a source of great frustration and a cause of her brooding and depressed nature. Both Victor and Irene were Jewish, a significant fact because of the trouble this caused Lili throughout her life, particularly during the 1930s and 1940s, when Hitler's madness disrupted the civility of the world.

The Kraus family lived in one room above Victor's shop

on the Königsgasse, and baby Lili slept in a laundry basket on the table. The other member of the family was Lili's half-sister, Dora, daughter of Victor by his first wife, who was Irene's cousin. Four or five years older than Lili, Dora was overweight and slow but not retarded. As a child Lili pitied Dora and defended her, a relationship that changed when Lili was in her late teens and felt increasing exasperation with Dora. Irene dealt harshly with her stepdaughter, barely tolerating her husband's "other" child and treating Dora with disdain and frequent cruelty. Lili repeatedly tried to intercede on Dora's behalf. Though the family was poor, they did employ a maid, a young peasant girl who cleaned the house, ate meals with them, and slept in the attic. Although poverty and the presence of a servant seem contradictory, this was the custom even for lower middle-class households; the maid received little cash, working mainly for room and board.

Lili also had to cope with parents in an unhappy marriage who were totally unsuited to rearing children. Because the family slept in one room, Lili witnessed all aspects of her parents' relationship, including violent arguments. She described their marriage as the "unhappiest" imaginable. Irene, difficult, frustrated, and arrogant, felt she had married beneath her station in life, blaming Victor and Dora for her austere and deprived state. For her unfulfilled vocal career she blamed her parents, who, she said, regarded that option as "just one step better, if any, than walking the street."[1] Convinced she had wasted her youthful beauty and musical talent, Irene lashed out at the world. Lili viewed her mother as a "really crazy lady" and tried

to explain Irene's behavior as a consequence of typhoid fever, which she had contracted in 1886, an affliction that was never completely cured. Deeply depressed and frustrated, Irene would sit for hours with her hands covering her face, bemoaning past decisions. She never learned how to enjoy the moment, living instead in a malaise of "what-ifs." From her earliest recollection, Lili realized that she, not Irene, must assume the role of supportive and comforting parent, and she did what she could to raise her mother's spirits. Mother and daughter took long walks daily, no matter the weather, and Irene seemed to respond to her daughter's kindness, particularly Lili's efforts at humor in the guise of a game in which Lili mimicked one of the apes in the local zoo. To help her mother through many sleepless nights, Lili would often stay up with Irene until she fell asleep. "For nights on end I prayed that God would let her sleep. How much she slept and how much I was awake, nobody will ever know."[2] Despite Lili's efforts, Irene continued to manifest signs of mental illness, causing Lili to observe that her mother "was really almost hysterical with fear and ambition."[3] She never forgave her mother for the theft of a happy childhood.

Victor escaped when he could, spending evenings gambling. Irene pursued him even there, once taking Lili along with her into a gambling hall to fetch her husband, intending to embarrass and humiliate him by his daughter's presence. Although Lili adored her father, finding inspiration in his open and vivacious personality, she blamed him for not confronting Irene. She later expressed amazement that any child could have survived that upbringing. Perhaps the difficult childhood

became the forge from which Lili's independence and forcefulness, so evident later in her life, were molded. From her mother she learned toughness, and from her frustration with her father's reaction she learned to deal with difficult issues forthrightly, coming to hate meekness in any form.

Irene's thwarted musical aspiration led her to become the classic stage mother. Lili said, "All the ambition of my mother was centered on my growing up and being what I have become."[4] Initially, though, Lili wanted to be a dancer. "I danced as I breathed; I had to dance wherever I heard music, and I heard it even if it wasn't there."[5] She recalled that when she was five, the family vacationed at "a cheap little summer resort" where she danced happily and with abandon when Hungary's great tragic actress, Yascai Mari, happened upon the scene. Mari was taken with the child's spontaneity and rhythmic impulse and told Irene that she could turn Lili into the greatest dancer the world had yet known. Irene refused this offer despite protestations from Mari and Lili, explaining that dancing was not a "proper" vocation for a woman. She was steadfastly determined that Lili would become a musician, and Lili's hopes for a dance career abruptly ended. Nearly eighty years later she lamented, "This was a terrible, terrible disappointment for me, a real almost breaking-point disappointment."[6]

When she realized that her choice was to be music or nothing, Lili opted for the violin, a choice Irene vetoed. Her preference was the piano "because it belongs to decent households."[7] At first, Lili hated the piano, believing it to be "too mechanical, ugly, and far away from the music."[8] Indeed, Lili's

first piano was such a wretched instrument that she was bound to dislike it. Somehow her parents had managed to find just enough money to buy an old, dilapidated piano. Lili later recalled that its sound was like a tin can hitting a radiator, and its keys were so stiff and hard to depress that they required considerable muscular effort to play, a characteristic that distinguished her playing the rest of her life. Indeed, her highly articulated finger strength was among her greatest talents as pianist.

Despite her piano's limitations, Lili began taking lessons at age six:

> *From the moment onward when I set finger to it, it dawned on me that I can do anything on that piano. I had absolute good pitch since ever and ever. Anything, any melody I know or heard, I immediately found, plus the improvised bass, plus improvisations. I was happy as a lark and would have remained that happy had I been allowed to continue to study with my superb little piano teacher.*[9]

This "superb little piano teacher" whom Lili so adored (she could not recall his name) had been a student of Arpád Szendy, a man who "was perhaps a hundred years ahead of his time, and so was my little teacher."[10] Despite Lili's love for her first teacher and excellent progress, Irene decided that her daughter's career would be better served if she were sent to study at Budapest's premiere musical institution, the Royal Academy of Music (now known as the Liszt Academy). At age eight, Lili

auditioned at the academy, in spite of the urgent pleas of her teacher, who feared that the young student might be placed with an inexperienced student-teacher. Notwithstanding the fact that the academy's normal age of admission was fourteen and that Lili's feet did not yet reach the pedals, she gave it a try:

> *At the Royal Academy, as it was called then, nothing helped you except talent. You could be as rich as hell and the child of the prime minister—never mind! You either were outstanding or not taken.*[11]
>
> *I created a sensation. True to my entire lack of diplomacy displayed throughout my life, it showed its devastating fearlessness during the audition. István Chován, Chairman of the Piano Faculty, had compulsory pieces on the repertoire to be presented by the aspirants. When asked to play one of the selections, I answered truthfully that I don't play them. In the awestruck silence following my statement, one of the more courageous professors, with a camouflaged laughter in his voice, asked me how come I haven't studied any of the pieces. I answered that I didn't like them and my teacher said they are not good compositions either. Astonishingly, they accepted me all the same. We had a little shop quite near the school, and after the audition, where I think some 157 competitors played and only eleven were taken, including myself, one professor after the other came to our shop and wanted to be assured that I would be their prospective student. I did create a real sensation.*[12]

The good news was that while still a child, Lili had earned full admission to the most prestigious conservatory in her country; her talent was obviously remarkable. The bad news was that, as feared, Lili was placed with a student-teacher during her first year at the academy, probably because the fee was much lower than if she would have studied with a more senior professor. She blamed this young teacher for assigning a much-too-difficult repertoire and for demanding excessively fast tempos, so that by the end of the year her hands and arms were almost paralyzed with pain. The professors had stopped coming by the shop, and Irene asked if Lili wanted to go on. The child answered in the affirmative, though she later reflected on what a crucial, pivotal decision this was: "I assure you that I am equally talented, equally adored, equally seduced by, equally productive in dance, painting, writing, and acting."[13] Life for Lili could have taken a very different turn, but music won out.

In despair about her instruction, Lili changed teachers. "I was taken by God's grace by a very excellent teacher called [Arnold] Székely, who was a direct student of Busoni, and his beneficial advantage was that he let me do what I wished; he never interfered."[14]

Székely's laissez-faire pedagogical style allowed Lili to seek her own technical approach, one that was characterized by a focused relaxation, finger strength, and rejection of a display of virtuosity for its own sake. This prodigy charted her own course, and soon Budapest's music community knew her name, because she was appearing throughout the city with increasing frequency. Also, students were beginning to beat a path to her door.

Lili's first teaching assignment, accepted during her initial year at the academy, was with a five-year-old child. By the time Lili was ten, she had other students, including a forty-five-year-old woman. She was learning that she could earn respect, admiration, and financial rewards through her talents, a stunning revelation for a child reared in poverty and saddled with a frustrated and aggressive mother. Music would always be Lili's entree to a better life.

While continuing her studies with Székely, she also studied theory with Zoltán Kodály. With Leo Weiner she studied chamber music but had to go unprepared to those lessons because her mother thought them a waste of time. Lili normally practiced between two and three hours daily, sessions that were not completely volitional nor always pleasant. Irene at times dragged Lili to the piano literally by the hair and hit her hands with a ruler when she made mistakes. The child sought relief from all the unpleasant aspects of her life through fantasy and imagination, hallmarks of her musicianship. Drama was always more prized than accuracy; interpretive freedom was more precious than musicological research; heart and soul were elevated above head and reason. The torment of unpleasant piano practice yielded to the ultimate refuge and salvation of transcendent emotionalism, with the piano as the medium.

Lili also escaped through childhood play whenever possible—"play with my peers was a source of infinite joy and totally carefree passionate abandon."[15] When not with friends or at the piano, Lili visited the zoo daily from her seventh to her

seventeenth year, trips that were made regardless of the weather and almost always alone. She felt a bond with the animals, believing that they reciprocated her affection and empathy. For instance, she once crawled under the retaining wall into the wolves' lair. She approached a wolf, who by happenstance was also named "Lili," fed it a peanut, and scratched and petted the animal. To the great relief of the startled attendant, the two Lilis coexisted in complete harmony, and the child retraced her steps without incident. In another zoo story, Lili came to the brink of catastrophe:

> *I made an agreement with the son of one of the wards [zoo keepers] that, if he allowed me to go into the lion cubs' cage, he gets all my Christmas treats. He said, "yes, yes, yes." He did as the agreement was made, but, in the meantime, those cubs had become big, big animals, and the door was open, unfortunately, between the mother and the cubs. Luckily that ward was somewhere nearby, and so I survived. But I must say, I stood there. There was no question of patting the lions.[16]*

Such adventures suggest the courage, trust, instinct, and willfulness that plagued and graced Lili all her life. To her credit, although she was afraid of many things, she never let fear get in the way. She boldly went anywhere and everywhere and did what she wanted.

At the beginning of Lili's last year at the academy, she was accepted into the studio of Arpád Szendy, her first teacher's

teacher. But before the classes started, Szendy died, and Lili was set adrift. With her plans for attending the conservatory that year disrupted, she looked for other opportunities. The one that presented itself afforded her escape from her unhappy homelife. Lili gladly accepted a job teaching piano in Losoncz (a small Hungarian town ceded to Czechoslovakia at the conclusion of World War I) and left her family for the first time. She lived in a house that doubled during the day as her studio. She later recalled those days of release from the burdens of her family with a glowing satisfaction and longing. A manifestation of her newly found freedom was her quick turn to cigarette smoking, a habit strictly forbidden at home. She smoked more than a pack a day for over two decades.

In Losoncz, she was thrust into the adult world, a role she was eagerly ready to assume. The transformation was now complete: Lili the child had become Kraus the woman, and all the world was hers to conquer, with her reign beginning in this tiny border town.

Eugene Fodor, the Hungarian-born editor-publisher of travel books, was one of Kraus's students in this tiny outpost. He remembered that his teacher was a dynamic and charismatic young woman who seduced the town. About her teaching he recalled:

> She was an inspiring teacher because she taught even young nonprofessionals in a way where the appreciation and understanding of music were just as important as technique, if not more important. She could demonstrate what she meant by perfection, but she also had that ability to explain

*to her students the nature of music and the intentions of the composer and a deeper meaning in music that gave her students an entirely different type of understanding of music from the routine type which was available in a provincial town.*

*Another thing she did right from the beginning was to initiate pupils in the latest contemporary Hungarian music alive at that time, namely the works of two great composers appearing on the scene—Bartók and Kodály. Even the Hungarian public knew little about them, but she was teaching complete beginners with the most sophisticated music, and the children took to it like ducks to water.*

*She was a very, very stunning young woman . . . when I first met her. She was beautiful and very, very dedicated to her music. The whole town, whether young or old or man or woman, simply madly fell in love with her, and I called her a sort of a revolutionary phenomenon.*[17]

About the friendship with Fodor, Kraus said later that it was perhaps "the only relationship I can think of totally innocent, at least for my part, of any sexual overtones."[18]

Kraus recalled the months spent in Losoncz as a time of great exploration and growth during which she taught, practiced—often until dawn and in the dark because the lights frequently failed—and made friends:

*There were a pair of twins, the ugliest sisters you can imagine, with whom I had philosophical discussions from*

*here to the next orbit. Oh, that was a wonderful time. A really fruitful time.*[19]

During her stay in this hamlet, one event demonstrated Kraus's susceptibility and penchant for psychic phenomena, power of suggestion, and fertile imagination. She attended the show of a visiting hypnotist, and when a volunteer was requested, her hand shot up. She went forward and in short order was under the man's spell: "It's very easy if you are so suggestible as I am."[20] She was then ordered to bend a metal poker, and to the astonishment of everyone present—except perhaps Kraus—she did it. If she were not made of iron, at least she could bend it. She also discovered, or maybe instinctively already knew, that people are easily persuaded if they are under a spell, and she could cast one over an audience like nobody else.

While in Losoncz, Kraus completed some of her course work at the academy via correspondence; however, she needed to return to Budapest to finish her studies. The magnet that drew her home was the opportunity to study with the most celebrated pianist in Hungary, Béla Bartók, professor at the Royal Academy since 1907. She had long wanted to study piano with him, and he was to exert tremendous influence over her. Not only was he a world-class musician, but also he had a captivating personality—a combination that she could not resist. Never did she tire of talking about her study with him:

*The greatest influence I ever was blessed to experience was that of Bartók's teaching. Not only did he play the piano like*

*nobody else in the world ever has or ever will, but he also impressed upon me that it is ridiculous to assume that with coercion you get anywhere. It is not possible. He was the least coercive teacher I ever knew to exist. In the lessons, after we played something, he just sat there silently. It was under-stood—I don't know how one knew—that you have to replay the piece. And so, for the better or the worse, you did replay it, and somehow it was totally different from the first time. That was his emanation, his projection, his vividness of creating the vision and the will. He would say, "Don't you see?" or "Have you considered what it could be?" or "I think it is more or less" or "But don't you find . . ." There was never, "That is like that; that you do like that." Never coercive! He taught like the Indian Gurus, to whom people pose their questions and they would remain silent, but they stay together in congenial silence for hours. At the end, the disciple stands up and he has received his answer. He never taught me any technique—absolutely never.*[21]

*Now, there is nobody, nobody, nobody today, I repeat, comparable to that playing of Bartók, but now why was it so incomparable? First of all, his method was that of Liszt, first class pianism, but inborn also, of course. He had very thin fingers, and he was not a sensuous man. Sometimes you had the feeling that bone hit against bone, so it was not a luxurious song, but boy, every note had its meaning. Every transition, everything, every phrase breathed out and in, and began again and went there, and came back. You heard the speech in all the voices, but implicated. There is no such playing today.*[22]

*Bartók taught mostly his own works. It was difficult to ask other professors to teach Bartók's compositions; permission was given reluctantly or not at all. I was passionately drawn to his music and his teaching enabled me to do things I never imagined I would be able to do. The only other music I studied with Bartók was the occasional Beethoven sonata [including the* Waldstein *Sonata], no Mozart, and some Liszt, including the E-flat major Concerto and the* Eroica *Transcendental Etude.*[23]

Bartók was her first role model as an international artist, and she basked in his glory, wanting to be with him and like him. She was so infatuated with Bartók that she continued to have occasional lessons with him over the next several years, even after she moved from Budapest. She saw him for the last time in Italy in the 1930s.

Notwithstanding her affection for Bartók, Kraus at seventeen had just graduated from the academy with honors and was hungry for a taste of the outside world, an appetite whetted by her stay in Losoncz. Budapest was not the place for a musician to find either international fame or fortune, so she set her sights westward toward Vienna. Once departed, Kraus would never again live in her native land. ❀

# $\mathscr{A}$CT II~TALES FROM VIENNA

In 1920 Kraus moved to Vienna, that dynamic, glittering cultural mecca, the capital of western music, and the spawning ground of Classicism, the force that was eventually to play such an important role in Kraus's musicianship. In the city that had been home to Mozart, Haydn, Beethoven, Schubert, Brahms, and Mahler, among others, Kraus took advantage of all that Vienna had to offer, attending concerts, plays, master classes, and parties. Here she first experienced the glory of Mozart, the composer with whose name she was to become linked. At a Viennese concert in 1922 when she was nineteen, she heard his *Jupiter* Symphony, K. 551, with the great Felix Weingartner conducting. She recalled, "I thought I would not survive that beauty."[1] Her love affair with Mozart's music grew steadily from that moment.

Kraus's first priority was to study with Severin Eisenberger at the New Vienna Conservatory. Eisenberger was a Leschetizky student who at twenty-three had taught at the Berlin Academy, but during World War I he suffered shell shock, affecting his memory and ending his career as a public performer. Although the normal course of study was three years, Kraus completed the work in one. The following year she studied contemporary music with Edward [or Eduard] Steuermann, the disciple and interpreter of Arnold Schoenberg's music. About Steuermann, Kraus commented:

*He was the brightest, intellectually the brightest, teacher I can possibly imagine, shedding light right and left, yet, the most boring player there ever was in the world. But apropos technique, he didn't teach me technique either; but when I played for him, I'll never forget—it was the Brahms' Schumann Variations—the first piece I played for him, he said at the end of it: "I am really full of admiration." My seams burst. However, he continued: "As to your technique, I can't understand that, against all rational consideration, you escape breaking every one of your ten fingers."[2]*

While at the conservatory, Kraus studied no Mozart, a composer whose piano music was not often played in those days, but she did work on a few Haydn pieces. Mainly, her teachers assigned the works of Chopin, Beethoven, Liszt, a little Rachmaninoff, and "countless, countless Bach Preludes and Fugues, Two and Three Part Inventions, etc."[3] She also worked on pedagogical etudes by such composers as Heller and Czerny as well as Clementi's *Gradus ad Parnassum*.

Eisenberger had tried to interest her in the music of Schubert. He played fragments of the composer's works for her one day, but she told him she did not care for it. She later changed her mind. "Happily, I came to adore Schubert, but that was a late acquaintanceship."[4]

In 1923, Kraus was named a full professor of piano at the New Vienna Conservatory, a significant accomplishment for someone only twenty years old, a distinction never before accorded a woman of foreign birth and training. She had begun

teaching at the conservatory in 1922 as an assistant teacher, but her popularity was such that she soon had more students than did her supervisory teacher. Though this situation was clearly untenable for the faculty and Kraus almost lost her job, she managed to turn near-disaster into victory:

> *The director came to me and said, "Lili, what is hap-pening, dear?" I answered, "I don't know what is happening. People come." "Yeah, but this is an impossible situation. I will have to ask you to leave that position." I said, "Yes, I wouldn't mind that, but I have no money, and we have no master class in Budapest, and therefore, I would like to teach here at the Academy." "But a permanent job as a full professor?" I said, "Yes." "But that's impossible; you're much too young." I said, "Please make it possible." And he did.[5]*

Kraus continued to teach at the conservatory throughout the 1920s. Somehow she always managed to wield this kind of power over people, and she reveled in it. So much did she come to revere power that the one trait in others that she most despised was weakness. No one ever could have accused her of believing the meek would inherit the earth.

A great deal of Kraus's success at the conservatory was due to her budding concert career. Although she had been playing professionally since her sixteenth year, her career had been provincial. Her international debut finally took place just outside The Hague in the Netherlands in 1921, when she was eighteen. There she performed at the famous Kurhaus, a resort

hotel in Scheveningen with the Orchestra of The Hague under the direction of the renowned Ignaz Neumark. It was Neumark who invited Kraus to play after overhearing her rehearsal with his friend, Eisenberger. She was engaged to play the Beethoven Fourth Concerto, and because this was her first professional appearance with orchestra, and because it was in such a significant setting, she was especially eager to do well. Naturally, she expected to have rehearsal time with the orchestra to work out details such as tempo and rhythmic nuance. To her dismay, no rehearsal was scheduled—Neumark's custom was not to rehearse with soloists—and she had to walk out onto that stage cold. Despite this adversity, her debut was a success, and within the next two years, she played forty-five European concerts, including appearances with the Dresden Philharmonic with Eduard Mörike and the Berlin Philharmonic with Erich Kleiber. This was also the period when she became a "Steinway Artist," a designation that meant that she was to perform on Steinways and that she would be provided a Steinway grand on loan (one that had once belonged to the famous operetta composer, Franz Lehar) for use in her room in Vienna.

Kraus's repertoire was then almost exclusively Romantic, as was her stage presence. She played a great deal of Chopin in a manner that, by her own admission, must have been quite dramatic:

> *From about eighteen to twenty-three I was known as a Chopin player. I had then a forest of hair on my head, and no matter how many hairpins I would use to keep it up, by*

*the end of a dramatic piece—say, the F minor Fantasie—the
hairpins would be scattered on the floor and my hair
down. I'm sure the audience thought: "If this isn't
Romantic, what is!"*[6]

For those who were familiar with Kraus in her later
career, the Romantic bent of her repertoire during the 1920s is
surprising. She played little Mozart and Haydn. By 1930, for
instance, she knew only two Mozart concertos—D minor, K.
466, and E-flat major, K. 271, the *Jeunehomme* Concerto.

At this time her concerto repertoire included the first four
Beethoven, the Schumann, the Liszt E-flat major, the Schubert-
Liszt *Wanderer* Fantasy, and the Rachmaninoff C minor. (A list
of most of her solo repertoire from this era is provided in the
Appendix, no. 1.)

People who knew Kraus in the 1920s agreed that she
was indeed a romantic figure. Admirers considered her the
most beautiful woman in Europe, which partly explained her
popularity. Although she did occasionally return to Budapest
for a brief visit, most of her free time was spent attending
concerts and going to countless parties, frequently in the
company of some young man or another, most of whom
adored her. Among her more serious courtiers were a
Hungarian physician and another man named Schnabel (not
Artur Schnabel). This Schnabel was Viennese, and he and
Kraus were apparently intimate. When she ended the affair,
he was heartbroken. As a final gesture of his feelings, he
brought her a book titled *Mutations of Love*, the inference

being that he hoped the estrangement was temporary. To his dismay, it was permanent.

Kraus's career flourished throughout the 1920s, and reviewers wrote enthusiastically about this young sensation. Her playing and beauty intrigued them. In Vienna, a reviewer for *Die Stunde* wrote of a March 1926 recital that included Franck's *Prelude, Chorale, and Fugue*, Schumann's *Symphonic* Etudes, and several Chopin etudes:

> *The concert given by the beautiful young pianist, Lili Kraus, proved to be a real sensation. She is highly gifted. She reigns supreme in all styles, Mozart, Franck, Kodály, Certainly a great career lies before her.*[7]

Two weeks later, in April 1926, the critic for the *Neue Freie Presse* observed that Kraus's "spiritual force and ambitions raise her interpretations to a very high artistic level." He was also impressed by "her deep insight full of fantasy."

In November 1926, Kraus played the Schubert-Liszt *Wanderer* Fantasy in Dresden and received a glowing notice in the *Dresdner Anzeiger*:

> *A young pianist of extraordinary gifts was introduced to us: Lili Kraus, of Vienna, a former pupil of Eisenberger. For the first time in many years, we were made to feel that Lili Krauss is an artist who is destined to follow in the footsteps of Carreño, Elly Ney, Kleeberg, Sofie Menter. Her technical equipment is as astounding as her precision of*

*purpose which subjugates every rubato and shade of touch to
a real artistic temperament. Her phrasing of a cantilena is as
convincing as her strong rhythmical force.*[8]

Kraus's career was now established. Though not yet a well-
known name, even in Vienna, she appeared bound for success.

Kraus had also formed a brief professional collaboration
with the American violinist Olga Rudge, with whom she
performed in Vienna in 1928, probably in May or June. This
association with violinists was the beginning of an important
part of Kraus's career.

After Kraus's orchestral debut at the Kurhaus near The
Hague, she continued to play there and in Amsterdam to the
delight of the critics. So much did she enjoy her visits to Holland
that she went there often throughout her career, developing
many close friendships in that country. In September 1927,
she played again at the Kurhaus with Ignaz Neumark
conducting. The critic for *Het Vaderland* wrote, "Her playing
was that of the virtuoso, displaying an elastic touch and great
rhythmical insight, and she was recalled many times." About the
same concert, the reviewer for *De Avondpost* took note of Kraus's
charm: "This talented artist scored a very great success and was
overwhelmed with flowers, which match her captivating and
charming personality so well." In March 1930, Vienna's *Neuer
Wiener Tageblatt* made a similar observation:

> *. . . we are paying her no empty compliment if we
> refer to the support which her execution receives from her*

*charming and beautiful personality. One can but say
that her playing is charming to both the senses of hearing
and sight.*[9]

While the critics and public were noting Kraus's charisma,
she steadfastly disavowed any pretense or premeditated show-
manship, claiming that magnetism must be come by naturally
and cannot be copied:

> *I never had the airs of a prima donna, never. My
> behavior on stage was perhaps so attractive because it was
> completely natural. I never thought of being a famous artist;
> I never thought of being arrogant.*[10]

One manifestation of her presence was her frequent
stage commentary, which she did exceedingly well. About this
practice she commented:

> *Expressing the meaning of music in words is an easy
> task if you know the literature, for almost all composers at one
> time or another have put words to their musical symbols:
> Mozart in his operas, Schubert in his songs, Beethoven in his
> Mass, Bach in his cantatas.*
>
> *Now why is expressing the meaning in words so
> helpful? Because if someone has a completely wrong feeling
> for a passage, words will help. . . . Schnabel used to
> improvise texts for almost all the music he taught, and his
> texts were extremely helpful.*[11]

Her remarks were always artfully stated in the host language, delivered by a consummate actress. (See Appendix, no. 2, for an example of her comments, as spoken at a London recital in reference to Bartók's *Fifteen Hungarian Peasant Songs*.)

Kraus spoke always about the music, not about herself, as many other artists who talk from the stage do. When the pronoun "I" is overused, the talks are always an abuse of time and an insult to etiquette. She did not bother audiences with reminiscences about her study of the piece, her first hearing of it, or her personal reaction to it. Instead, she spoke of the dramatic meaning of the work, brilliantly articulating its aesthetic essence. Eventually, her commentary was equally effective in Hungarian, German, English, French, Italian, Dutch, and Indonesian.

Kraus was certainly a performer who gave her public more than just music, and they loved it. Fortunately, so did most of the critics at this time in her career. Not only did she talk, but also she might, on occasion, leave the stage to fetch the music if she had a memory slip. If she discovered a torn fingernail during a program, she would ask if anyone in the house had nail clippers. She was both musician and stage personality, a combination the audiences seemed to adore.

Berlin was as impressed as the rest of Europe with the youthful, vivacious Kraus. In March 1930, the reviewer for *Die Deutsche Allgemeine Zeitung* judged, "The outlook for her future is excellent." Later that same month, when Kraus played a recital in Berlin's Beethoven Saal, the critic for *Die Allgemeine Musikzeitung* wrote, "This exceptional artistic performance

*23*

must be classed as a real event." Kraus's future was bright indeed, and managers began to court her. On the continent George Albert Backhaus of Berlin managed her career. In Great Britain, she was then and for many years thereafter associated with the management firm of Ibbs and Tillett.

Still in her twenties, Kraus must have felt both pride and excitement. She was playing concerts extensively, and the reviews were glowing. She was talented, beautiful, and successful. Kraus seemed to have it all. But did she? Despite the burgeoning career, she longed for the security and love of family. Her dysfunctional family in Budapest was certainly not the answer; in fact, she wanted exactly the opposite of that model. In 1929, she was about to get her wish.

The winds of Kraus's social life eventually put her on the same course as various members of the Mandl family, a clan that was to alter her life, and vice versa. Head of the family was Otto, a wealthy Austrian mining engineer, a doctor of philosophy with an avid interest in literature and theology, an ardent art patron, and a tall, thin, distinguished man with a goatee. He was born on February 16, 1889, making him fourteen years older than Kraus, an age difference Kraus later portrayed as a twenty-year span in order to maintain public deceit about her own age. In fact, Mandl may have appeared older than the energetic Kraus because of a limp he suffered as a result of a shrapnel injury he received while serving as a captain in the Austrian army in 1914. Forty years later he developed lead poisoning as a result.

A man of broad interests and humanitarian concerns, Mandl was an advocate for many liberal social and political

issues, including an investigation of the social conditions in the coal mines of Wales and Newcastle. Also an astute businessman, he was one of the first to develop plans to send lumber from the Caucasus and Armenian forests to the British market.

Mandl became a close friend of H. G. Wells, first meeting the famous author in Prague in 1919 when Mandl secured permission to translate Wells's *Outline of History* into German, the first of twenty-one Wells books he translated. Through Wells, Mandl met Bertrand Russell, English philosopher and Nobel Laureate, and the actor Charlie Chaplin, men who remained lifelong friends of his and, later, Kraus. He also translated some works of J. B. S. Haldane, Julian Huxley, the French philosopher Alain, and Colette, renowned French author.

Shortly after World War I, Mandl moved to England and married Mary Durant. They had three children: William, Lavinia, and Maria, who eventually married Ferdinand Grossmann, founder and longtime director of the Vienna Boys Choir.

Otto was introduced to Kraus by his younger brother, Felix, who, while in Vienna in 1928, met and fell in love with Kraus. Felix repeatedly asked her to marry him. She later admitted she never loved him, but she was unable to tell him this; in response to his proposals, she replied, "Maybe." Felix naturally told his older brother, who at the time was living with his family in northern Italy, about the love of his life. In the fall of 1928, Otto came to Vienna, and Felix took him to hear one of Kraus's recitals. They arrived late and waited outside the concert hall door until an appropriate moment to enter. Otto was convinced that the vigorous playing he heard must be

coming from a man. When he went into the hall and saw a stunning young woman seated at the piano, he was instantly interested in her for himself. Kraus met Otto and reciprocated his interest, leaving Felix out of the picture for good.

Mandl's problem, of course, was that he was married, which meant he had to exercise great care and discretion while he courted Kraus. His solution was to send his daughter Lavinia, who was just a few years younger than Kraus, to Vienna to study piano with her. He also arranged for Lavinia and Kraus to share an apartment. Then he moved back to London with his wife and other two children, but now he had the perfect alibi to visit Lavinia—and Kraus—often.

Love and nature took their course, and by November 1929, Kraus became pregnant with Mandl's child. They both recognized their timing and image problem. He could not divorce Mary in nine months, and Kraus did not need a husbandless pregnancy to complicate her career. A plausible and necessary solution was to find a man who would agree to marry Kraus to create a façade of respectability. This marriage was to be made with two conditions: One, the husband must grant Kraus a divorce as soon as Otto was free to marry her and, two, the arranged marriage was to exist in name only. A Polish man (whose name nobody now remembers) was not the first to whom this plan was proposed, but he was the first to accept. The "marriage" took place as stipulated, a handsome fee was paid to the Polish groom, and Kraus's honor was salvaged.[12]

Kraus was ecstatic during this period. First, she was deeply in love with Mandl, a man who had the wealth and business

skills to shepherd her career to new heights. Mandl was, she felt, just the right age for her to marry. At forty-one, he was old enough "to have sown his wild oats." Younger men, she insisted, could not reasonably be expected to devote themselves to a wife and children because they would be distracted by demands of building a career and by the allure of other women. Conversely, Kraus argued that women should marry young, preferably just after leaving their parents, in order to have children early in life. When the children are grown and the husband is old, the woman, now endowed with the sagacity of middle age, is ready to commence her professional career. Such was Kraus's vision of marriage, and she was about to make it a reality. She was also overjoyed to be pregnant. She felt that a woman's highest calling is to give birth; she had pity for women who could not have children and contempt for those who chose not to have them. She also believed that being a parent is essential for an artist, an experience that would bring her both personal and professional fulfillment and enhancement:

> To my mind, a real artist, . . . must be composed of the animal and the angel—must be. It is a sensuous manifestation as well as it is a spiritual, intellectual, and emotional one. When I became pregnant, the animal had the upper hand, and I was so happy being pregnant as only that one-time experience can produce. You see, all great women who came to fulfillment had children.[13]

A favorite Kraus story about her first pregnancy provides

a striking example of the daring sense of challenge and risk taking that characterized her life. At the eight-or nine-month point, she vacationed alone in the Swiss mountains, where she "roamed . . . like one possessed with joy." Her roaming was not a leisurely stroll around gentle hills, but rather racing up and down steep mountains: ". . . the word 'fear' didn't enter. The whole concern was that I carried that life up and down . . . with a speed which no guide could ever match."[14]

Kraus, who usually wore her hair in two long braids during this period, scaled the mountains for days—even once at night by the light of a lantern—all while smoking cigarettes "like a chimney."

While Kraus was climbing, Mandl had his hands full back in London arranging his divorce. Mary acquiesced to reality but with the greatest reluctance. She knew that Mandl wanted out, and even the three children had come to love Kraus. To Mary's everlasting credit, she welcomed the pianist into her home in 1929 when Kraus played her debut recital in London on June 24 in the Aeolian Hall. Mandl's son, William, remembered the indelible impression Kraus made:

> *She was ravishingly beautiful, dressed completely different than people were in London at that time. She wore clothes which, as my mother expressed it, were a little sudden. The colors were intense, but she could afford to wear intense colors because she had an enormously dynamic and vivacious personality. Her movements were majestic, and when she walked on the street, there was a queen walking. She tossed*

*her head and people turned around because she was so
beautiful, just marvelously beautiful. Her personal
appearance was just something you never forgot. The same
is true of her stage presence. She has this marvelous way of
giving the audience a feeling that she cares. She just does
that by the way she moves on stage.*[15]

Despite Kraus's regal and dramatic intrusion into an
established family unit, she recollected that she did not destroy
the marriage. "They were already apart, but for the children's
sake they remained together in very good friendship."[16] Mary
Mandl, however, continued to hope that her husband would
one day refocus his attention on her. Obviously the differing
perspectives of those involved colored the cause, blame, and
effect of the Mandl divorce and Otto Mandl's marriage to Kraus.

On August 18, 1930, Kraus gave birth to a daughter, Ruth
Maria. About six weeks later, on October 31, Mandl and Kraus
were married just after his divorce was final.[17] (It should be
noted that the exact date of the marriage is disputed; it may not
have occurred until later in 1931 or early 1932.) Kraus never
took her husband's name in public or private life; professionally
she always preferred to be known as "Madame Kraus."

Even before he and Kraus were married Mandl's life began
to change drastically. He owned the British-American Timber
Trust Company, a firm that had imported timber from Russia,
with offices in Vienna and London. With the stock market crash
in 1929, the firm suffered financial reversals and went into
liquidation. Mandl had no choice but to sell the business. Its

collapse left him depressed and with no meaningful professional outlet. At the same time, Kraus's career was soaring, and Mandl found himself inexorably drawn into it. Kraus felt that Mandl's increasing involvement with her career was his salvation: "After the terrible crash of 1929, my husband surely, as he said, would not have stayed alive but for me."[18]

In short order Mandl became Kraus's husband, impresario, confidant, critic, and constant traveling companion. William Mandl felt that his father willingly made a remarkable sacrifice in order to promote Kraus's career:

> *She adored him, and he worshipped her. He gave up his entire career, he gave up his entire money—his entire fortune—all went into Lili. And went—I mean, it went.*[19]

About their relationship, Kraus said, "How I adored my husband who was absolutely everything for me: lover, idol, guide, and source of information."[20] She properly credited him with having infused her life and career with vitality, purpose, and direction, though he did run the show with an iron fist.

In fact, his family bestowed the nickname "Dicky" upon Mandl because he was considered by them to be a bit of a dictator. As a former soldier and captain of industry, he was used to being in charge. According to his son, he was "a born leader," who was once told by Chaim Weizmann, the first president of Israel in 1949, that Mandl should have been president instead of Weizmann. He was also an excellent lecturer who spoke to audiences on a wide variety of topics. His son suggested, "He

was perhaps one of the last great Renaissance men."[21] Such a powerful intellect and personality was bound to have a profoundly altering effect upon the vivacious Kraus, and William Mandl witnessed the metamorphosis:

> *When she was young—I met her in 1929—there was really only one thing that dominated the specter of her many gifts, and that was the piano. My father broadened her ability to perceive life to the extent that he taught her to appreciate literature to some extent. She was almost illiterate; she read trash —mystery stories and things like that when he met her. He sort of cajoled her over into a somewhat more sophisticated way of observing the possibilities in literature, and, also, she became very much more aware than she had been as a young woman of how important it is what one eats and what one drinks. This was a completely new realm for her that these kind of things had any effect on life. She was a really very innocent person when I first met her. She was changed through my father's influence and to some extent ours— "ours" being myself and my two sisters (we were brought up as English aristocrats, with an English prep school education, so we knew what was right and what was wrong).*
>
> *That idea of the possibility of knowing what was right and wrong as regards behavior patterns towards other people was completely unknown to Lili. Whatever felt good she did. She shocked people and alienated them and made them feel very unhappy. She said impossible things because she was so impetuous. That changed over the years. She became very*

*much more tactful, more receptive to what other people might find useful to hear or might need to hear, instead of just saying what came to her mind at the moment regardless of who the other person was. There was definitely a stronger ability to understand other people, of which she had very little when she was young because she was so full of herself.[22]*

Kraus admitted as much when she said that her husband had "pruned" the "wild garden" she used to be.

Part of the pruning that Mandl undertook was to urge Kraus to consider carefully her status as a Jew in a hostile world. Actually the specter of anti-Semitism had haunted Kraus her entire life, cutting her to the marrow, but she must have suffered most from the powerful grasp of discrimination in her beloved Vienna. The Imperial City, home of Mozart, Beethoven, Haydn, and Schubert, was also the site of Europe's worst anti-Jewish sentiment. The origins of Austrian anti-Semitism are complex, but one strong factor was resentment of the wealthy and powerful Rothschild family who controlled big banking interests in much of Europe. Nowhere, though, were the Rothschilds more ingrained into the fabric of society than in Vienna, where they enjoyed a symbiotic relationship with the Hapsburg monarchy.

Anti-Semitism formed the basis of political activism in Austria since at least the financial crash of 1873, and a struggle to wrest control of Austrian railroads from the Rothschilds in 1886 exacerbated the confrontation. Consequently, Vienna in 1897 elected as mayor Karl Lueger, who ran as an openly hostile

anti-Semite. When the emperor's government collapsed after World War I, nationalism fractured Austrian society, and Jews became every group's scapegoat. The novelist Joseph Roth observed in the 1920s, "It is terribly difficult to be an East European Jew; there is no harder fate than to be an East European Jewish alien in Vienna.[23]

Realizing that the situation was fast becoming even more horrific in the 1930s throughout the German world, Mandl persuaded his wife to join him in disclaiming their Jewish heritage and converting to Christianity for the sake of career and safety. This act of apostasy was sadly but fortunately a route of escape for many, and Kraus reluctantly concluded that she must also take it. Although no one will ever know how many Jews renounced their religion during this period, the number appears to have been quite large, particularly among physicians, lawyers, teachers, and other public figures. Even the revered Gustav Mahler had accepted Catholicism in 1897 so that he could become director of the Vienna Court Opera. This cruel necessity was a stunning blow to Kraus, a pain she harbored and hid— even from her children—to the end of her life. Hard as the decision was, it was the only way, because Kraus and her family were about to move to Berlin just as the Nazis were coming to power.

Even before their wedding, Mandl had decided that Kraus should go to Berlin to study with Artur Schnabel, the great Austrian pianist, Leschetizky student, acquaintance of Brahms and champion of the Viennese Classicists. Kraus demurred, largely because Eisenberger had warned that Schnabel was an

intolerant tyrant who would leave those who dared to study with him little more than caricatures of himself.[24] Despite all attempts at persuasion, Mandl failed to convert his wife on this issue. So he resorted to trickery, insisting that Lavinia, Kraus's pupil for two years, should audition for the revered pianist. Knowing that Lavinia was wholly inadequate for such a task, Kraus vigorously protested. She lost the argument, and the three of them arrived at Schnabel's studio in Berlin in 1930. As expected, the great man rejected Lavinia, suggesting that she might study instead with one of his assistants. As Mandl had hoped, Schnabel then turned his attention to Kraus. An anxious Mandl filled in what Schnabel did not already know about her career. After some conversation, Schnabel asked if Kraus would like to study with him. Kraus, who later admitted to having been "overwhelmed by the terrific personality" of Schnabel, accepted his offer despite her earlier position. Her musical life would never be the same again. ✿

# $\mathcal{A}$CT III~THIRTY-SOMETHING

Kraus and Mandl moved to Berlin in 1930 for study under Schnabel. The lessons started right away and were totally unlike anything Kraus had experienced. She recognized the genius of her new mentor and was determined to be remade in his image. Kraus vividly remembered those early lessons:

> *After the first session, agonizing in front of twenty to thirty auditors, I had a vital decision to make: would I accept my total ignorance in view of Schnabel's total knowledge, knuckle down and trample my pride underfoot—or would I walk out, never to return? Never to succeed in scaling the wall behind which lies a world of infinite splendor, adventure, deadly hazards, and undreamed-of glory? I felt that Schnabel lived and moved in that world with complete ease and freedom as in his native element; but I was outside, for I failed to understand what he had to tell me. The terms used, the context he used them in, and his entire approach were new and strange to me. Naturally, after a short struggle, one "seal" after the other yielded and the initiation took its course.[1]*

Kraus never had a private lesson with Schnabel during the years she studied under him. As was then the custom of many

teachers, including Bartók, lessons were almost always conducted in front of twenty or more auditors. The lack of privacy was particularly hard on Kraus. She was an acclaimed performer in her own right. Now her ego had to bend in order to accept the kinds of wholesale changes Schnabel demanded. Kraus shed many tears and bore much humiliation during her transformation, but she never questioned the value of what she was learning:

> I had already reached the level of a fine young upcoming artist, having given many concerts. Of course, there I learned everything that is worth knowing in that his genius did not know compromises. For the better or the worse, the exaggerated slow and the exaggerated fast tempi that he moved in commanded by his nature were totally acceptable and valid and admirable if you knew him, if you heard him play, if you were taught by him. You had to be, however, superbly talented to benefit by his teaching. I, for instance, was shattered for two years. I couldn't, practically couldn't, play because I had to spit out and digest all that which I was taught.[2]
>
> He was the most eloquent speaker you have ever seen. Before he let the person play his or her piece from beginning to end, he embarked on a dissertation on which we all hung like on the gospel. He adored to speak. Now what would he say? The essence of what he said was, "No matter how fascinatingly, colorfully, brilliantly, musicianly, thrillingly you play, unless you have learned to read the score and do, and feel, and say everything that that score contains, your

*playing is not worth a blown out egg.[3]*

*What he cared for, in a nutshell, presuming that the student had sufficient insight, passion, and humility, was to invoke the meaning of the work beyond the shell. To Schnabel's best conviction, no matter how brilliant the presentation turned out to be, it remained valueless unless it succeeded in projecting the artistic image of the composition. He preferred a musically compelling rendition, even if not flawless, to the most infallible production of technical proficiency. The inestimable principle I received from Schnabel was the fact that, no matter how clever the commentator [editor] was, the edition to be used had to be the* Urtext, *the original edition which showed the intentions of the composer, un-adulterated.[4]*

Kraus absorbed every atom of Schnabel's musical approach, particularly his emphasis on using the piano to depict drama. Her playing and eventually her teaching reflected his style and artistic temperament. She willingly yielded a good portion of her own professional identity so that she could be more like the master.

With Schnabel, she studied an eclectic repertoire, including Mozart, Schubert, Bach, Weber, and Brahms. Though he insisted on fidelity to the composer's indications (a curious predilection in light of his extensively edited and personalized versions of Beethoven's sonatas), he was motivated by a dramatic impulse to employ a good deal of tempo *rubato* and daring agogic accents that manifested themselves in both his playing and teaching.

Kraus was greatly influenced by this sense of drama and freedom. From Schnabel, she also learned the practice of overdotting, that is prolonging tones, and of a surging drive to phrase peaks, an interpretative characteristic that became a trademark of Kraus's playing, as it was of Schnabel's. Further, he taught Kraus to mask metric accents and to use the metronome during practice:

> One day he asked, "Do you use the metronome?" Somewhat astonished I answered: "No—I don't think so." He said, "You should, you know, but not when you 'practice' but when you play. You will be amazed how necessary the metronome is because you have no idea what kind of freedom you take at the cost of an even tempo in trying to 'express your feelings.'"
>
> Of course, there can never be a uniform metronome beat in a performance. But, within the "beat" of the metronome, you may use all the freedom of your own heartbeat, employing the infinitely minute entities projecting the nature the human heart manifests: now quickening in joy, reaching out towards the keynote of the goal (accelerandi) or saddening or at peace or calm after having fulfilled its intent (ritardandi). It cannot be sufficiently emphasized that none of these fluctuations may destroy the even, fundamental tempo of the piece.
>
> I also observed that Schnabel, being a composer himself, read and played no matter what was put before him as if he had studied that piece his whole life. From that I learned that it is a total misconception to speak about "style"

*of playing. If you understand the language, the style is given. If you understand the fabulous message of Mozart's dynamic signs, you will have no doubts.* A fortepiano, *a* fortissimo, *or whatever dynamic mark he uses are but a heightened* espressivo *within a narrow frame in accordance with the nature of his instrument and his mode of expression. Unfortunately, to this day people either totally ignore them or emphasize them instead of understanding that they are simply explanations of that experience. You must have endless grades of emphasis depending on what the music says.*[5]

Claude Frank, the concert pianist, was also a student of Schnabel some years after Kraus. Frank, who knew Kraus's playing well, shared important insights about Schnabel's influence upon her:

*I would say she got two things from Schnabel. One is a complete refusal of artistic compromise which is exemplified in the playing itself. There are no concessions to trying to be "expressive" like slowing down the end of a phrase to show an imaginary audience, "Here is the end of the phrase." Schnabel refused ever to do that, and Lili also refuses to do it. Schnabel's influence was very strong in this. The other thing is something that actually I think no other teacher really, at least by example, gave to his students as much as Schnabel did, and that is to give every phrase in music, every theme, every motive a particular face. Character is not enough to say, but a face, just like he was painting it or just like a character*

*appearing in an opera. When he played a theme that returned throughout a piece, Schnabel insisted and demonstrated that it is another character, it is suddenly a man where it had been a woman; it is suddenly somebody young if it had been somebody old; it is suddenly somebody in green where it had been somebody in red and something very, very distinct. He constantly did that and Lili very much does that too. Everything she does in her playing has a particular specific character that defies words, that one cannot describe in words, that one can describe only in music. I think, those are the two main things.*[6]

Despite the profound changes Schnabel wrought in Kraus's interpretative sensibilities, he did not talk about technique with her.

*He didn't teach me technically. We became very dear friends; he stayed at our house. One day, unforgettably, we went out for a beautiful evening walk, and I said, "Artur, how does one play a* forte?*" "Are you serious?" he replied. "I am damn serious," I told him. "But all you do is this," and he waved his wrist. As it happens, in a nutshell and with countless modifications, this movement is the key to a flexible wrist. But, yes, I was left to discover technique partly through the other students and partly through myself; I understood that.*[7]

Kraus and Mandl soon developed a close friendship with

Schnabel and his wife, Therese Behr, the lieder singer. For a time Kraus served as his teaching assistant. She never tired of extolling Schnabel's brilliance and was proud to recall that he once told her that she was his only true spiritual heir.[8] Also, he said that he particularly admired her *Spielfreudigkeit* or playfulness. She became his disciple, spreading his gospel and singing his praises.

While busy with her studies, Kraus was presented with many opportunities to perform throughout Europe. However, an expanding family offered new complications. In addition to daughter Ruth, a son, Michael Otto (nicknamed "Miessi"), was born on November 15, 1931, and the challenge of balancing family demands with her career was awesome. Kraus and Mandl saw only one practical solution to this dilemma, and that was to hire a nanny to care for the children while the couple toured as well as while they were home so that Kraus could practice. Understandably, Kraus felt guilt about these frequent and often protracted separations:

> *Every time you leave, you leave half your life behind you. When I was at home, I was torn by the necessity to prepare my concerts but dying with the wish to be with the children.[9]*
>
> *When the children are tiny, you worry about the nana to whom you entrusted them. When they are bigger, you hope to God that their peers are not yet spoiled and contaminated. When they are adults or adolescents, you hope that their friends won't seduce them to drugs or alcohol. And the more positive your relationship is to them, to life*

*and to your husband, the more you are likely to succeed in your assumption that it might go well. More you cannot do.*[10]

Marius Flothuis, Dutch composer and musicologist and family friend, recalls that Kraus admitted to him: *"Die Kinder sind das Opfer, das ich meiner Kunst darbringe"* ("The children are the sacrifice that I give to my art").[11]

From the perspective of the children, the separations, although difficult, were compensated for by the joy of their charismatic mother's presence during her stays at home. Years later, Ruth remembered:

> *I think that Lili managed her artistic life and her family life as well as a human being could. I never felt growing up that we really, I must speak for myself, that I really suffered under the fact that she was a world-renowned concert pianist. When she was around, it was such a special time that it made up for the absences and the separations. It was such a great thing to have this person being your mother because we had always grown up with the knowledge that this was a great thing. My father I think contributed a tremendous lot to that because he worshipped her. She was on a pedestal all our life. He instilled this great love of her, of her art, of the importance of her work into us children, or into me certainly. We took the good with the bad and I've always felt that it was a great privilege to have Lili as a mother.*[12]

With the nanny issue settled, Kraus was free to perform

widely and broadly. During 1931, for instance, she played many joint recitals with her countryman and friend of ten years, the pianist-composer Géza Frid, who had been a fellow student in Budapest. In February and March of 1931, Frid and Kraus performed in Amsterdam, Rotterdam, Paris, Geneva, Zurich, and Vienna. Their two-piano repertoire included the Mozart Sonata in D major, K. 448, the Saint-Saëns Polonaise, op. 77, and Debussy's *En blanc et noir*. For four hands at one piano, they played Stravinsky's *Five Easy Pieces* and Frid's adaptation of his Suite for Orchestra. Kraus rounded out each of the programs with solo selections, including J. S. Bach's Toccata and Fugue in D minor, Beethoven's *Eroica* Variations, a Chopin group, an unidentified work by Handel, and a solo piece by Frid, *Twaalf Muzikale Karikaturen*, op. 8, which the composer dedicated to Kraus in 1930. The reviews of these performances were excellent. Interestingly, during their appearance in Vienna, Kraus and Frid had dinner with the great Austrian dramatist and writer Arthur Schnitzler one month before his death. Kraus had known Schnitzler well during the 1920s when she lived in Vienna. There she and Schnitzler's niece, Anni Donath, a pianist and fellow student of Eisenberger, had become best friends. In fact, Kraus spent practically every weekend for several years with Donath and her family, and in that way she became well known to and much admired by Schnitzler, with whom she had many conversations about the Jewish problem. In Schnitzler's novel of *fin-de-siècle* Vienna, *Der Weg in Freie* (1908), a character is dissuaded from renouncing his Jewish heritage out of fear of offending his parents. Conversations with Schnitzler must have

been profound and moving for the young pianist.

Kraus was now playing throughout Europe in increasingly important engagements, evidence that the great promise she had initially exhibited was coming to fruition. She was fast becoming a major international artist. For instance, on December 7, 1930, she made an appearance with the great conductor Willem Mengelberg; together they performed the Schumann Concerto in Amsterdam's renowned Concertgebouw. In January 1931, she played at London's prestigious Wigmore Hall, where her program included Bach's *Capriccio on the Departure of a Beloved Brother*, a sonata by Mozart, Beethoven's *Eroica* Variations, and Bartók's *Fifteen Hungarian Peasant Songs.* The review in the *Times* of London praised her playing for its "fresh vitality and individual style."[13] Her reading of the Beethoven received high marks for "a delightful variety of touch and a really well-thought-out technical balance of tone and control." Interestingly, the Mozart was criticized as being "less well played as a whole, since at times the time-keeping got out of hand; a *rubato* was too apt to ignore the natural accentuation, but otherwise the expression was sensitive."[14]

While Kraus's career continued to run in high gear throughout the early 1930s, problems at home demanded her intervention. When Michael was about six months old, he contracted tuberculosis from the nanny caring for the children. The child's doctor prescribed a warmer climate than Berlin's. In early 1932, the family moved, partly because of Michael's health and partly because Hitler and the National Socialists—the Nazis—were on the verge of ascending to power in

Germany, to an idyllic spot in north-central Italy near the Swiss border, close to the area where Mandl had lived before he met Kraus. Even though Kraus and Mandl had converted to Catholicism by now, conditions in the German world for anyone of Jewish heritage were rapidly deteriorating, causing many artists to flee.

The family's new Italian home was a rented 450-year-old villa, built for royalty and nestled in the foothills of the Alps in the village of Loveno, just outside Tremezzo on the north edge of Lake Como. They could have found no more beautiful or relaxing location. Lake Como had been a favorite retreat of European nobility in the last century and until World War II remained a playground for the richest and most famous. The great conductor Toscanini, for instance, called the area home and became a friend of Kraus. The lake is lined with villas and mansions; small boats, reminiscent of Venice, ply the waters; snowcapped peaks of the Alps crown the surrounding vista; and tropical palm trees grow along the banks.

Mandl furnished his family's new home exquisitely, including two Steinway concert grands, three thousand books (many of them first editions), prized facsimiles of Leonardo da Vinci's diaries, and oriental carpets covering the marble floors. There were even servants for cooking, cleaning, and gardening. For Kraus, who had been born in poverty, this must have seemed like a dream. She spent as much time as her career permitted at Lake Como. While there, her daily routine was predictable. William Mandl, who frequently visited, described Kraus's schedule and shed light on her productivity during this

period and on her role as parent:

> *She got up at 7:00 a.m. and had breakfast. At 8:00 she was at the piano. She played the piano until 11:30 or so. She then took the kids for a walk—it was the big sensation of the day—then came back and had lunch. Usually she lay down for about a half hour or so, and then she played uninterrupted until 7:00 or 8:00 when she stopped for dinner, and then she played from 8:00 or 9:00 until 1:00 or 2:00 in the morning. That went on for months and months and months in preparation for concerts. She knew how to work.*[15]

Indeed, Kraus knew how to work with searing devotion. She was driven by a passion for music, causing some around her to question her priorities. William Mandl felt that for his stepmother, "Music came first—I think above all things—even above my father."[16]

Certainly, diversions did tempt Kraus, and when she indulged in them, she did so with abandon and absorption if only for short periods. For instance, she liked to be read to, and Mandl was always happy to oblige. She enjoyed long walks, even in the snow. She went to see films frequently. She climbed mountains and was an amateur artist, rendering admirable sketches. She did not cook, do housework, or drive, though Mandl did let her get behind the wheel occasionally. She adored speed and had no patience with slow drivers. She also liked to sit and talk with friends but only for short periods, the siren call

of the piano never being long absent. William Mandl aptly depicted the internal struggle that Kraus faced:

> *She loved to sit in the garden with coffee and the evening sun when it's warm but cool and everybody is feeling comfortable and the conversation is not on a very high level, but everybody is fascinating and feeling good towards the other—sort of a coziness. She loved that.*
>
> *But it all lasted, at best, half an hour. Then something of her enthusiasm and excitement about being together with beloved friends and everything being so nice gradually waned.*
>
> *When you see a horse that is away from the herd for one reason or another because it has to be shod, you feel that this horse is being held at the smith's place, but with eyes and ears it is ogling towards the friends over in the field. The minute you take it back to the field and you open the gate, he runs towards the other horses. He can't help it. And that was Lili at the piano.[17]*

Kraus continued forever to demonstrate this impossibility of living both in celestial and temporal realms. She almost always manifested the former and rejected the latter, mainly because she had no choice.

So infatuated was Kraus with Lake Como that she told her family and music friends about it. Her parents came for a short visit in 1932, leaving Dora in Budapest. This reunion with Victor and Irene was probably the last time Kraus saw her

beloved father, who died sometime between 1933 and 1936. It is interesting that so little is known about Kraus's parents and her half-sister after she moved from Budapest in 1920. She visited them infrequently, especially after her marriage, and not even her children knew much about their grandparents. Particularly cold is the trail of Victor; no one in the family knows exactly when or how he died. What is certain is that Irene and Dora continued to live together in Budapest until their deaths in the early 1960s.

Kraus's friend and famed conductor Pierre Monteux saw her several times in Italy, as did Artur and Therese Schnabel. They came for a visit in the summer of 1932 and asked Kraus to find a home for them nearby. Because he was Jewish, Schnabel was also uncomfortable with the politics of Berlin and wanted a change of venue. Schnabel and his family arrived in Tremezzo in May 1933 and spent every summer there until 1938.

Kraus was thrilled to have Schnabel as a neighbor. The children of both families—Schnabel's sons were Karl Ulrich and Stefan, the former destined to become a celebrated pianist and the latter a successful actor—became good friends, and the adults often socialized, but according to William Mandl the situation abruptly changed one evening. During dinner, Schnabel made an amorous overture toward Kraus. She was dismayed, wanting him "as a teacher and not as a lover."[18] Kraus never again felt the same about Schnabel, though she continued to admire his musicianship, especially his interpretations of Beethoven.

Meanwhile, Kraus's career was entering an even more vigorous phase. The year 1934 was particularly important in Kraus's professional life, in part because she made her debut appearance at the Mozart Festival in Salzburg, inaugurating her long association with that event. To play in the renowned Mozart Festival was validation of the thirty-one-year-old pianist's achievement, and for the first time, many Americans attending the festival heard her, thereby initiating a relationship that proved very rewarding for Kraus.

Also in 1934, Kraus formed a partnership with the violinist Daniil Karpilowski, who became first violinist of the Guarneri Quartet. Together they played from February to May in Amsterdam, Rotterdam, The Hague, Brussels, Paris, and twice in London. The reviews were praising. In London, the *Observer* commented, "Mr. Karpilowski and Mme. Lili Kraus gave an admirably invigorating performance of Beethoven's C minor Violin Sonata . . . they make a fine ensemble." The *Daily Telegraph* spoke about "two accomplished musicians" who exemplified "complete success."

The Kraus-Karpilowski duo was supposed to continue after the initial set of performances, and engagements for November 1934 were announced for the Netherlands. But by then the Polish violinist Szymon Goldberg had replaced Karpilowski, with whom Kraus had a clash of temperaments. Wilhelm Furtwaengler had appointed Goldberg concertmaster of the Berlin Philharmonic Orchestra in 1929, but he left in 1934 because he was Jewish. The Kraus-Goldberg partnership quickly became a success throughout Europe and further catapulted Kraus's career.

Although Kraus and Goldberg had agreed to collaborate, she invited him to come to Lake Como in 1934 to live with her and Mandl for six months to prepare for the upcoming concerts. She recalled that they immediately experienced some professional disagreements:

> Our principles were as different from each other as can be, Goldberg's and mine. He wanted to be a soloist; that was his hottest desire. I was a soloist though I never cared about that. The reviewers said that all the heart and life, etc., comes from Kraus, and the intelligence from Goldberg. That's not what a soloist wants to hear.
>
> Also, I was very beautiful, and he was not very beautiful. He never had a soloist's life.[19]

Whatever their relationship (and, no, they were never married to one another despite such reports in some sources), the Kraus-Goldberg duo made their debut in late 1934. For their December 6, 1934, program in The Hague, they played Mozart Sonatas in C major, K. 296, and in B-flat major, K. 454; the Hindemith Sonata in E-flat major, op. 11, no. 1; and the Beethoven Sonata in E-flat major, op. 12, no. 3. The duo followed that success with a tour featuring the ten violin-piano sonatas of Beethoven. In all, they played about 125 concerts in the 1934–1935 European season.

Reviewers consistently praised the duo's sense of ensemble, an interesting observation in view of the evidence of their disputes. The London *Times* in 1935 described the partnership

as "one of mutual understanding, and the confidence—and indeed the brilliance—of the playing a source of content-ment."[20] The following year, the *Times* extolled the duo's ensemble playing but found that Kraus "did once or twice overwhelm the violinist's rather slender tone."[21]

In addition to the ten Beethoven sonatas, their repertoire included eight Mozart Piano-Violin Sonatas (K. 296, 377, 378, 379, 380, 404, 454, and 481), the Debussy Sonata, the Franck Sonata, the Brahms D minor Sonata, the Fantasy in E major and the D major Sonatina of Schubert, J. S. Bach's Sonata in E major, and the Haydn Trios in F-sharp minor, op. 73, no. 3, in C major, op. 75, no. 1, and in E-flat major, op. 75, no. 3. Kraus and Goldberg joined Anthony Pini, cellist, in the Haydn trios.

Also important to Kraus's life in 1934 was the beginning of her recording career. For Odeon, the German counterpart of the English firm Parlophone, she made her first record—Chopin's Waltz in E minor and Mozart's *Turkish* March. Another early recording was of Mozart's C minor Fantasy and Sonata, K. 475 and K. 457; the latter she described as the most difficult of all piano compositions. Kraus remembered that this recording created a sensation in the music world. According to her, London's *Gramophone* critic wrote, "Would that all pianists would sit at the feet of Mme. Lili Kraus."[22] More than forty years later, Kraus listened to the pieces on that recording again and observed, "They are now different but good." At thirty-one, Kraus felt that Mozart was her specialty and that she "could play Mozart whenever I liked."[23] As already noted, before World War II, Mozart's music was not frequently played by pianists, except

by Kraus's mentor, Schnabel, who championed the Viennese Classicists, and by Edwin Fischer, Walter Gieseking, and Wanda Landowska. Though these colleagues served as pioneers by performing a portion of Mozart's piano music, it was Kraus who began to program it all. In a sense, Kraus joined these advocates of a composer whose piano works were at the time mainly ignored. Cognizant of this fact, Kraus claimed that she was the one who brought Mozart into the twentieth century. Indeed, she was the first pianist of her generation to be concerned—above all else—about the authenticity of the Mozart editions she used, a novelty for that time. She wanted the purest classical tradition to be manifested, and her care to use the best editions set a standard for others to follow. She also was concerned about the accurate execution of slurs and ornaments, the proper addition of *Eingänge,* or lead-ins, at *fermatas* in the concertos, the sound of sparse damper-pedal effects, and the use of elegant, stylistically correct cadenzas rather than the more elaborate and flashy Romantic ones that were then the fashion. Further, she insisted on chamber ensembles rather than full nineteenth-century orchestras in the Mozart concertos, a practice Edwin Fischer had started in the early 1930s. Kraus went a step further by increasing, whenever possible, the rehearsal time with the orchestra, contrary to the Romantic practice of scheduling only a brief meeting. Kraus felt that chamber music, which the Mozart concertos are, demanded an intimacy of collaboration requiring substantial discussion and analysis. She also read and played the concertos from the orchestral score as Schnabel did, so she could understand the nuances of orchestral voices and color. In the

late 1930s, she even proposed to her recording company that she should play Mozart on a period instrument, but the company declined for fear that the public would not accept the authentic eighteenth-century sound. Her suggestion to use authentic period pianos was revolutionary at the time. In all these ways, Kraus brought attention to Mozart's piano music, and she built an international career largely on this repertoire. Years later, she sought to summarize her devotion to Mozart:

> *When I began to explore Mozart, I discovered the infinite beauty of that music, and somehow it is given to me to give life to that beauty. Now, I am quite sure that there are any number of my colleagues who play Chopin, Schumann, Brahms, Rachmaninoff, and Shostakovich and the rest infinitely better than I do. I do not think that that is the case in Mozart. So, I find it my God-given duty, privilege, and if you like, cross, to consecrate my life to this music.*[24]

(For a fuller discussion of Kraus's reflections on her Mozart style, see the Appendix, no. 3.)

Kraus's way with Mozart won her a lasting place in the musical firmament. Only a few performers in any medium are able, by their imagination and conviction, to place their interpretative stamp on an artistic genre. Gould did it with Bach; Schnabel with Beethoven; Rubinstein with Chopin; Gieseking with Debussy. Only a limited number of such partnerships come to mind, because the requisite strength of certainty allied with musical genius is a rare combination. Kraus had

this for Mozart and perhaps found psychological under-pinning for the alliance in the bond of shared traits between the pianist and composer: both were products of the Austro-Hungarian empire; had parents who passionately drove them to become musicians; and had personalities characterized by a zest for life.

With her growing list of recordings, including Mozart's C major and G major Piano-Violin Sonatas, K. 296 and 379, with Goldberg in 1935, and budding identification with the music of Mozart, Kraus planned her first world tour for 1936. She, Mandl, and Goldberg visited Japan for six weeks, where they played to eight sold-out houses in Tokyo. Although she claimed to be the first western pianist to perform in Japan, she obviously did not know that American Rudolph Ernest Reuter had played in Tokyo in 1909.

A sojourn in the Dutch East Indies (now Indonesia) was also part of the 1936 tour. During that visit, on June 12, 16, and 19, Kraus and Goldberg played the Beethoven cycle in Bandung, on the island of Java. Sjoerd de Witte, music critic for the *Bataviasch Niewsblad,* described Kraus's June 12 concert as presenting "an ensemble player of the highest rank."[25]

On June 24, 1936, Kraus and Mandl left Batavia (now Jakarta) on the liner *Sibajak* bound for Rotterdam with stops in Singapore, Sumatra, Sabang (Dutch Indies), Colombo (then Ceylon; now Sri Lanka), through the Suez Canal, on to Marseilles, Lisbon, Southampton, and finally the Netherlands. Goldberg was not on the passenger list, so he must have found his way home by other means.

The year 1936 was eventful for Kraus and Mandl in another way. Back home in Italy, Mandl published his translation of H. G. Wells's *The Shape of Things to Come* (1933), which envisions a disastrous world war raging from 1940 to 1950 and depicts Hitler as a gangster. The Gestapo later remembered that "insult."

Despite the growing political problems throughout Europe, Kraus's career continued unabated. In 1937, for instance, she played again at London's Wigmore Hall, presenting Haydn's F minor Variations, Bartók's *Fifteen Hungarian Peasant Songs* and *Romanian Dances*, Beethoven's Sonata in E-flat major, op. 31, no. 3, and Mozart's C minor Sonata, K. 457. The *Times* reviewer admired her playing:

> *The most immediately pleasing thing about her playing was that she made effective dynamic contrasts within a reasonable scale. She never had to resort to banging for a* fortissimo, *and the quality of her tone throughout its range was consistently good. From a purely technical point of view her performances were charming. Quick, easy finger work produced neat articulation (the ornaments in Haydn's Variations were most daintily touched in), and the melodies were made to "sing" with grace and pretty sentiment.*[26]

Though Kraus's technique was praised, her interpretative powers were criticized. As was the case of the notices of her London debut recital in 1929, the reviewer argued that, "tempo

and rhythm were not judged with much idea of dramatic effect."[27] In 1938, however, the *Times* effused about Kraus's interpretation of the Mozart Concerto in B-flat major, K. 456, which she recorded for Parlophone with the London Philharmonic Orchestra under the direction of Walter Goehr:

> *Miss Kraus is an admirable interpreter of Mozart, clear without being finical, and appreciative of the deep emotion in the music without overloading it.*[28]

Back at the Concertgebouw in Amsterdam in 1938, she played the Beethoven Fourth Concerto with the Rotterdam Orchestra on May 17.

In 1938 the peaceful life that Kraus and Mandl had on the shores of Lake Como began to unravel. In March, German troops moved into Vienna, marking the beginning of the *Anschluss* or annexation of Austria by Nazi Germany. For people of Jewish heritage, the situation deteriorated rapidly. Kraus and her family were repeatedly hounded by the police in Milan to exchange their Austrian passports for German ones. They refused out of fear and disgust.

By the end of October 1938, the Germans had induced the Italian government to impose discriminatory laws against Jews, so Kraus and Mandl decided to leave Italy. Mandl informed the Italian authorities that he and his family would become British subjects. In response, the German government told the Italians to expel Kraus, Mandl, Ruth, and Michael immediately. Mandl was in Berlin at the time, and Kraus and

the children were given twenty-four hours to pack suitcases and leave. After hurriedly collecting a few possessions, they went by train to Paris where they were met by Mandl. Left behind were almost all of their belongings, including two grand pianos and their library. The Italian government appropriated everything not taken. Ruth recalled the panic of that last night in Italy:

> *Within twenty-four hours it happened. What I remember is darkness, Lili frantically trying to collect what she could. It was chaos, and I remember being scared as we left in the middle of the night. We were shoveled into trucks and taken to the railway station at Menaggio. All of this scene took place by oil lamp and candlelight for some reason. Lili was calm. She concentrated on doing the best job in the shortest time.*[29]

After a brief stay in Paris, the family moved on to an English cottage named "Love's Abode" in Betteshanger, on the estate of Lord Northbourne. There their friend H. G. Wells introduced them to Walter Nash, the minister of finance and immigration for New Zealand. Nash suggested that they become New Zealand citizens and residents because they had renounced their own citizenship. Kraus and Mandl gratefully accepted the offer of a new homeland. However, Kraus had already scheduled engagements to play in London, Belgium, Holland, and Scandinavia, so the departure to New Zealand was postponed one year. Meanwhile, Kraus, Mandl, and the children obtained British "Certificates of Identity," or temporary papers issued by

the British Foreign Office granting them the privileges of British citizenship.

During the issuance of her new British passport, a clerk who was typing an identity card for Kraus misread the year of her birth. Instead of "1903," the clerk typed "1908," and from that moment forward, Kraus used the 1908 date. Though later she admitted her deception to a few, she forbade their divulging the secret during her lifetime.

Kraus stayed busy in England during the first half of 1939. She frequently performed at receptions held at the Austrian Legation and arranged by the Austrian minister, Sir George Franckenstein. She continued to record for Parlophone and Odeon. In fact, a list of recordings by Kraus in the Parlophone and Odeon catalog in 1939 was one of the most extensive of any of the piano listings—certainly the lengthiest of any female pianist—evidence of the stature she had attained in the music world. One of the leading pianists of the era, Kraus by 1940 had recorded the following repertoire:

Mozart:    Concerto in B-flat, K. 456, London
           Philharmonic Orchestra, Walter
           Goehr conducting
           Fantasy and Sonata in C minor,
           K. 475 and 457
           *Unser dummer Pöbel meint Variations*, K. 455
           Rondo in D major, K. 485
           Adagio in B minor, K. 540
           *Alla Turca* from Sonata in A major, K. 331

Sonatas for Piano and Violin
(Kraus-Goldberg Duo)
C major, K. 296
F major, K. 377
B-flat major, K. 378
G major, K. 379
E-flat major, K. 380
C major, K. 404
E-flat major, K. 481

Chopin:    Impromptu in F-sharp major, op. 36
Prelude in E minor, op. 28, no. 4
Waltz in E minor, op. posth.

Schubert:    Sonata in A minor, op. 143
Laendler, op. 18, nos. 1-9 and 11
*Valses Nobles*, op. 77

Haydn:    Variations in F minor
Trios (Kraus-Szymon Goldberg, violin;
Anthony Pini, cello)
F-sharp minor, op. 73, no. 3
C major, op. 75, no. 1
E-flat major, op. 75, no. 3

Bartók:    *Three Rondos on Folk Tunes*
*Romanian Folk Dances*

Beethoven:  *Eroica* Variations in E-flat major, op. 35
Sonatas for Violin and Piano
(Kraus-Goldberg Duo)
A major, op. 12, no. 2
F major, op. 24 *Spring*

A major, op. 30, no. 1
A major, op. 46 *Kreutzer*
G major, op. 96

A number of these recordings were groundbreaking as the first issuance on disk of the following: the first complete recording with all repeats of the Haydn Variations, the same composer's Trios in F-sharp minor and C major, Mozart's B minor Adagio and Piano-Violin Sonata in G major, as well as the Concerto in B-flat major, all of the Schubert pieces, and Bartók's *Three Rondos*. Also significantly, the Mozart piano-violin sonatas, except for the C major Sonata, K. 404, were all recorded under the auspices of E.M.I.'s "Mozart Chamber Music Society," a group formed in London to encourage and promote the recordings of "musical works that appeal in the first instance more to the cultivated than the general musical taste," and the Haydn trios were similarly recorded for E.M.I.'s "Haydn Chamber Music Society." The Mozart and Beethoven piano-violin sonatas recorded with Goldberg in the late 1930s are still considered collectors' items. Regarding the Bartók recordings, Kraus claimed to be the first to record her teacher's music and did so at his request. She was likely unaware that the composer had recorded his own *Romanian Folk Dances* in 1915 and in 1920, and in 1936 recorded the first of his *Three Rondos*. In any event, Kraus recorded the first of Bartók's music on a major international label when Parlophone risked a repertoire that it feared was "much too modern."[30]

The reviews in Britain praised this performance, as

London's *Morning Post* review shows:

> *Lili Kraus may be congratulated on one of the most successful Mozart concerts we have had for a long time. Her playing of the concerto (K. V. 271) could not have been better. It was a model of what Mozart playing should be. I do not remember ever having enjoyed an evening more.*

London's *Daily Telegraph* was equally enthusiastic:

> *Lili Kraus has the true fire . . . . The final variations (Beethoven, op. 109) were played with an intuitive feeling for their ethereal qualities, that only a great artist and a woman can possess.*

Perhaps the *Glasgow Bulletin* description of her as the "finest living woman pianist" is her highest, if also controversial, praise.

Kraus and Mandl were so preoccupied professionally and socially in England that they decided right away to place Ruth and Michael in boarding school. Unfortunately neither child spoke English, which they were forced to learn quickly. They in turn taught the language to their mother, and thereafter English was always spoken at home. Ruth was faced with additional difficulties because she was sent to the same boarding school that Michael attended; for a year the eight-year-old was the only girl in a boys' school.

In late summer of 1939, Kraus, Mandl, and the children moved to Amsterdam, where they remained for six months.

That city had played an important role in Kraus's career before, and now her agent, Ernst Krauss (no relation to her), lived there. The half-year spent in the Netherlands and later in the Dutch East Indies deepened the personal bond between Kraus and the Dutch people.

While in Amsterdam Kraus continued to perform at a feverish pace. As early as 1938, she had started accompanying the renowned Polish singer Doda Conrad. They appeared together a number of times with repertoire that included Schumann's *Dichterliebe*, Debussy's *Fêtes galantes*, Chopin's Songs from op. 74, Brahms's *Vier ernste Gesänge*, Schubert's *Die schöne Müllerin and Die Winterreise*, Haydn's Six English Songs, and various songs by Ravel, Fauré, and Duparc. In their concerts, Kraus always played some solo repertoire to complete and complement the program, such as Mozart's Fantasy and Sonata in C minor, K. 475 and 457, Bartók's *Three Rondos*, Haydn's often-played D major Sonata, Schumann's *Papillons*, Debussy's *l'Isle joyeuse* and several preludes, and Beethoven's *Eroica* Variations. A reviewer called the Kraus-Conrad team an "ideal partnership."

Of course, Kraus continued to play solo recitals and concerts. On July 23, under the baton of Ernest Ansermet, she played Weber's *Konzertstück* and Beethoven's C minor Concerto in Scheveningen, the site of her international orchestral debut eighteen years earlier. In Amsterdam, Kraus formed her own fifty-four-member chamber orchestra, known as the "Mozart Orchestra," and together they performed ten times, with the Dutch musicologist and conductor Bertus van Lier at the podium. Kraus created this orchestra in order to accurately

re-create the small orchestra sound demanded by Mozart. In one evening foreshadowing her later, great Mozart marathons, they played three Mozart piano concertos, the E-flat, K. 271, the C minor, K. 491, and the B-flat, K. 456. Also, on October 19, 1939, she participated in what many musicians would today regard as a remarkable event. She played the *debut* in Amsterdam of Mozart's Concerto in B-flat major, K. 456, in the Concertgebouw with Pierre Monteux. When Kraus claimed to have brought Mozart into the twentieth century, perhaps she had this evening in mind.

Critics in the Netherlands joined colleagues elsewhere in praising the thirty-six-year-old pianist. Of her recordings, a reviewer noted that her Schubert *Valses Nobles* were "full of temperament but not sentimentality, clear but full of poetry." About her reading of the Mozart Adagio in B minor, K. 540, the first recording of this piece, the same critic commented: ". . . beautiful rendition full of delicate atmosphere and true understanding; she really catches the deepest qualities of Mozart's music." Regarding her only Mozart Concerto recording to date, the B-flat, K. 456, with the London Philharmonic Orchestra conducted by Walter Goehr, the reviewer praised Kraus's "short touch, transparent sound, clear Mozart style, and utterly lively tempi."[31] In Amsterdam, *Algemeen Handelsblad* commented, ". . . a favorite of Amsterdam like Casadesus and Gieseking. . . . a great personality of quite exceptional standard amongst the pianists of our time." Kraus must have been pleased with the names with whom she was compared.

As hectic as her schedule was, Kraus also found time to

*63*

teach in Amsterdam. She even spent an evening or two playing Schubert duets with Clara Haskil, the "other" great female Mozartean. Though a certain professional rivalry seemed possible, Kraus assessed Haskil's Mozart as, "good, but not enough fire." However, in 1939, with war raging throughout Europe, Kraus and Haskil put aside any differences and found peace in music. Unhappily, the rest of the world was listening to a different tune, and the strains of Hitler's madness would soon prove disastrous for the Mandl family. Kraus, who had entered the 1930s on such a jubilant note, was, at the end of the decade, on the threshold of the most discordant period in her life. ✤

# $\mathcal{A}$CT IV~STURM UND DRANG

With the situation deteriorating rapidly throughout Europe because of the Nazis, Kraus and Mandl decided they should not postpone their trip to New Zealand. World War II was already under way, having started September 1, 1938, when the Germans invaded Poland. Two days later Great Britain and France declared war. Although Hitler did not begin his attack on the western front until May 10, 1940, alarming headlines filled the papers daily, frightening everyone. In February 1940 Kraus and Mandl made plans to leave the Netherlands for a world tour, going directly to the Dutch East Indies for a four-month concert tour, then to Australia for two months, and to New Zealand for three months. Next would come California, where Kraus was to make her American debut playing three concertos with her friend Pierre Monteux and the San Francisco Symphony. After concerts in New York and Canada, she and Mandl would return to Amsterdam in the fall of 1941. In all, she was scheduled to appear fifty times in solo recitals, orchestral concerts, and with Szymon Goldberg and Doda Conrad. Unfortunately for Kraus and family, these well-laid plans were not to materialize.

On Thursday, March 9, 1940, Kraus and Conrad presented a farewell concert in Amsterdam. The reviewer in *De Telegraaf* wrote movingly about that evening:

*Last night Amsterdam had to part from Lili Kraus and Doda Conrad. For their last Schubert evening the public had been actually pouring in, and in the big hall of the Muziek Lyceum—crowded as we never have seen it before—they once more applauded the two artists.*

*You who know them are aware of what our musical world is loosing [sic]. You who don't have missed one of the greatest and purest treats our platform has offered us in many years. We miss them all the more as we had hoped that, owing to the formidable successes they had in our country, they would settle down amongst us. Our loss is . . . irrepairable [sic].*

*Indeed, when shall we experience again a Schubert evening as genuinely Schubert as this one? When again shall we hear such a Sonata op. 143 in this clear and never weakly tenderness, in this perfectly natural and renewed beauty, when again can we hope to experience an enchantment as* "Nacht und Träume," "Gesänge des Harfners," *or* "Nachtstück" *gave us?*

*For years to come we shall have to be contented with memories, memories which shall remain alive as they are now, great and warm and deep!* Die schöne Müllerin, Winterreise, *this last evening and every thing else Lili Kraus, as a soloist, gave us. All this has become our property, of us here in Amsterdam, an imperishable property of everyone who loves and cultivates music.*

*And so Amsterdam bids them Au revoir, these two who bestowed upon us such priceless beauty and hopes that some*

*of the gratitude we feel might find a lasting echo in their own hearts, binding them to us wherever their journey might lead them however long it might last.[1]*

On Monday, March 13, 1940, Kraus, Mandl, Ruth, and Michael traveled by train from Amsterdam to Rotterdam to board the ship they would take to the Dutch East Indies. Just as the train was about to depart, the family cat jumped from the open window and disappeared under one of the train's cars. Kraus kicked off her black suede shoes and pursued the cat while the children screamed, fearing for the safety of mother and pet. Unable to find the cat, Kraus boarded the train and cried during the journey to Rotterdam.[2] There Doda Conrad joined them for the voyage aboard the luxury liner *Johan van Oldenbarneveldt.* During the thirty-day trip, Kraus and Conrad entertained other passengers as they made their way east with stops in Southampton, Algiers, Nice, Genoa, Port Said, Suez, Colombo, Sabang, Sumatra, and Singapore. On Thursday, April 11, 1940, at about 8:00 A.M., the Mandl family and Conrad docked in Batavia on the northwest coast of Java. What they could not realize at that moment was how lucky they were to have left Europe when they did. The *J. V. Oldenbarneveldt* was one of the last ships to depart the Netherlands for the Dutch Indies before the German invasion began on May 10.

Kraus, Mandl, and the children settled in Bandung, a city located in the mountains in the west of the island of Java, about 250 miles from Batavia. There the stifling heat was not quite so severe. First the family moved in with Szymon Goldberg and his

wife, who had come on their own to be part of the tour, but intense quarreling between Kraus and Goldberg proved to be a *casus belli*. The Kraus-Mandl clan then went to live with the Sie family, he a Chinese surgeon, she—named "Lili"—an amateur musician of Dutch birth who studied piano with Kraus in exchange for accommodation, and their three sons. Right away Kraus started playing, and on April 24 she and Conrad presented an all-Schubert program in Bandung. The performing pace never slackened. Once a month, Kraus and Mandl traveled to Batavia so that she could play a recital for broadcast on the local radio station.

The stay in the Dutch Indies was supposed to last four months but kept being extended, partly because Java was pleasant, partly because Kraus's performances kept multiplying (the forty concerts grew to 150), and largely because Europe was now embroiled in World War II and travel in the South Pacific was dangerous. All these factors delayed their departure.

On Java, Kraus and Mandl had an active social life. They became close friends with the governor-general of the Dutch Indies, Tjarda van Starkenborgh-Stachouwer, and his American wife, Christine. They also had a network of European friends in Bandung and throughout the Dutch Indies. They even found a nanny, a young Dutch woman, for their children.

Meanwhile, as always, Kraus stayed busy with her career. She had a number of private piano students but somehow found time to enlarge her repertoire. For instance, in a recital in Bandung on June 6, 1941, Bach's *Italian Concerto*, some of the *Moments Musicaux* of Schubert, Mozart's A minor sonata, K.

310, and the Stravinsky Sonata all appeared on her programs for the first time. On August 28, 1941, in Medan in northern Sumatra, Kraus played Schubert's Impromptu in E-flat major, op. 90, no. 2, also new.

By fall 1941, Kraus, Mandl, and the children had moved to Sajan on Bali, an area east of Java where many artists lived. There they rented a thatched-roofed house nestled beside a big river, and thick and lushly green rain forests encircled them on all sides on this island of quiet villages, temples, and terraced rice fields. A huge covered porch furnished with rattan furniture surrounded the house, and a guest cottage was nearby. Kraus had a piano trucked in over rough roads. She practiced during the days, learning two new Beethoven sonatas (op. 53 and op. 31, no. 3). In the evenings, the family socialized, often sitting outside listening to gamelan orchestras and watching people dance. They quickly adjusted to the local cuisine of rice and sambal. Life in Bali was well-suited to Kraus's decidedly open and sensual style. Things physical played a critical and central role in her life, and she took no pains to hide her warm, hearty nature, a characteristic of many Hungarians. People who knew Kraus then remember her enjoyment of Bali, recalling her daringly liberated personality there and elsewhere, punctuated by sexual energy and overtones.

On December 7, 1941, the South Pacific suddenly changed when the Japanese attacked the U.S. Navy base at Pearl Harbor. On December 8, the Netherlands declared war on Japan, and the Japanese invasion of the oil-rich Dutch Indies soon followed. When Bali fell, Kraus, Mandl, and the children

*69*

went back to Bandung, which the Japanese quickly captured. On February 15, 1942, "Fortress" Singapore, bastion of British colonial dominance in the southwest Pacific, fell to the Japanese, and the back of European resistance was broken. By March 8, Java was conquered, and the Dutch surrendered. Escape was now impossible for Kraus and her family.

What happened next to the family is difficult to confirm. It is known that Kraus and Mandl were summoned before a Japanese commander and asked why they had refused German citizenship on several occasions. Mandl replied he declined because he hated Hitler. Fortunately, the Japanese commander said that he, too, disliked the Führer. Discovering common ground with the two Axis-born Europeans and probably not aware they were Jews, the commander allowed Kraus and Mandl to go free without signing the citizenship papers but stipulated that Kraus was to play recitals in the prison camps being set up throughout the islands for the internment of the Dutch and other Allied nationals. Many European musicians had ceased to perform because doing so implied, or so some thought, complicity with the Japanese. Europeans who cooperated with the Japanese were known as "Japan Workers," a term that some of Kraus's colleagues applied to her. Ruth recalls the situation differently:

> *She was one of the very few artists alive who adored playing the piano, and every occasion where she could play, she did. So of course if she had the chance to play for the radio, she would. Did she care those were Japanese? Oh no.*[3]

Nonetheless, and whatever the motivation, Kraus's career continued. She played on the radio and in person in Batavia and the prison camps. Of significant interest is Kraus's involvement with Nobuo Aida, a Japanese composer and conductor posted to Java in early 1942 as part of a propaganda unit. Under Aida's direction, the European orchestra that once played in Batavia was reorganized and played regularly for entertainment and propaganda purposes. On December 13, 1942, Kraus appeared with them, playing the Mozart C minor Concerto. The performance was broadcast back in Japan, a real coup for Japanese political purposes, and for Aida personally, who otherwise would never have had the chance to collaborate with an artist of Kraus's international stature.[4]

Whereas many Europeans had been forced into concentration camps, Kraus had been only briefly detained for greeting a group of POWs outside the recording studio, then quickly released. Sadly, though, her appointment with imprisonment was to come all too soon. The exact date of her arrest is in question. Kraus later recalled that it occurred in March 1942, but another date is probable. For instance, a Dutch publication chronicling these years asserts that as of October 22, 1942, "the well known pianist Lili Kraus is not yet interned and is giving concerts at the NIROM (Dutch Indies Radio Broadcast Company).[5] She also played two benefit recitals—one in the afternoon for children and an evening recital for adults—on December 26, 1942, in Camp Tjideng, a women's and children's camp in a suburb outside Batavia. Her program consisted of the *Waldstein* Sonata of

Beethoven, the Mozart Sonata in A minor, K. 310, Bartók's *Hungarian Peasant Songs*, a prelude of Debussy, and Schubert's *Wanderer* Fantasy. Several who heard those performances remember that Kraus was resplendent in a full-length cape that Mandl triumphantly pulled from her shoulders to reveal her jewelry and a beautiful strapless gown open in the back. Such a scene belies her incarceration.

On June 26, 1943, she played another benefit recital for the Dutch and native people in Batavia. Her program was Schubert's Impromptus in E-flat major, op. 90, no. 2, and in B-flat major, op. 142, no. 3, the Brahms Rhapsody in G minor, Chopin's B-flat minor Scherzo, Mozart's C minor Fantasy, K. 475, and Beethoven's *Waldstein* Sonata. At the June 26 recital, Aida, who sat on the front row, knew that the Japanese were about to arrest Kraus. He intervened with the military police, and the Japanese agreed to delay the arrest until after this recital.[6]

That Kraus was performing as late as June 26, 1943, obviously argues against a March 1942 date for her imprisonment. Another bit of evidence comes in a diary entry made by an acquaintance of Kraus in Java. That entry records June 29, 1943, as the day of Kraus's arrest, and the preponderance of evidence confirms this date.

What precipitated her arrest was an extracted confession from a French woman who, while being severely beaten, implicated Kraus and her friend Christine Tjarda van Starkenborgh-Stachouwer in a plot to free the British and Australian prisoners by killing the guards. Though this accusation was false, Kraus

had committed other "offenses" of which the Japanese were ignorant:

> *It was fortunate they had only this charge against me, for if they had known what my husband and I had done, they probably would have killed us: we had a hidden radio, we were harboring goods for the Dutch already in prison, transporting money from camp to camp, smuggling letters from wives to husbands.*[7]

Likely another reason for Kraus's arrest was that the Japanese finally realized she was Jewish.

Kraus and Mandl were in Batavia when she was summoned to the headquarters of the Kempei Tai, the Japanese secret police. Along with her husband, Kraus arrived as commanded, assuming that Mandl was the target of Japanese suspicion. She was shocked to learn that she was the one under arrest. She inquired about the charge, but no answer was given. After a moment alone with her husband, Kraus was led away to a filthy subterranean cell four feet by twelve feet in width and four feet high. For two weeks, she shared this space with fifteen other women while the Japanese paraded by the caged women, jeering at them. For several hours daily, Kraus was repeatedly asked, in English, to describe her alleged plot to kill guards and free prisoners. Her constant denials went unheeded. Luckily, she was never beaten during this ordeal because the Japanese were afraid to harm her due to her fame.

Friends urged Mandl to return to Bandung to be with the

children, who were left in the care of servants. Instead, he went to the prison four days in a row in a vain attempt to see his wife and to offer himself as a hostage in her place. The Japanese responded by arresting him on the fourth day while refusing to release Kraus. He was placed in a cell not far from hers.

The two weeks spent in the prison were, of course, traumatic for both Kraus and Mandl. Although the women were spared, many men were beaten savagely, though Mandl escaped that horror. Kraus recalled those desperate days this way:

> *They did not beat him, but from his cell—it was three cells farther than my own—there was such yelling, heard every night, that I thought, I really died there. I never knew for sure that my husband was not among them. The people whom they beat so mercilessly were mostly their own people who would be caught either drunk or fraternizing or who knows what. My husband later told me that they were so beaten that, for protection, they hid their head between the feet of those who beat them.[8]*
>
> *At the beginning, I guess I was just too dazed to think or feel anything. I never became used to the yelling and cries of pain that echoed through those subterranean cells. I would sit with my hands over my ears to help shut out the screams. I imagined that Dante's* Inferno *was a tea party compared to this place.[9]*
>
> *You sat there with the absolute command that you may not talk, not open your mouth. To let my husband know that I was alive and okay, I began to sing Hungarian folk*

*songs. At the first sound, one of the guards rushed at me. Though he didn't beat me, he promised to do so if I once more opened my mouth. Five minutes later, I sang again. Finally they got used to it. What could they do? They were enchanted, so they listened, and my husband knew that all was well.*[10]

At the conclusion of the two-week nightmare, Kraus and Mandl were led outside their jail and put into a taxi; naturally, they assumed they were being released. The car started down the street, then suddenly it stopped. Mandl was ordered to get out immediately, which he did, and the taxi sped away with Kraus, who broke down.

Kraus was driven to Struiswijk, a camp for women and children in Batavia, where she was put in an underground cell with several other women. The tropical heat was stifling, and cockroaches, rats, and swarms of buzzing flies were everywhere. Fleas, ticks, and hordes of bedbugs infested every square inch. Daily rations consisted of two bowls of rice flavored with bitter herbs and bits of insects served in dirty bowls, along with an occasional sweet potato. Food was always in short supply, and getting any extra scraps became an obsession. The prisoners even coined words for obtaining food: The Dutch called it *snerken*, the British and Australians referred to it as *doover*. Conditions were worse than miserable. Guards were surly, beating the women with little or no provocation. Kraus remembered a Chinese man who was caught throwing bread into her camp being tied to a pole until he died of thirst and exposure three

days later. Malaria, beriberi, cholera, and dysentery were rampant, claiming many victims. Horrible skin ulcers, caused by the jungle climate, could grow to the size of a dinner plate, eating the flesh down to tendons and exposing the bone. Perhaps worst of all were the isolation and sense of fear, leading to depression, bickering with one another, and extreme despondency. Characteristically, Kraus spoke of those experiences with passion and compassion:

> *I saw grown women cry like babies because they got three corns of rice less than someone else—and with good reason, since such things were sometimes the difference between life and death. I saw unbelievable corruption and incredible integrity. Sweetness and cruelty. It always boiled down to what you had inside.*[11]

Mandl went to a prison camp for men, Camp Tjimahi, near Bandung where Szymon Goldberg was also incarcerated. The children, who had remained behind in Bandung, had no word about their parents. After two weeks, the youngsters dismissed the servants and went to stay with friends, the Vitringa family (Henk, Thea, and their teenage daughter, Beatrice). Three weeks later, a postcard arrived from Mandl, written in Malay and heavily censored, reassuring the children that all was well and that a reunion would take place soon. However, the Japanese were now jailing all Europeans on the islands, so Ruth and Michael, along with Thea and Beatrice Vitringa, voluntarily entered Camp Tjihapit in Bandung. They

knew they had no alternative; food was running out and arrest was imminent in any event. The prison was actually a ghetto area of ordinary houses that had been cordoned off from the rest of the city and crowded beyond capacity with women and children. Even the children were forced to do hard labor. Ruth, whom the Japanese assigned to road work, also did the cooking on an open brazier. Michael worked making coffins.

For a full year, Kraus, Mandl, and the children knew nothing about each other's whereabouts or fate, probably the worst blow that Kraus had to absorb. Life was almost unbearable, though Kraus knew it had to be borne. In speaking about these horrors, she fixated on music, as she often did:

> *For a year, I didn't know if my husband and children were alive. A year. To hear, 365 times, the Japanese national anthem played on a gramophone as they raised the flag and think that to the end of my days . . . . It was such a tin-tone thing, with no fundamental key, and it just ended somewhere, on some arbitrary note. Oh, God, I hated it.*[12]

The Japanese used the daily early-morning flag-raising ceremony called *tenko* as a symbol of their mastery over their captives. The European internees were forced to line up and count off—*ichi, ni, san,* and so forth—a ritual known as *bangō.* Then they were required to bow deeply in the direction of Emperor Hirohito during the playing of the Japanese anthem. For the strong-willed Kraus, this association of humiliation and deprivation with music was particularly unpleasant. The

Japanese anthem came to represent hardship and misery.

Despite the unspeakable circumstances, Kraus somehow remained resilient. When she first arrived at Camp Struiswijk, however, she saw that many of the women had given up:

> *Unsure of their future, they had already lost hope, dignity, self-respect. It was in their face, in their voice, in their stance, in their crude treatment of each other.*[13]
>
> *They were filled with hatred against the Japanese. They also felt humiliated because they had to bow to the prison warden.*[14]

Kraus refused to acquiesce to self-pity and defeatism and determined to make even this experience fulfilling in some way. She drew on her enormous reservoir of strength, supported by a deepening faith:

> *I knew I had to make a choice. Either I would deteriorate or I could make this experience the treasure fund of my life by falling back wholly on whatever I had within myself. I chose to cling to God.*[15]

Hard work was also part of Kraus's camp life. She was assigned to a regimen of grueling labor that varied every two weeks. For instance, she had to clean street gutters with her bare hands:

> *My nails broke; my fingers split. Another chore was to*

*draw water in a bucket attached to a metal chain from a deep well. My palms were blisters that broke but never festered although the rest of my body was a mass of festering wounds.*[16]

Kraus volunteered for jobs the other women refused, trying to assuage her grief and pain by staying busy. The more desperate the day, the harder she worked in an effort to sublimate the focus on personal despair:

*Nobody saw me with a sad face. . . . Life is so miraculous, so manifold, and the less you are occupied with that fictitious personal self (that is really only a figment of our imagination—it doesn't exist), the easier you bear it.*[17]

Another source of escape for Kraus was daydreaming, and with her extraordinary power of imagination she often breached the figurative prison wall if not the literal one. Interesting, too, is what she fantasized about:

*I am one who dreams all the time—fantastic dreams. But the whole time I was there, I never dreamed once about my husband or my children. The other women used to say "Why are you so cheerful? You never tell us about your family." "No," I reply, "I don't." And that was all. I had put them away in my subconscious mind, where we could be together in spirit, safe from my fears and uncertainties for*

*them. Instead, I concentrated on the work I had to do. And as I worked, I played music in my mind.*[18]

The internalization of art was the consummate act of salvation for Kraus, one that turned her both inward and upward:

> *This experience deepened my music to no end because it all had to take place in the region that matters, namely the spirit, the emotion, and the intellect, and that was fully at work.*[19]

Kraus later explained how this imposed period of intense mental study had strengthened her musicianship:

> *. . . I was consumed by the desire to sit down at the piano and play and play. This longing almost drove me mad. So I resorted to a kind of "recall" from the subconscious realizing that I had to materialize all the music within me—the composition and the projection—silently. I worked so hard at doing this that scores and technique, which seemed to have been burning many fathoms deep, now appeared so real, so present, that I knew that if I were seated before a piano I could play pieces I hadn't practiced since childhood, and in doing so discover new wonders that never seemed so apparent before.*[20]

This internalization of music led Kraus to believe that art

and an artist can withstand all tests and travails and emerge with an undiminished aesthetic psyche. As with a broken bone that has healed and is stronger at the break than it was before, so Kraus—after this ordeal—experienced an enhanced fervor and passion for music. Music had saved her, and she was forever in its debt and service:

> *I became more conscious of something else during this period of my life, namely, that an artist is born and not made. Talent is given, and there is no way it can be poured into someone. An individual can study until doomsday but, if the gift isn't there, progress will remain forever only surface brilliancy, technical progress at its best. What sustained me most in those years were my faith, my love and my identification with music. I was able to live in the music. And during this period, the conviction grew in me that, unless man totally disappears from the face of the earth, whether by atomic bombs or abuses of nature, his final evolution will be the replacement of words by music. Nobody will talk, nobody will sing. Music may well become the communication between man because it will be so alive in everybody that it will not need any more material manifestation. When you look at a person, you will know what kind of music is going on in him: "song without words," ultimately, in the final destination, "song without sound."[21]*

The hard physical labor also strengthened Kraus's hands,

giving her playing a new physicality when she finally returned to the piano. She regarded that as another "silver lining" in the dark cloud of imprisonment.

Amazingly, Kraus was later to recall her imprisonment almost as a beneficence, a divine gift that somehow enriched her life. Perhaps she constructed this "rationalization" in an effort to modify the anger that this injustice otherwise would have visited upon her. Also, she came to understand that deprivation brings heightened appreciation; later in life, for instance, she observed that just having a clean glass to drink from brought her joy, an emotion she would not have realized but for the lack of it. Most profoundly, though, she knew from the beginning that the highest artistic insight is bought in the currency of peak experiences on all points of the continuum of life. To suffer is to grow:

> *These were the most privileged experiences God ever gave me. The significance of spiritual life showed nowhere more than in prison because you had nothing to fall back upon.*[22]
>
> *Imprisonment was an arc of experience, and one can't imagine what it contained in revelation. Locked in a subterranean chamber, starving, no human contact, so alone, alone, alone, you must grow as you cannot grow in normal life. You must have something that far surpasses your tangible being, that intuitive certainty of your indwelling God.*[23]
>
> *So I am happy for these experiences, grateful, and I can*

*only tell you that it is a tremendous asset to know the value of food, to abhor waste, therefore to know the incredible nobility of work. And I use this word not as a high faluting adjective, I mean nobility. Whether you clean the latrine or the gutter, or carry rice for eight hundred people like a coolie, if you do it to the best possibility, it's noble, it really lifts you to your highest potential. And that's the whole thing.*[24]

*I have spent years more pleasantly but not more fruitfully. The miracle of it is that I was aware even while it went on that there was no greater privilege God bestowed on me than these three years, because what I learned then I could never, never have understood and learned under any other circumstances.*[25]

By the end of her first six months of captivity, Kraus was at the nadir of her experience. Her suffering had been complete and terrible, yet she had borne it with dignity. Now, finally, she was about to be dealt a better hand. In December 1943, she was moved to another camp, Tanahtinggi, where an old upright piano was located in the main office. The commander, recognizing Kraus's name on the prisoner list, sent a guard to fetch her. Then he pointed to the piano and asked her to play something. Her memories of that moment are truly lyrical:

*It was as if a crystal source had sprung up from the sand of the Sahara before a man who had spent days and days wandering in the desert; I just poured over that piano and*

*without any music, I played on and on with my whole heart, in pain and joy. I don't even remember how long, but I don't recall repeating any piece, nor do I remember making any mistakes while playing them. It was as if I could play anything and everything ever known to man—what merciful madness.*[26]

Her first piece was Schubert's *Wanderer* Fantasy, followed by some Mozart. She played for about half an hour before the camp commander stopped her. The windows had been open, allowing the entire camp to experience this extraordinary moment. Kraus recalled the collective reaction:

*As I left the building, I saw that scores of women had stopped at their work. Others had come out of their cells. The guards had lowered their rifles. They had been listening. I hoped I had given them the same peace I had received.*

*That night and for the next few days, an unusual quiet settled upon the camp. There was less dissension among the women. The guards were less brutal, less threatening. The work went easier.*[27]

Impressed by the effect on the guards and prisoners alike, the commander had the piano moved into Kraus's cell, permitting her to play about an hour each week. Eventually the commander decided that Kraus should present a recital in the cafeteria. Here is a fellow prisoner's memory of that incredible evening:

*It was near Christmas, 1943, and though most of us tried not to think of it, we were all feeling pretty miserable and ill too. The concert was given in the huge room we used as a food-serving hall. It had walls with barred windows high up, and the rafters were hung with cobwebs and filth, which we could not reach to clean.*

*An old upright piano was brought in for Lili, and all who could leave their children and were well enough came and squatted on the broken tiled floor. Outside it was cold and wet, but inside we soon began to steam and get warm as we crouched close together in the gloom. Lili came in and sat at the piano, which was lit with two guttering candles which threw eerie shadows over the huge barnlike building. Her black hair hung, as usual, in thick plaits over her shoulders, and she looked more gypsy-like than usual. She played, I don't remember what, and there was complete silence. When at last she came to an end, it came time for us to be shut in for the night, we got up and walked silently away, many women crying bitterly.*[28]

It was probably in March 1944 that Kraus was moved to Camp Tangerang in the Batavia region. There she also had access to a piano, and she was allowed to weave her magic more pervasively. Her daily practicing could be heard throughout the camp, and her occasional recitals were exceptional events, as a fellow prisoner recalled:

*One great relaxation in Tangerang for me was to listen*

*to Lili Kraus, who of course had come with us, practicing each morning in a shed off the parade ground. I always tried to get through my work so that I could go and sit near the shed to listen to her for a short while. It was forbidden by the Japanese, but with a little care it was quite possible and well worth the risk. On two moonlit evenings Lili was again allowed to give two concerts in Tangerang, and the sight of the motionless crowd squatting on the ground was quite unforgettable. I do not believe she, or any other great artist who gave concerts in internment camps, will ever have more appreciative audiences.[29]*

Sometime around May 1944 Aida, the Japanese conductor, came to visit her. He brought food and asked if he could do anything to help. Using his influence, he arranged for Kraus to be moved to a fenced-in single-car garage in a residential section of Batavia that served as prison for privileged internees. Aida's intervention may have saved Kraus's life by securing improved living conditions for her. He also managed to have an old piano placed in the garage.

Meanwhile, in Bandung, Ruth and Michael, who since incarceration had been in Tjihapit, were summoned to the camp commander's office. Michael had just stolen some jam from the commander and thought he was in trouble. Instead, the two children were given food, put onto a truck, and taken to the train station, where they waited. Suddenly, a truck drove up, and standing on the back was Mandl (who had been held in two different men's camps), sporting a beard and large cape. After the

joyous reunion, the three were put onto a train, though they did not know their destination. For eight hours, the train rumbled through the Javanese countryside, and the Japanese guard in attendance fed them a meal consisting of boiled rice and fried egg. As they rode and ate, they dared to wonder if they might see their wife and mother at the end of their journey. As if an answer to a prayer, upon arriving in Batavia they were driven to the garage where Kraus awaited them. After a year of being separated and not knowing if the others still lived, the family was reunited. "Exultation" and "thanksgiving" are inadequate words to describe the moment.

The garage that served as their home was modest at best. Though rats and insects infested it, the garage had been equipped with indoor plumbing. Kraus, who wore shorts with purple patches, began a routine of practice on the battered old piano, and she continued to play weekly recitals for fellow prisoners and even to give lessons. She also found time to study art with fellow prisoner, close friend, and confidant Bep Rietveld-Eskes. Kraus had always been a skillful sketcher, drawing the designs for her own gowns and doodling on bits of paper. Now, under the guidance of Rietveld-Eskes, she became quite an accomplished visual artist. She produced a number of watercolors and drawings for her friends in camp that depicted daily prison life, often including portrayals of herself, Mandl, and the children. In exchange for art lessons, Kraus gave Rietveld-Eskes's son, Fons, piano lessons.

Ruth became the family cook—Kraus never was much help in the kitchen—creating dishes using grasses and a variety

of tasteless pumpkins found nearby. Michael made wooden sandals for the family and cared for a pair of pigeons the Japanese let him keep as pets. Despite the fact that the pigeons increased in number from two to eight, they remained pets, and none ever found its way to the dinner table. Kraus later recalled both the temptation and the restraint:

> *No matter how hungry we were—and at times we were very hungry—we could not have eaten the pigeons. They were our friends.*[30]

On June 13, 1944, Kraus and her family, along with the piano, were moved, this time to a garage apartment apparently near one occupied by Szymon Goldberg and his wife. The Goldbergs, who in early 1940 came to the Dutch Indies via Palestine, were also accorded privileged status. Mrs. Goldberg, according to friends, allegedly developed a cautious jealousy of the beautiful and vivacious Kraus and considered the pianist a rival for Goldberg's attention and affection. The rift that developed between Kraus and the Goldbergs finally became tiresome, and the relationship ended except for a brief revival in 1975 in Holland. To the end of his life Goldberg refused to be interviewed about Kraus, and she summed up her feelings about him in a conversation with her Dutch colleague, Marius Flothuis. While holding a cat in her lap, Kraus reflected: "*So eine Katze ist so etwas Feinfühliges. Da könnte Herr Goldberg noch etwas lernen*" ("Such a cat is so very sensitive. Mr. Goldberg can learn from that").[31]

Mandl meanwhile was the emotional mainstay of the family, keeping everyone's spirits up. He read the few books he found, lectured to other prisoners, and wrote, including a two-hour play called *The Point of View*. The text, in English except for a few scenes that the children wrote in Dutch, had only four characters, each a member of the family. Ruth was cast as a forty-two-year-old Dutch widow, Michael played her daughter of eighteen, Kraus portrayed Prince Gopal, a painter, musician, and former piano student of Lili Kraus, and Mandl took the part of the mischievous old Hungarian count. *The Point of View* was an allegory for freedom, a longing for recognition, and an expression of liberal thought. Mandl provided the following synopsis:

> *The scene was a Swiss luxury hotel. The time, five years after liberation. You can imagine how we had fun making the garage in which we lived look like a boudoir in a luxury hotel. The Dutch widow had been interned during the war and she had met Lili Kraus—of course! And the characters talked of having been to a Lili Kraus concert, which was never heard, but only discussed. We put in all the bad gossip we could think of. I invented the things people might be saying about us. Afterwards we found it was very much to the point! And the Dutch lady ordered meals in the Swiss hotel, and looking back to her time in the prison camp, she found it was not so bad. With her daughter, she talked of how they had raised one single tomato, and that gave as much pleasure as gallons of chilled tomato juice, from the*

*luxury hotel. And there were long serious parts, about music, racial questions, and so on. There was an eight-minute lecture on why Vienna was the musical center of Europe; Prince Gopal told how his father had indignantly objected to his marrying anything so low as a white woman (the Dutch daughter); there was a passage on Russia as the great experiment in mixing Asiatic and European cultures; and a part on the sweet revenge of the negroes, whose music has so much life in it that their slave-driver's all over the world are now compelled to sing and dance to their tunes. This part showed how very important the fact might be when some day the negro problem is solved, the negro assimilated by the white man, and their clash softened by the fact that in music the union has already been made . . . .[32]*

The play was scheduled to be performed for the benefit of fellow internees on New Year's Eve 1944, but Mandl injured himself when he fell into a gutter, forcing a postponement. In January 1945, ten performances were given despite an official prohibition against such gatherings.

The family thus managed to remain busy and out of harm's way through the rest of their internment. They knew little of the events of the outside world, which was witnessing the slow triumph of the Allies over the Axis forces. The family could only suspect that the Japanese might be losing because daily rations were diminishing. Ruth recalled the increasingly desperate situation:

*The last six months prior to the Japanese capitulation were the hardest physically. We were really short of food. We were worn down. Had the war gone on another six months, probably none of my family would have survived. We had four ounces of cooked rice a day, which is half a cup, some sloppy vegetable soup that was basically just hot water, and from time to time some meat, and who knows what the origin of the meat was. No fruit. We had the equivalent of chili—sembal—hot peppers, which I mashed with water. We got two ounces of brown sugar per head per week, and then we got what I called the apology for bread, which is tapioca with flour, in rock-hard loaves, and we had one loaf for four people. Incredibly monotonous. Eggs by that time were history. I don't think the others would have survived. . . .[33]*

At the end of the first week of August 1945, a Korean guard who had studied piano with Kraus in the camp came running to them one evening with the momentous news that the war might soon end. Two days later food arrived, giving Ruth new cause for optimism, despite some immediate unpleasant consequences:

*We got tripe—of course I had no idea what tripe was—it was the worst tasting food we had ever eaten. It stank. It was slimy; nobody could really get it down. We ate it, but everybody was sick, everybody in the camp. But this was a sign that something was about to happen.[34]*

Over the next week, the number of Japanese guards began to dwindle. Finally, on August 15, several English majors appeared, the remaining Japanese put their guns down, and the long period of darkness ended. Kraus remembered that sweet day of liberation:

> *The Japanese didn't say anything. But they lifted the blackout. Then they brought some food. Finally, they read the declaration that the war was over. But they told us to stay in the camp because it was dangerous outside. We all went, tore holes in the fence, and scattered.*[35]

A couple of days later Kraus went to the NIROM radio station in Batavia, where she had played before her imprisonment. Though emaciated—she weighed less than one hundred pounds—and covered with open wounds, she sat down at the piano there and celebrated her emancipation and the triumph of her indomitable spirit over those harrowing years. Seigi Shimaura, the broadcasting center chief, was present:

> *On that day at the studio in August 1945 Lili ran to the piano. For some time she touched the keys as if she were touching something she loved. Suddenly, with enthusiasm— as if she had gone mad—she began to play, with her whole body. She was crying. There was sweat on her shoulders, and she was wearing dirty sandals which she kicked off before she sat down to play the piano.*[36]
> *Aida was also there that day to greet her, saying, "It*

*was a tough time for you, I bet. Now it'll be my turn to be arrested." She replied, "And now it'll be my turn to provide the comfort."* [37]

To say that Kraus had "survived" imprisonment is to underestimate this remarkable woman. She must have been one of a handful of war prisoners among millions who not only emerged victorious but also had remained so throughout the ordeal. The supposed vanquished was, all along, the vanquisher. If her "captors" did not understand that, Kraus did.

After the Japanese capitulation, the indigenous population of the Dutch Indies turned their wrath against the weakened Dutch, their former colonial masters, and in fear Europeans remained in the camps—protected by British and Japanese troops—for a few more months until transportation out of Java could be arranged. Kraus and her family did not leave Java until October 1945, when the British Red Cross flew them to Australia.

As difficult as the years of captivity in the Dutch East Indies were, Kraus professed no resentment toward the Japanese. She played in Japan many times after the war, enjoying great popularity. On one such tour, several guards she had known at the camps met her at the Tokyo airport to present her with gifts, an act of contrition typifying the Japanese ethic of apology for a past harm in order to obtain forgiveness. Kraus remembered that this meeting was totally amicable and that the feelings of penitence and absolution were genuine. After a recital in Japan in 1967, Kraus met with Toshiyaki Kondo, commander of a

camp where she had been imprisoned. He nervously approached her, and she greeted him, "Your name is engraved on my heart."[38] Kondo was the one who first arranged for Kraus to play the piano in the camp, having heard the Hungarian pianist perform in Tokyo in 1936.

Whereas she was able to feel forgiveness toward the Japanese, Kraus's attitude toward Germans for their part in the war was quite different:

> . . . *the Germans have no excuse. The Germans were my people, and their barbarism and cruelty and irresponsible cold-blooded lie of being the ruling race has no excuse. I cannot say that as a human being because I have absolutely no right to judge, but in the heart of my heart—and this is a hiatus in my Christianity—I cannot forgive that. I am that much less of a real Christian.*[39]

To the end of her life, Kraus loathed Germany and found it personally difficult to teach German students. Although she played in Germany after the war, she never again enjoyed her travels there.

Though the cruelty of Japanese internment and German barbarism had been devastating, Kraus was ready to move on. She drew upon her iron-bending strength of will to compartmentalize the war years, casting her vision upon the future. Her career had been on hold too long, and she was eager to return to her place on the world stage. ❈

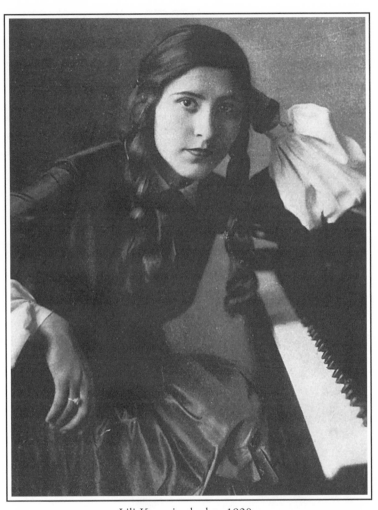

Lili Kraus in the late 1920s.

*Courtesy Frans Schreuder.*

The thirty-six-year-old pianist during her sojourn in Holland in 1939.

*Courtesy Frans Schreuder.*

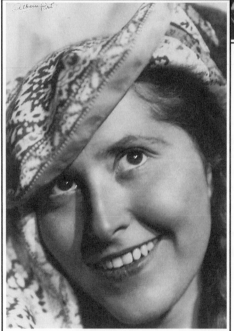

The prominent cheekbones and blazing eyes framed by a silk scarf typify Kraus in the early 1930s.

*Courtesy Frans Schreuder.*

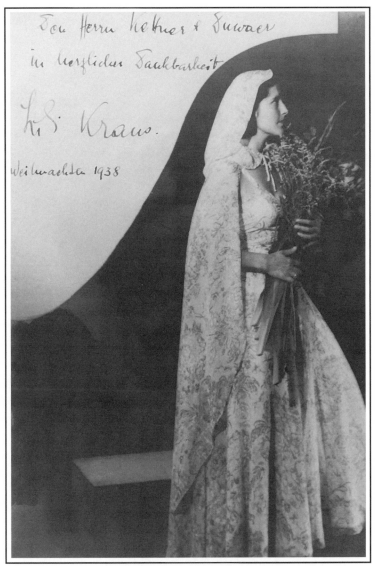

Taken in Zurich in 1936, this photo captures Kraus's dramatic style.

*Courtesy Frans Schreuder.*

While in Japanese internment camps in 1944-1945, Kraus received daily drawing lessons from a fellow inmate. In this watercolor, she depicted daily life for son Michael, herself pointing the direction, a boy named Rudi with the chair, daughter Ruth and husband Mandl. The inscription reads, "To dear Rudi in remembrance of the time when he yet never tired in helping us, in bringing joy to us, pigeons and what not, but most of all—his own true kindness!—Lili Kraus Mandl."

*Courtesy Frans Schreuder.*

Kraus and family on the veranda of their thatched-roof house in Bali in 1941.

*Courtesy Frans Schreuder.*

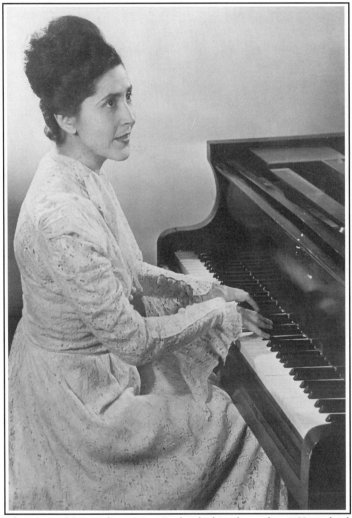

Taken in 1946 in Nelson, New Zealand, this photo shows Kraus back
to robust health after the harrowing war years.

*Courtesy Frans Schreuder.*

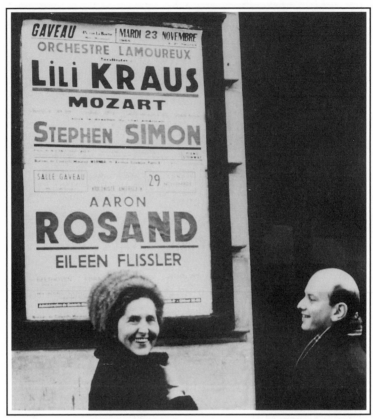

Conductor Stephan Simon and Kraus outside the Salle Gaveau
on the rue La Boétie in Paris in 1965.

*Courtesy Frans Schreuder.*

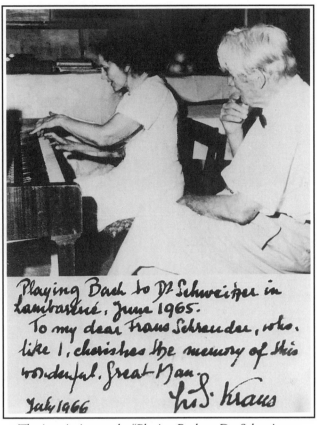

The inscription reads, "Playing Bach to Dr. Schweitzer
in Lambaréné, June 1965. To my dear Frans Schreuder, who,
like I, cherishes the memory of this wonderful, great Man.
—Lili Kraus, July 1966."

*Photo by Erika Anderson. Courtesy Frans Schreuder.*

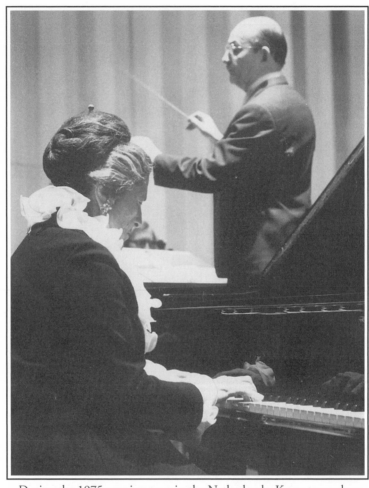

During the 1975 reunion tour in the Netherlands, Kraus teamed up
with violinist-turned-conductor Szymon Goldberg.

*Photo by Ton Leenhouts, Courtesy Frans Schreuder.*

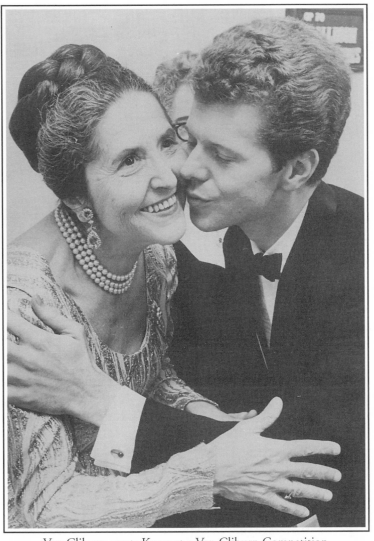

Van Cliburn greets Kraus at a Van Cliburn Competition.

*Photo by Truman Moore.*

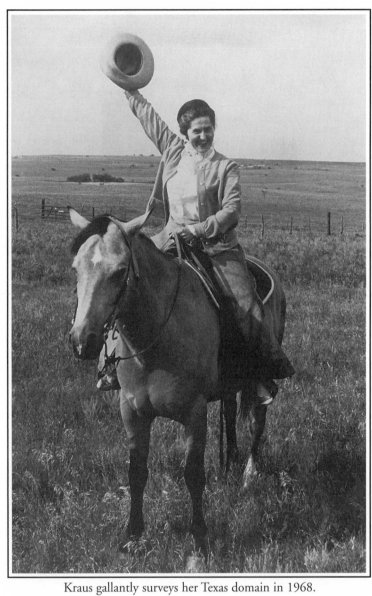

Kraus gallantly surveys her Texas domain in 1968.

*Photo by Truman Moore, Courtesy Alix Williamson.*

# $\mathcal{A}$CT V~LE RETOUR

The family traveled to Sydney, Australia, in October 1945 with stops along the way in Singapore and the Philippines. Kraus brought from Java nine of her evening gowns that had been hidden by friends during the war; however, her entire winter concert wardrobe—over thirty gowns—had been confiscated by the Japanese. Mandl's pre-war fortune was either lost or inaccessible, and Kraus had to pawn her wedding ring, which the French counsel had kept for her during the war, to help pay the bills. She also started playing in public again, earning whatever small fee was offered:

> We had lost everything, so I had to earn money. There was no other way; my husband was much too frail with diabetes. Now I was down to the bone. There was no air conditioning, and the days were very hot. So, I earned money, earned money sweating blood, but ever more believing that I played more beautifully than anybody ever has, mainly because my hands were so strong from the harsh physical labor I had performed with them at the prison camp.[1]
>
> I began to work when we got to Australia. I worked from morning to night. I would have fainted from it except that I am not a fainting person.[2]

Kraus knew that the family relied on her. Practice and play she must.

Her first Australian postwar performance was at the Sydney Conservatorium on Wednesday, November 28, 1945. The program included Mozart's Sonata in A minor, K. 310, Schubert's A major posthumous Sonata, and Beethoven's *Eroica* Variations. The reviewer the next day effused:

> At her Conservatorium recital last night, Lili Kraus amply fulfilled the expectations that wide European fame had aroused.
>
> This was piano-playing of a rarely poetic, delicate, and mature kind.[3]

The following Monday evening, December 3, she appeared again in the same hall:

> The radiant Lili Kraus brought such numbers crowding to her piano recital in the Conservatorium that they overflowed on to the stage. This is perhaps the first time at the Con. that a pianist has played against a human background.
>
> In spite of the stormy weather—thunder and lightning and a steady deluge of rain—the Con. seethed with expectant multitudes. When the little pianist appeared, elegant in her long black lace frock with its rippling streams of silver sequins, wearing a high black turban that hid the hair, and had in it a suggestion of India . . . There were grace and beauty and force in her playing, and there was that tingle of

*excitement in the audience that is the sure sign of profound interest.[4]*

Interestingly, the reviewer noted that Kraus showed "no sign of the bitter years she spent in a Japanese POW camp," this just a little less than four months after her liberation, which indicates a swift return to at least an appearance of health.

Kraus was again riding the crest of a robust career. Her fame had preceded her, and concert dates began to pile up. The Australian Broadcast Commission (ABC) soon signed her to a contract for three performances with the ABC Symphony Orchestra and fourteen solo recitals to be given in Sydney, Canberra, Melbourne, Adelaide, Launceston, Hobart, Newcastle, and Brisbane. The first commitment, a broadcast recital from Sydney, was on February 9, 1946. The program included works of Brahms, Bach, Schubert, Bartók, Mozart, and Beethoven. In addition, Kraus's performaning repertoire at the time included the Stravinsky Sonata, the Schumann *Carnaval,* and several Haydn works.

Her concert appearances created a sensation in an Australia starved for internationally known artists. For instance, the critic for *Radio Call's* wrote the following about Kraus's forthcoming recital on February 26 in Adelaide:

> *Her visit to Adelaide is therefore an important musical event, which every true music-lover must already be anticipating with delight. She is an interpreter of great piano music rather than a mere pianist. Her audiences should carry*

*away from her recitals memories of the good things of Beethoven, Mozart, Schubert, Schumann, and Brahms, instead of the ear-tickling sensation of virtuosity. In this regard she is another Schnabel.[5]*

Just three weeks prior to this notice, an article in *The Broadcaster* lamented the fact that Kraus's Australian itinerary would not include Perth and western Australia. The pianist was obviously in great demand and received enormous press coverage. Her photo and her own drawings and sketches of dress designs were reprinted in papers throughout the country.

Her appearance during this period was predictably dramatic. Her head covering of choice was a black Balinese scarf fastened in the front with a gold clip, and she wore matching gold earrings. For daywear, she chose Balinese printed frocks or slacks and sweaters. She frequently wore her hair in loose braids or arranged under an oriental scarf wrapped around her head and fastened on one shoulder.

In her spare time, Kraus went for long walks, usually alone. As was true throughout her life, even during her first pregnancy, she enjoyed mountain climbing. She was also a frequent movie-goer, seeing one or two films a week. She told an interviewer in February 1946 that her favorite film stars were Claudette Colbert, Katharine Hepburn, Bette Davis, Charles Laughton, whom she knew personally, Charlie Chaplin, Gary Cooper, and James Stewart. Throughout her life, Kraus enjoyed the cinema. Later she came to admire Vanessa Redgrave, though she never liked Laurence Olivier, whom she found too mannered.

In June 1946, Kraus and Mandl moved to New Zealand, first to Auckland and then to Christchurch. Michael, fourteen, was left in a boarding school in New South Wales, Australia, a situation that did not bring him happiness:

> *[It] was marginally worse than the Japanese prisoner of war camp. The discipline was almost tougher. We had to do things with which I totally disagreed. I was actually beaten more often by the Jesuit priests than by the Japanese, and I ran away. Unfortunately, since I had nowhere to go, I had to come back again.*[6]

Whether Kraus and Mandl knew of their son's unhappiness is not clear. Ruth remained behind in Australia for a few weeks but soon made the journey to New Zealand, where she took her own apartment and studied acting at Canterbury University. She saw her parents once every three months or so during the remainder of their time in New Zealand. Kraus and Mandl stayed with various friends during their New Zealand sojourn.

The family was granted New Zealand citizenship, an honor bestowed upon them in recognition of Kraus's "unrelenting efforts in aid of countries in need as well as for educational achievements." Kraus and Mandl continued to use their New Zealand passports the rest of their lives, feeling grateful to the country that adopted them. Years later Kraus commented:

> *Everytime I go to New York, someone at Columbia Artists will ask, "Mme. Kraus, have you made your application*

*yet for U.S. citizenship?" But I tell them I will not make such an application. For very valid reasons, I love New Zealand, and I am very beholden to the New Zealanders.*[7]

New Zealand welcomed Kraus enthusiastically. One observer remembered, "She was so beautiful and gracious and yet so natural that I felt I'd known her for a long time." Owen Jensen, well-known New Zealand musician, explained, "The Kraus magic was already at work."

Under the auspices of the Community Arts Service (CAS), Kraus played concerts throughout the country. She agreed to play for thirty cents per seat, not a bad fee if the hall were filled, which it usually was. Jensen recalls that "her CAS concerts had become a legend." Kraus played everywhere and all the time, sometimes as many as three concerts within twenty-four hours. In all, she performed more than 120 times in New Zealand, frequently on dilapidated instruments. Years later Kraus talked about those pianos:

> *They were the most beautiful English instruments, made by Challen. They were huge, shiny; they looked like a million dollars. But when you begin to play, even not very big chords, you hear a sound* [imitates a baby crying very softly]. *That was the despair of the performer. The public couldn't understand how such a gorgeous piano could sound so terrible. . . . I could never forget that! That was a real torment.*[8]
>
> *But, there and then I learned to play on any instrument at all. Any. It cannot be so bad that I cannot play on it.*[9]

*100*

At several CAS concert engagements, Kraus appeared with violinist Robert Pickler. On three successive nights, they performed the ten Beethoven Violin-Piano Sonatas, each night to the accompaniment of a thunderstorm, the patter of rain on the roof, and intermittent power failures. For enduring the pianos and the elements, the pianist was loved all the more. (Quoted in its entirety in the Appendix, no. 4, is a lengthy review of Kraus's recital at the Auckland Town Hall on Thursday, June 20, 1946, demonstrating the sort of adulation showered upon her.)

She also taught while in New Zealand. For example, in 1947, she conducted master classes at the Cambridge Music School. Owen Jensen recalled:

> *She arrived full of zest as usual, and she at once became part of the school's life: swimming, playing on occasion for the evening dances, making the last night frolic a personal romp, hobnobbing with everyone. The quintessence of grace and lithe energy—tireless—Lili gave all of herself, always, as pianist and teacher.*[10]

While immersed in her work, Kraus was also determined to fully regain her health. First, she quit smoking. Since the age of seventeen, she had smoked at least a pack daily, frequently rolling her own cigarettes. Second, one of Kraus's New Zealander students persuaded her to become a vegetarian, a diet which she remained on from 1947 until she went to London in 1959 to live with Ruth. Even after that she preferred a diet of

salads, yogurt, and similar light, healthy foods.

Despite the happy sojourn in New Zealand, Kraus was beginning to feel the siren call of travel. She wanted to return to Europe, from which she had been absent almost all the decade. In February 1948, the family traveled by ship to London, arriving on a bitterly cold day. Ruth recalls:

> We had not a bean, and where did we stay? At the Hyde Park Hotel, one of the most expensive hotels in town. Lili never dealt with the luggage; she left that to Dicky and dashed off to the nearest piano. After six weeks—I was 17— I begged Dicky for us to move somewhere cheaper, because I was so worried about the lack of money. I thought it was crazy to be living there. Dicky said don't worry, I know what I'm doing. So I went to Lili, and she picked up on my anxiety, and the two of us went to Dicky, and he agreed to move. He rented a very fancy apartment in Kensington, but still a lot cheaper than the Hyde Park, where we stayed until June.[11]

Mandl was accustomed to living well and unwilling to accept the appearance—and the reality—of anything less. Though his prewar fortune was gone, he struggled to maintain appearances, supported entirely by Kraus's career, which he managed with zeal and devotion.

Kraus's return to the European concert scene occurred on Tuesday, March 23, 1948, in The Hague, near the setting of her orchestral debut in 1921, a fitting site for her reentry on the

European stage. Her program consisted of Mozart's Sonata in F major, K. 332; his *Gluck* Variations; Schubert's *Wanderer Fantasy*; and Bartók's *Three Rondos*.

A few nights later, Kraus played four Beethoven sonatas— op. 13; op. 31, no. 2; op. 53; and op. 109—in the small hall of the Concertgebouw in Amsterdam. Though the review the next morning noted that Kraus "was well-received by an enthusiastic audience with emphatic applause," the reviewer was less enthusiastic:

> *The remembrances of Lili Kraus's playing before the war are the reason for the reception she received. Yet, this great pianist did not return to our country just as she was kept alive in our thoughts judging the concert of yesterday.*[12]

The critic also mentioned many "memory lapses" and complained that her playing did not evidence the "spiritual quality and playfulness of the days before the war." A week later, the same reviewer heard another Kraus recital featuring Brahms's Rhapsody op. 79, no. 2, Intermezzo op. 117, no. 2, and Rhapsody op. 119, no. 4; Beethoven's *Waldstein* Sonata op. 53; Bartók's *Allegro Barbaro* and either the second or third Rondo from 1927; and Schubert's Sonata op. 42. Of this recital in the large hall of the Concertgebouw, the reviewer wrote, "Again, I noticed a somewhat capricious and pretentious interpretation which is so characteristic of the playing of Lili Kraus after the war."[13] Such negative criticism was new for Kraus, and she

*103*

found it shocking. She felt she was playing better than ever, yet the critics did not agree.

A few months later, another critic took Kraus to the musical woodshed:

> *Lili Kraus has here a circle of criticless devotees. However, this single severe critic can still save her. She shows feminine charm, youthful impulsiveness, and dynamic exuberance, but it is chaotic, capricious, mannered, and exaggerated. No two bars are in the same tempo. There is no nuance between a banging forte and an affected pianissimo . . . . [There is] boring mistreating of the best music of Mozart, Bartók, Schubert. A pity, because she is intelligent and has talent as a medium for the notes.*[14]

These words differed greatly from those about her farewell performances in prewar Amsterdam. Kraus had been away from Europe too long, and she no longer commanded the respect and admiration she once enjoyed. Reviewers complained of her overly dramatic stage mannerisms, including her stage commentary. Unfortunately for Kraus, critical expectations in Europe had changed during her eight-year absence; the pianist had not kept pace with them, and some reviewers found her anachronistic. A further annoyance to critics was Kraus's tendency to sing along with her playing, a recurring problem for her. According to witnesses, she sang that March night in The Hague on the occasion of her second European debut. Others of

the general public, particularly in Holland, resented that she had continued to play on radio and in public in the Dutch Indies after the Japanese conquest.

Ultimately, though, the negative criticism was based on what really mattered the most—her playing. Although Kraus's hands were stronger and her musical perceptions deeper as a result of imprisonment, her playing had lost polish and finesse, a harsh truth she came to realize. While listening to a recording session she had taped just after arriving in London, she found her musicianship to be shockingly disorganized when compared to her prewar standards. Years in the detention camps, of playing on terrible pianos and without discerning critics, took their toll:

> *When I heard the first thing which I played, I thought I'd die there and then. Undisciplined, incoherent, conceited, and stupid. I cannot tell you the shock.*[15]

For the next year, Kraus worked arduously to reconstruct her playing. Like the rest of Europe, she was struggling to recover from the war.

Despite all her efforts to resurrect her artistry throughout 1948, her career still lacked the momentum she wanted. A new generation of conductors assumed direction of European orchestras during the 1940s, and Kraus did not know them nor they her. She usually found herself performing in the small European cities, not musical capitals, though there were some exceptions. For instance, she played the Schumann Concerto on October 28, 1948, in Amsterdam's Concertgebouw with the

Utrecht Orchestra directed by Willem Van Otterloo. Holland, as it had done prior to the war, played gracious host to Kraus, offering her solo recital dates in various Dutch cities like Arnhem, The Hague, and Utrecht. Her repertoire on the evenings of December 29 and 30, 1948, and January 4, 1949, included:

Bach      *Chromatic Fantasy and Fugue*
Bartók    *15 Hungarian Peasant Songs*
Brahms    Intermezzo, op. 117, no. 2
          Rhapsody, op. 119, no. 4
Chopin    Waltzs in E minor and A-flat
          *Revolutionary* and *Black-Key* etudes
Mozart    Sonata, K. 331
Schubert  *Wanderer* Fantasy

But the review of The Hague recital was not good:

*It is very difficult for a critic to review this piano recital. Lili Kraus is a pianist of the international stage. She is an artist and a very musical, charming woman whose playing is extremely spectacular. From the point of view of high international standards pianistically and musically, it was not good enough. She is very comfortable with the instrument and has musical spirit. Her technique, though, is weakly developed, especially for pearly finger playing. Her right hand is not firm and is by consequence overshadowed by the left hand. Her musical concepts are often extremely good, but the realization is often too many times disappointing.*[16]

With the chorus of negative reviews growing, Kraus sought refuge in the guise of a ten-day visit with her mother and half-sister in Budapest in 1948, taking Mandl, Ruth, and Michael along. Afterward, Kraus and Mandl left for her concert tour in South Africa. There she made contact with the chairman of the music department at Stellenbosch University in Capetown, an encounter that led to Kraus's eighteen-month appointment in 1949–1950 to the piano faculty as artist-in-residence at the university. The escape from Europe and its demanding criticism was just the hiatus Kraus—and her playing—needed. Now she would have the time, under less watchful critical eyes, to restore her playing and battered confidence. Shortly after Lili and Mandl got to Capetown, Ruth and Michael joined them. Ruth, at Mandl's suggestion, took voice lessons; Michael studied the cello. The family moved to the suburbs, within walking distance of the university.

Kraus performed with amazing frequency during this period. Typical of her programs was her March 5, 1949, recital at Capetown's City Hall, where she performed Mozart's C minor Fantasy and Sonata, Beethoven's Sonata op. 109, Haydn's D major Sonata, Bartók's *Hungarian Peasant Songs*, and Schubert's *Wanderer* Fantasy. On September 28, in another recital in the same hall, she played Schubert's *Moments Musicaux*, op. 94, nos. 1–3, one of Haydn's E-flat major sonatas, Schubert's Impromptus op. 142, no. 1, and op. 90, nos. 1–3, Haydn's F minor Variations, and Schubert's posthumous A major Sonata. Her career was in robust health in South Africa, causing her to long even more for a triumphant return in more important

venues. After soul-searching practice and rebuilding, she felt she had fully regained her keyboard prowess and was ready to reclaim her place among the world's musical elite. ❀

# ACT VI~ECSTASY AND AGONY

With her playing back in good form, Kraus was ready to take on the New World. On Sunday, November 6, 1949, she played a solo recital in New York's Town Hall, which her former teacher and mentor, Artur Schnabel, attended. Her program consisted of Bartók's *Fifteen Hungarian Peasant Songs* and the two *Romanian Dances,* Mozart's A major Sonata, K. 331, Brahms's Rhapsody, op. 79, no. 2, Intermezzo, op. 117, no. 2, and Rhapsody, op. 119, no. 4, one of Haydn's Sonatas in D major, and Schubert's Sonata in A major, op. posthumous. Robert Sabin's review in *Musical America* was quite positive:

> *A vivid musical temperament was introduced to the United States at this recital. Miss Kraus was born in Budapest, but she is now a British subject. Her recordings had established a reputation for her here, especially as a chamber music artist and as an interpreter of her compatriot, Béla Bartók. Her personality in the concert hall was more fiery (and more wayward) than one had anticipated from the records. Miss Kraus played everything on her program with charm, intelligence and imagination. Even when she took liberties with rhythms, or indulged herself in caprices of phrasing, she did it with such brio that one was usually captivated into acquiescence. And many of her interpretations were as*

*felicitous in style as they were original and communicative in feeling.*

*Miss Kraus began with* Peasant Songs and Dances *by Bartók, actually the* Fifteen Hungarian Peasant Songs, *followed without a pause by the* Romanian Folk Dances. *She played them, as the composer used to, with heady rhythms and accents, but lightly. As her recordings had already indicated, Miss Kraus proved to be a distinguished interpreter of Mozart and Haydn. She treated the rhythm of the first movement of Mozart's Sonata in A major, K. 331 capriciously, but she played the* menuetto *deliciously and the finale,* alla turca, *with exquisite lightness and impeccable line. If her conception of the work was not as profound as that of some other artists, it was intensely alive and full of beauty.*

*Miss Kraus imbued Brahms' Intermezzo in B-flat minor, op. 117, no. 2, with nostalgia, sustaining the melodic line with a legato. And she played the Rhapsody in E flat major, op. 119, no. 4, majestically. Her tone was round and sonorous, her rhythms accurate, yet she did not find it necessary to pound the music out as so many pianists do. The Haydn Sonata in D major was wholly enchanting. Miss Kraus played it in harpsichord style, with almost no pedal, crisp touch, and enormous vivacity.*

*Perhaps the finest achievement of the recital was her interpretation of Schubert's posthumous Sonata in A major. Miss Kraus did not conceive the work as heroically as does Artur Schnabel (who was in the audience), but she played it*

*with warmth, dramatic contrast and sustained emotion.
Her touch in the* scherzo *was astonishingly light; and she
captured the tenderness and playfulness of the rondo as only
one who understands the Viennese spirit could. Her encores
consisted of Schubert dances, enchantingly played.[1]*

Kraus's confidence and playing were now restored, and the
seed she planted that Sunday in Town Hall eventually produced
an endearing and enduring relationship between the pianist and
the United States.

During this visit in New York, Kraus collaborated again
with her colleague from before the war, the bass Doda Conrad.
They recorded for the VOX label Schubert's *Winterreise,* op. 89.
Kraus also visited her old friend Schnabel. Sixty-seven at the
time, he was, according to Kraus, "a disillusioned man, half
blind." He allegedly told her that he was in love with a younger
woman and that his wife, Therese, knew about it. Kraus was
dismayed, perhaps remembering her own alleged experience
with Schnabel's advances. In any event, she never saw the great
pianist again.

Shortly after her New York engagements, Kraus journeyed
to Washington, D.C., to play a recital and give a master class.
Paul Hume, a leading critic who became her friend, recalled first
hearing her:

*[I heard Lili Kraus] in Washington, on a hot summer
night in Barker Hall of the old YMCA, where she had given
a superb master class that afternoon, and to which she*

*111*

*returned in un-airconditioned humidity that evening to play
a recital that concluded with the Schubert* Wanderer *Fantasy.
And so that you may know that the reactions to her playing
were not mine alone, but also those of a notable critic of the*
Evening Star, *let me quote him, for he said that Lili Kraus
played the greatest* Wanderer *Fantasy he had ever heard.
And Day Thorpe was a profound scholar of music, especially
that of Bach, Mozart, and Schubert. I agreed with his
judgment of that performance.*[2]

After the American tour, Kraus and Mandl went back to
South Africa, where she played in Johannesburg on November
1, 1950. Bach's *Chromatic Fantasy and Fugue* opened that recital,
followed by Mozart's A major Sonata, K. 331, Beethoven's
Sonata, op. 109, Schumann's *Papillons*, Bartók's *Romanian
Dances*, Haydn's E minor Sonata, and Schubert's *Wanderer*
Fantasy. In late 1950 or early 1951, the family returned to
Europe where, for professional and personal reasons, Kraus
wanted to be. They moved to Villepreux, a suburb of Paris.
There they occupied a wing of the Château de Saint Seine for
about six months. Then they took a beautiful apartment on the
Avenue de Versaille in Paris, as close to the heart of Europe as
Kraus could get. During these French years, she played with
increasing frequency in important music centers. On October
21, 1951, for instance, she played the Beethoven C minor
Concerto in the Salle Pleyel in Paris, with Jean Martinon
conducting. She was also busy with recording projects in Vienna.
In 1951, with the Vienna Symphony Orchestra conducted

by Rudolf Moralt, she taped the D major Concerto of Mozart, K. 537, the *Coronation*, for VOX. On a 1952 disc, also issued under the VOX label, she played Beethoven's C minor Concerto with the same orchestra and conductor. In 1953, they all joined forces again to issue the Mozart Concerto in C minor, K. 491, along with the Piano Sonata in C major, K. 545.

In 1953 Kraus returned to the United States to conduct a concert tour and to teach for two months at the Music and Arts Institute in San Francisco. She played frequently in the Bay Area, including many appearances in Wheeler Auditorium in Berkeley. Her repertoire included Mozart's *Unser dummer Pöbel meint* Variations, Weber's A-flat Sonata, Chopin's Ballade in A-flat, and Beethoven's Second Concerto. Her students in the master classes at the institute included some of San Francisco's leading pianists. She also met the violinist Henri Temianka, with whom she eventually performed all of the Beethoven violin-piano sonatas.

On this California visit, Kraus met Michael Ehrhardt of Ventura, who wanted to form a record company that would present intermediate-level teaching repertoire played by concert artists. Educo Records was the result, and Kraus made the first several recordings for the new label, making Ehrhardt ecstatic. He saw Kraus "as the perfect answer to the most exacting requirement of all—a truly great artist, internationally known and loved, who would be willing to devote the necessary time and study to record the music I had in mind in a manner that would place it in its proper place beside the many times recorded concert works of the masters."[3]

*113*

Shortly after meeting Ehrhardt, Kraus went to Boston to make RCA recordings of two Mozart concertos, K. 414 and K. 456, with the Boston Symphony Orchestra under the baton of the legendary Pierre Monteux, her friend with whom she was to have made her American debut in 1941 in San Francisco. Of course, those plans were made before the Japanese imposed a travel ban.

By October 1953, Kraus was back in Paris recording the first of the several issues for Educo, a project she completed in the summer of 1954. The Educo records included works of Bach, Haydn, Mozart, Beethoven, Schubert, and Bartók. (The jacket of the Bartók record notes that Bartók himself played the selections from *For Children* "as originally composed and taught to Lili Kraus [by Bartók.]) A final Educo recording later added to the catalog was a master class given by Kraus in Long Beach, California, at the Sigma Alpha Iota National Convention in 1954. A reviewer called these two discs "an excellent profile of her highly precise and sometimes hypersensitive keyboard style."[4] (For a transcription of Kraus's comments at this master class, see the Appendix, no. 5.)

One Educo recording was made in collaboration with Jean Pierre Rampal, the celebrated flautist; it includes Mozart's Sonata in B-flat major, K. 454, and Schubert's Sonatina in G minor, from op. 137, both works originally for piano and violin. The association between Kraus and Rampal led to a 1954 concert tour of northern France. Rampal remembered Kraus as both performer and personality:

*She and I played Mozart and Schubert, and she was fantastic, I must say. She was beautiful. She had spirit and the fire for Mozart's music which was very suitable for me with the Mozart style. Her Mozart was not just precious and charming; it also had a lot of fire. The same is true of her Schubert too.*

*She was charming—a fantastic person. She always told many wonderful stories about her experiences, the music, and her concerts that were very rich in souvenirs. She and I always agreed on the music.*[5]

In 1954 Kraus and Mandl left Paris for Vienna. She had just signed a contract with the distinguished French label, Les Discophiles Français, in conjunction with the Haydn Society of Boston, to record the entire piano works of Mozart, including the concertos and chamber music, all to be released during the 1956 bicentennial celebration of Mozart's birth. The recording sessions were scheduled to take place in Vienna, reuniting Kraus with the city that was her home in the 1920s. Ruth had already traveled from Paris to Vienna in late January 1954 to study voice. She found her parents a large apartment on the Liechtensteinstrasse, near the Schottenring, close to the city center. Mandl hired a secretary, a young woman named Catherine Oget. Kraus, observing the flirtation between the two, confided her deepest concerns to her daughter. Ruth recalled that her mother, who was otherwise exceedingly stoic, wept when speaking about the issue. Unclear is whether an improper relationship developed between Mandl and Oget, but Kraus was

clearly alarmed, fearing that Mandl might follow Schnabel's example. Oget was soon dismissed, and Ruth moved in with Lili and Mandl to serve as secretary and housekeeper.

The recording project for Les Discophiles Français was a major undertaking, and its demands on Kraus were enormous. Ruth, as she had done in the prison camp, did the cooking and household chores so that her mother was free to practice. Though Mandl lent his support and encouragement, his health was failing. He had suffered a heart attack in 1952 and was being treated for circulation problems.

During 1954, Kraus produced an amazing number of Mozart recordings. For Les Discophiles Français, she played all the Mozart Piano Sonatas except K. 533; she recorded three sets of Variations (K. 353, 398, and 460); the Sonata Movement, K. 312; the Fantasies (K. 396, 397, and 275); the B minor Adagio, K. 540; the Minuet, K. 355; the G major Gigue, K. 574; and the A minor Rondo, K. 511. In June, she joined the renowned Willi Boskovsky—with whom she later recorded Beethoven's *Kreutzer* Sonata—to record eleven of the Mozart piano-violin sonatas. A few months later, from October through December of 1954, cellist Nikolaus Hübner joined with Kraus and Boskovsky to record all Mozart's piano trios. This last album was awarded the famed Grand Prix du Disque in 1956 and remains a valued collectors' item, as are the celebrated Kraus-Goldberg recordings from the 1930s.

Also in 1954, Kraus recorded for Les Discophiles Français two of Mozart's concertos, the E-flat major, K. 271, and the D minor, K. 466, with the Orchestra de Chambre du Wiener

Konzerthaus under the direction of Willi Boskovsky.

Unfortunately, before Kraus finished the mammoth project Les Discophiles Français had proposed, the firm declared bankruptcy. Kraus made a few other recordings for the label. But the grand scheme—to record all of that composer's solo and concerted piano repertoire—never materialized. Nevertheless, Kraus must have felt a comforting sense of accomplishment with what had been done. More than four decades later an English viewer offered the following assessment of these recordings:

> *Lili Kraus's reputation, high during her lifetime, must surely be restored to an appropriately exalted level by this Music and Arts reissue of the Mozart sonatas she recorded for the Haydn Society. The* New Grove *entry, which deems her "an exceptionally clear and musicianly interpreter of the Classics," gets it absolutely right. The joy of these sonata performances and of those of the variations and shorter pieces which fill the fifth disc never falters; it lies in their extraordinary exactness of touch, the cleanness of outline, clarity of thought, stylistic command—and, above all, in the beauty of sound that radiates from every work played.*
>
> *These are the attributes of a sovereign Mozartian, which Kraus seems to me unarguably to be. And so, perhaps more important than any other, is the distinctness of personality which informs her interpretative thought processes. Like Curzon, Horszowski, Rudolf Serkin, Haskil, Perahia, Lupu and other front-rank Mozart pianists, living and dead . . . Kraus masterminds an intensely personal and*

*117*

*particular approach to the flow of phrase, the build-up of sequence, and the long-term clinching of arguments—an approach supported and, indeed, made possible by the solidity and security of her technique.*

*There is a vitality in the approach to tone and line, a sparkle at the core of the articulation, that releases a wealth of tone-colour in the music. Details—pinpoint attentiveness to accentual and dynamic variety, the sometimes unpredictable yet always graciously lyrical unfolding of melodic phrases that in other hands can seem wearily hackneyed— stand out, but never betoken any eccentricity or attention- seeking in their placing and purpose. Listening in sequence to the four middle-period sonatas—in C (K330), A (K331), F (K332), and B flat (K333)—I was constantly exhilarated by the as-if-for-the-first-time freshness of the readings, which (for instance) revivifies both the Variations of the A major first movement and the* Alla Turca *finale beyond all possible expectation.*[6]

Buoyed by her success, Kraus embarked on a European tour in 1955, while Mandl moved to a resort hotel, the Tülbinger Kogel, on the outskirts of Vienna. That spring she returned to Vienna to record Haydn's Sonatas in E-flat major, Hob. XVI-52, and in D major, Hob. XVI-37.

In the summer of 1955, Mandl's declining health contributed to the couple's decision to move to the sun and warmth of southern France. They left Ruth behind in Vienna and went to live with a friend near Nice. Kraus, who continued

to perform and record, spent as much time as possible with her husband.

The following summer, Kraus made her first solo trip to the United States. Mandl was too ill to travel. Though she was reluctant to leave him, the Educo Record Company wanted her to visit fifteen western American and Canadian cities to promote the recordings she had made for it. Billed as "A Day with Lili Kraus," the presentations arranged by Educo started with a morning seminar in which the pianist discussed style and inter-pretation, followed by an afternoon master class and an evening recital. Alice Myers Winther, in a *Christian Science Monitor* review of "A Day with Lili Kraus" presented in Seattle, said:

> . . . *[Lili Kraus is] obviously a born teacher as well as a fine musician and a charming, beautiful woman. . . . I have never seen anyone give of herself more unstintingly or more joyously.*[7]

During her travels in California, Kraus discovered the "Happy Valley School" in Ojai, near Santa Barbara. Here she found friends with whom to explore the metaphysical bent in her imagination. She returned frequently to this retreat for a decade or so.

Despite the warmth of her reception in America, Kraus longed to be with her husband, returning to his side as soon as the grueling summer tour ended. Ignoring his frail condition, Mandl met his wife at the train station in Nice. There they passed their last week together in the paradise of France's Riviera.

On Sunday, August 26, 1956, Kraus and Mandl joined
friends for an afternoon drive to the countryside to visit a chapel
Mandl wanted to see. Kraus tried to persuade him to rest at
home, but Mandl persisted. Years later Kraus recalled that fateful
afternoon:

> *We had to traverse a square to arrive at the beautiful
> old place which was exactly like a backdrop to an opera,
> a little place with a fountain that allegedly has healing
> powers. He couldn't really walk properly because of his bad
> circulation. I asked him, "Dicky, don't you want to see the
> fountain?" He replied, "No, no, no. I can't make it there."
> We were standing with the couple who had driven us. I was
> with the lady in front, and my husband with the man,
> looking at that fountain, and so suddenly, he stretched out
> his arm quite slowly and sank, and that was his death.*[8]

Kraus was absolutely devastated, recalling that she was
literally "bowed down" with grief. For several days, she remained
in Nice to bury her husband, trying to find some way to deal
with the loss. She also had to face the question of when to
resume her career. There was a concert to be played in
Scandinavia in just twelve days; her first thought was to cancel
it. However, upon reflection, she asked herself, "Would Dicky
want you to cancel that engagement?"[9] Certain of the answer he
would have given, she resumed her career as planned. As she had
learned in the camps, work can be a salvation.

Ruth and Michael, who flew in to join their mother the

day after Mandl's death, witnessed the terrible adjustment that confronted Kraus. Ruth recalls:

> *They were as close as any two people could possibly be. This was probably one of the great marriages of the century, if I may be so bold to say that. It totally wiped her out except that she had her music.*
>
> *From doing nothing practical from not buying a toothbrush to not having the foggiest idea about money or anything else, from one day to the next she got herself together and really managed her own life.[10]*

As testament to Kraus's dogged determination to take charge of her life, she soon discovered that her husband had left behind an $8,000 debt, a large sum for the time; Kraus repaid the entire amount within five years.

Anguished as she was—Ruth later remembered that she saw her mother cry for only the second time in her life—Kraus summoned the strength to press on, a trait as automatic for her as breathing. Within a few days after Mandl's death, Kraus packed her possessions and moved to London, where she rented an apartment. From that location she continued her career as before.

Despite personal trauma, Kraus was at the peak of her artistic powers. Her repertoire had grown impressively, as demonstrated in a flier issued by her manager, Maurice Werner of Paris (see the Appendix, no. 6). She also played—and recorded —three Haydn sonatas: G minor, Hob. XVI/44; A-flat major, Hob. XVI/46; and E-flat major, Hob. XVI/52. For Disques

Alpha, she recorded Schubert pieces for four hands with Homero de Magalhaes.

In 1957 Kraus was invited to serve as a judge for the first time in an international piano competition to be held in Rio de Janeiro. There she developed associations that would bring her back to Brazil. Interestingly, Kraus viewed competitions as inherently evil because they encouraged, she felt, a sterile perfection, and she lamented the shallow playing of most contestants:

> *Technically, they are wonderful; after all, we are living in a technological epoch which was never dreamed of in our evolution. The emphasis, therefore, seems to be on playing every note in its proper place, but without making a personal statement, showing no passionate involvement and taking no risks. Sometimes, when I listen to them, I fail to detect any joy or sadness. It all sounds the same: slow, fast, soft, loud. But I want to hear concepts, not just notes. The emotional content of what is played must be in head and heart, not just in the fingers or on the sleeve.[11]*

By October 17, 1958, Kraus was back in the United States, where she played in New York's Town Hall. Her program included Haydn's F minor Variations and Sonata in D major, Hob. XVI-37, Mozart's C minor Fantasy and Sonata, Schubert's A minor Sonata, op. 143, and Bartók's *Hungarian Peasant Songs.* Julius Simek of *Musical America* wrote:

> *The listener forgot quickly the technical ease with*

*which she manipulated the keyboard, for it seemed to be the least important phase of the concert. Musical continuity, breadth of expression, and a wondrous mental and emotional grasp of the music captivated the imagination.*

*Rapid passages had momentum without any suggestion of haste, and she molded the slow movements with great inner tranquility and contained expressiveness. Her touch is an inexhaustible source of color and variety. Yet, as much personality as she was able to display, it was always combined with a thorough artistic objectivity.[12]*

In London the same year, the *Times* commented, "Kraus has her own way of playing the piano, growing from a very warm heart, and she sticks to it no matter who the composer."[13] In 1959, the same paper printed this review:

*There is a distinction between the builder and the architect and no less of a distinction between the pianist of talent and a master of the keyboard.*

*Miss Lili Kraus, who played at Wigmore Hall yesterday afternoon, proved beyond a shadow of doubt that she belongs to the master class. Her interpretation of Schubert's great A minor Sonata, op. 143, was on a majestic scale only rarely encountered. When it is, how grateful we must be![14]*

Of Kraus's 1959 recording of Schubert's Sonata in A major, op. posth., *La Tribune* of Geneva commented:

*With seeming effortlessness and with ever more concentrated surges of the imagination, she soars from expressive depths imbued with spontaneous, impulsive charm and feeling up to those realms where constructive intelligence reigns supreme in all its full might. Lili Kraus is an artist completely in a class by herself, one who defies comparison.[15]*

Other recording projects from this period included the *Jeunehomme* Concerto in E-flat major, K. 271, with the Vienna State Opera Orchestra under the baton of Victor Desarzens in February 1959. In December 1960, she recorded the *Coronation* Concerto in D major, K. 537, with Gianfranco Rivoli and the Amsterdam Philharmonic Society.

Meanwhile, in 1959, Kraus's daughter, Ruth, and her husband since January of that year, Fergus Pope, an American medical student, bought a house in a section of London known as Half Moon Crescent. Kraus moved in with them. According to Ruth, that house was a "slum house" with a dirt floor, but Kraus seemed happy there. While her career continued to bloom, including some recordings for the Musical Masterpiece Society (later Festival Classique), Kraus also busied herself with a host of activities, including the care of a grandchild and participation in peace marches. In the early 1960s, "Ban-the-Bomb" demonstrations were gaining momentum in England and elsewhere. Fergus Pope was working with Bertrand Russell and Norman Cousins, editor of the *Saturday Review of Literature* in the nuclear disarmament campaign. Kraus, always

the political liberal, needed no encouragement to join the movement. She participated in a march in Trafalgar Square and, for her efforts, was arrested. She was held only a few hours, "but that was a gesture to risk all you had—the most valuable thing you had, to prevent them from doing these foolish things."[16] Pope found that his mother-in-law's involvement was typical:

> *She really wanted to be in on everything. There wasn't a thing she could miss. Whether it was a good experience or difficult experience, Lili was in on it.*[17]

Trouble with the authorities notwithstanding, Kraus could apparently do no wrong on the concert stage. A *Musical Courier* reviewer in 1961 tried to probe the secret of this success and noted that Kraus infused her playing with passionate drama:

> *And this is not merely a cheap theatricality but a feeling for the value of contrasts, large and small, that one finds in all art. Her* crescendo *and* diminuendo, *her* staccato *and* legato *are not only musically exciting in themselves; they are intimately related to each other.*[18]

Wriston Locklair of *Musical America* also tried to explain Kraus's popularity and appeal as a performer:

> *Her playing remains unmistakably Viennese. In Mozart, rapid chromatic passages are executed deftly, but without a sense of rushing; in Haydn, the themes are broadly*

*and beautifully stated; in Schubert, the melodies are meltingly lovely. The listener is not aware of Miss Kraus's technique, though it is there, and in abundance. The ease with which she performs the most complicated passages . . . is deceptive.*

*What really captivates an audience during an evening with Miss Kraus is the freshness and brilliance she brings to a repertory that can sound faded and out of fashion in less attentive hands.[19]*

A reviewer for the London *Times* observed in 1962 that perhaps the real hallmark of Kraus's musical genius was the way in which she shaped the ends of phrases. But the same reviewer complained that Kraus's exaggerated dynamics occasionally led to a "touch of coarseness."[20] Ross Parmenter of the *New York Times* cited in November 1963 his own formula for Kraus's rise to prominence:

*Lili Kraus, who played a recital last night at Carnegie Hall, is one of the world's leading women pianists. She is also an artist with sharply personal ideas.*

*Both factors contributed to the pleasures of her latest appearance here. With her wide experience, her keyboard command and her manner of playing in front of an audience with a combination of flair and intimacy, she was always a compelling personality. And her ideas, some of them unexpected, constantly held the interest.[21]*

Parmenter also noted that one of Kraus's most important advantages was "a particularly articulate right hand, one that enables her to give strength and independence, and very distinct emphasis, to any treble melodic strand or figuration she wants to stress."[22] He found her second gift to be the ability "for making a melody sing almost as in an aria."[23] But Parmenter agreed with his London colleague that Kraus's "sharp contrasts seemed a little exaggerated."[24] It is important to remember that although Kraus was criticized for a weak right hand upon her return to the European stage in 1948, her strength there was now notable, further evidence of the resuscitation of her playing prowess.

But not every reviewer was as smitten by Kraus's playing. For example, Peter Davis of *Musical America* gave the pianist's November 18, 1963, appearance at Carnegie Hall a mixed review:

> *Moments of truly great pianism alternated with an extremely puzzling treatment of the music. Bach's* Chromatic Fantasy and Fugue *opened the program. After a brilliantly executed fantasy, with scale passages of remarkable evenness and clarity, the fugue disappointed by being muddy and overpedaled. . . . Miss Kraus' Mozart playing is deservedly celebrated, for there was an inevitability in phrasing and touch that proved most rewarding, and the finale was quite delicious.*[25]

Perfection obviously escapes every performer, at least in reviewers' perspectives. Relying on criticism to evaluate an artist

is risky because of the reviewers' subjectivity. What one person dislikes another may love. For instance, Frederick Page's review in *The Musical Times* in the same month as the Davis review asserted that Kraus "gave a monumental performance of the *Chromatic Fantasy and Fugue* at one of her Wellington recitals, superb even by her own standards."[26]

The early 1960s were exciting and successful for Kraus. For instance, from May 22 to June 1, 1960, she was in Tehran to give a command performance for the Shah of Iran's marriage to Farah Diba. Kraus, who thought this event one of the highlights of her career, was as impressed by the wedding as by her part in it:

> *I played in the small mirror hall of the palace in Tehran. It was an eastern fairytale. I played Mozart, Haydn, and Schubert. After that we went on the balcony to watch the fantastic fireworks. At that moment a sister of the Shah invited me to play the next day in her palace. Also, Farah Diba appeared. She is a remarkable, intelligent, and very musical young woman. She brought me a brilliant present— a precious jewelbox—of which I of course am very proud.[27]*

Back in London in the fall of 1961, Kraus prepared two Mozart concertos—C major, K. 246, and B-flat major, K. 450—both new works for her. She performed them in London in January of the following year.

In 1962, Kraus began her long and important association with Texas Christian University (TCU) in Fort Worth. Invited

to serve as an adjudicator for the inaugural Van Cliburn International Piano Competition held on the campus, she made such a favorable impression that she was subsequently named the only permanent member of that jury. Incidentally, Kraus had pledged to play a benefit recital for the Van Cliburn competition on November 22, 1963, the day that President Kennedy was assassinated in nearby Dallas. The recital was cancelled.

In the midst of Kraus's busy concert season in 1962, another family crisis emerged. Her ninety-two-year-old mother, Irene, was dying of breast cancer, a disease she battled for about fifteen years. Kraus had visited her family infrequently since the 1920s because she enjoyed the company of neither Irene nor of half-sister Dora. Since her father's death, sometime between 1933 and 1936, Kraus found less reason to make the trip. Also, the demands of career and family imposed time constraints, making it difficult for Kraus to travel to Budapest. After the 1948 family journey to see Irene and Dora, Kraus made only two or three trips to Budapest. When Dora died in 1960 or 1961, Irene was alone, so when she became critically ill in 1962, Kraus felt she had to go to her mother's side. She spent about ten days in Budapest making final arrangements, leaving before Irene's death. She did not return for the funeral. Though she had sent money to Irene for many years, she did not love her mother, a cause of profound sorrow for the sensitive Kraus. But attention on the career, as always, offered a measure of solace.

During the 1962–1963 season, Kraus played throughout Europe and in India, Iran, Canada, and Hawaii. Also, on May 19, 1963, she took part in a concert honoring Bertrand Russell's

ninetieth birthday in London's Royal Festival Hall; Colin Davis, whom Kraus greatly admired, conducted, and the actress Vanessa Redgrave narrated.

Kraus, along with Ruth and Fergus, moved in 1962. They left their "slum house" for better quarters in the London suburb of Hampstead. There the three of them remained, along with the Pope children, Clara and Daniel, until 1964, when the Popes moved to Long Branch, New Jersey, where he could complete his medical internship at the Monmouth Medical Center. Kraus remained behind in the Hampstead house.

In 1965, Kraus met the renowned humanitarian, Albert Schweitzer, with whom her son-in-law worked. Pope, now a practicing physician, had long admired the philosophies of Schweitzer and Gandhi, and he jumped at the opportunity to go to Africa in January to work with Schweitzer in the hospital in Lambaréné. On June 10 of that year, Kraus, Ruth, and her three children joined Pope. Kraus was eager to meet the great man, and Schweitzer in turn was immediately taken by the vivacious pianist, listening to her play night after night, until her departure on July 15. On occasion he even joined her for some four-hand music on an old upright piano with missing ivories. Fergus Pope remembered the impact Kraus had on everyone:

> *Lili came and was charming and charmed everyone, including Schweitzer. Nobody played that piano like Lili did and the Africans as well as all the nursing staff and everybody else just kind of came alive when she came into the dining room to play the piano.*[28]

After Kraus's return to London, Schweitzer continued to listen to her recording of Beethoven's Fourth Piano Concerto. Shortly before his death on September 5, 1965, he asked to hear that recording, the last music he ever heard.

Kraus would have stayed longer in Lambaréné had she not agreed to undertake a project of epic proportions and demands—the recording of all Mozart's solo piano concertos and their subsequent live performance in New York. This project was conceived by Kraus's personal representative since 1963, Alix Williamson of New York City. When Otto Mandl learned of Williamson's reputation as a dynamic and highly successful agent and promoter during his visit to America in 1953, he went to visit her; nothing came of that meeting. In 1963, Fergus Pope made a second pilgrimage to Williamson on Kraus's behalf, this time with more concrete results. Williamson later recalled both conversations:

> *An elderly gentleman came to see me at my office and told me that his wife was the greatest pianist in the world and asked if I'd be interested in doing her publicity. I didn't feel from what he told me that I could do anything for her at the time because they were just passing through New York very quickly. She wasn't coming back to the United States in the foreseeable future, and I'd never heard of her and knew nothing of her activities. But somehow I couldn't put out of my mind the burning intensity of this man and his glowing eyes as he talked about his wife as the greatest pianist in the world. Subsequently, through the next ten years or so, I found*

*myself occasionally seeing the name of his wife in record reviews from abroad or international music magazines and so forth, and I found myself with some curiosity.*

*Then, about ten years later, another gentleman came to see me who also had very burning, glowing eyes and a great deal of intensity and conviction as he told me that his mother-in-law was the greatest pianist in the world. It turned out that his mother-in-law was the same lady who was the wife of the gentleman I had originally seen. That time I was prepared to sit down with him and say, "Well, if your mother-in-law wants to have a career in this country, there are certain things she's going to have to do because at the moment she is not known in the United States."*

*We talked about what her strengths and weaknesses were, and I discovered that she was particularly a specialist in Mozart, and I said if she's such a Mozart specialist why doesn't she do something very daring. "Do you think she could play all twenty-five Mozart Piano Concerti in New York in one season? It's never been done professionally." I think it had been done by somebody on radio but never in a concert hall. Lili's son-in-law, Fergus Pope, and Lili, when I subsequently met her, threw up their hands in horror and said this is something that nobody could do. I said, "Well, that's why we're going to do it."*

*I brought her together with Stephen Simon and the orchestra and also negotiated for the complete Piano Concerti to be recorded in Vienna prior to the concert series so that they would be on the American market at the time*

*the concerts were presented.*

*That was the kind of publicity I was able to engender,*
*kicking off a whole new career for her.*[29]

Williamson's plan was daring and exceptionally ambitious. She was correct in remembering that Nadia Reisenberg had done it on New York radio station WOR in twenty-nine weekly broadcasts from September 12, 1939, to March 26, 1940, under the baton of Alfred Wallenstein. Also, Myra Hess included all the concertos in her repertoire in the course of her legendary National Gallery concerts in London during World War II. But Kraus was about to become the first to play the entire set publicly in New York, or perhaps anywhere else for that matter, in one season.

Kraus and Stephen Simon, the then-twenty-eight-year-old student of Josef Krips, met in early 1965 in New York's Russian Tea Room to make plans for recording sessions to take place in Vienna over four periods between May 1965 and September 1966. Members of the Vienna Symphony were assembled as the Mozart Festival Orchestra, and the setting for the recordings was the historic Mozart Saal of the Vienna Konzerthaus. Simon recalled the events leading to the completion of these first issues in America of all the Mozart piano concertos:

> *It's difficult to remember the first time that we actually*
> *met. What I remember most of all was sitting with her in a*
> *very dark second floor of a piano factory in Vienna and*
> *playing the Concertos four hands before we went into the*

*actual recording sessions. She discussed all of the Concerti as we played through them. She was an indefatigable artist, full of life and verve.*

*She described each of the Piano Concertos as a mini opera where you had major characters and minor characters and assigned themes to each of these characters in the opera and played through the work as if it were a drama. That approach was particularly effective in the entire project. The overview that we were able to construct by beginning with the very earliest ones and ending with the last ones is like a survey of Mozart's compositional life. This was an amazingly instructional force for me. Her ability to be able to bring that kind of expertise to the entire project was, I think, what made the recordings so valuable.*

*She worked very, very hard with all of the people with whom she ever made music. The recording sessions were extremely difficult. I remember over and over and over again she would complain to the members of the orchestra and say to them, "You must play softer, you must play softer." They would say, "but we cannot play softer, Mme. Kraus." She said, "Oh yes you can," and they did. From that point of view she would cajole people into getting what she wanted from them. She was very, very demanding indeed.*

*After the orchestral sessions were over, she would then go in and record the cadenzas. They were taken out of context because we didn't want to use orchestra time to do those segments which were without orchestra. Mme. Kraus spent hours practicing and going over passages and over*

*passages again because she wasn't happy with them. The cadenzas were either those which Mozart wrote or which Mme. Kraus composed herself in the style of Mozart for those Concertos which had no original cadenzas. I helped her to edit the cadenzas for publication later on, and what was amazing to me was to look at Lili's manuscript and then to look at Mozart's manuscript and to see how very similar they were. It was almost as though Mozart's hand had set down those cadenzas which were actually by Mme. Kraus.[30]*

Raymond Ericson in the *New York Times* review of the newly issued concertos tried to define the quality that distinguished Kraus's playing:

*For those who admire her, she possesses a basic attribute that is important—a tone that has vitality in and of itself. It has strength and glitter and each note has a kind of detached ping that reaches out to the listener and engages him forcibly. If the tone were hard or ugly, this sort of energy would be impossible to bear, as it often is in the case of today's young pianists.*

*The same aliveness that infuses the individual tone extends naturally to Miss Kraus's phrase-making and to her interpretations as a whole.[31]*

Stephen Sell wrote about the concertos in *American Record Guide:*

*A distinguished set of recordings that deserve a special place in the connoisseur's library along with such classics of the phonographic art as Landowska's* Well-Tempered Clavier, *Busch's* Brandenburgs, *Schnabel's* Beethoven Sonatas *and Walter's* Mahler. *Miss Kraus manages to balance rhythmic integrity with sympathetic sensitivity in what is for me the closest thing to perfection possible. The artist's keyboard work is a marvel of clarity. Miss Kraus really outdoes herself. I can hardly imagine a more convincing protagonist than the piano of Lili Kraus.[32]*

Along with these glowing reviews, other auditors expressed some dismay with the orchestral accompaniment. David Dubal observed that "the orchestral collaboration held her back; there was no symbiosis between orchestra and soloist."[33] Nevertheless, this collection represented a magnificent accomplishment for Kraus, especially because she had not known all the concertos before 1965. Learning them had proven to be a terrific challenge, but one that was paying off. For the third time, Kraus's position as the world's leading Mozart pianist was cemented in the opinion of many listeners. She had attained similar recognition in the 1930s and again in the mid-1950s in recordings for Les Discophiles Français. As was also true with Beethoven, Kraus's career had three distinct phases.

Two weeks after the recording of the concertos was completed in Vienna, Kraus and Simon presented the first of nine concerts in New York's Town Hall in an unprecedented series that featured all twenty-five of the concertos in live performance.

The sold-out concerts took place on nine Tuesday evenings—
October 4 and 25, November 15, and December 6, 1966, and
January 17 and 31, February 14, and March 14 and 28, 1967.
Kraus played three concertos on seven programs, whereas on two
programs she played two. Simon regards Kraus's accomplishment
as legendary:

> *It was a monumental undertaking. I remember having*
> *to convince Lili that she was actually up to the task of doing*
> *all of these concerts in New York. She came to me in Vienna*
> *and said, "but I don't think I'm able to do it," in that*
> *wonderful Hungarian way of hers, and everyone sort of*
> *bandied around her and said, "of course you can, Lili. It's going*
> *to be a very major series."*
>
> *Lili was performing all of them from memory, which*
> *was an incredible task for any pianist. Twenty-five piano*
> *concertos from memory is really an impossible task, I think.*
> *In the third concert, she actually had a memory slip and got*
> *lost and had to stop. Now, for most people this would have*
> *been a disaster and a blemish upon one's career, but not for*
> *Lili. She had this wonderful way of being able to improvise*
> *an answer for every difficulty. She said, "excuse me," and*
> *went off stage and brought back her music and a pair of*
> *glasses, as I recall. She said, "I have to use these," and put on*
> *the glasses. Then she got up and went to the front of the stage*
> *and began to talk to the audience about the concerto that she*
> *was playing. It was as though the audience had been brought*
> *into not a concert hall but her living room, that these were*

*137*

*all intimate friends of hers for whom she was giving this soiree and that the orchestra members on stage were also friends of hers. She transformed the entire concert into a very intimate evening. It was a format in fact that we used throughout the rest of the series where she would give her own personal insights into the rest of the concerti.*[34]

As for memory slips in public, Kraus suffered them too often for some auditors. However, she was less troubled by such lapses than were some critics, trading security for spontaneity and dramatic interpretation. She had a rather unorthodox way of memorizing. Actually, she did not like the word "memorize," preferring instead, "learning by heart." She never consciously memorized, eschewing the painstaking note-by-note process used by many artists. Rather, she recalled the music when playing publicly by remembering a drama or scene she had manufactured to fit the music. When a memory slip occurred, Kraus would look genuinely shocked and totally lost.

Playing the Mozart concertos required enormous stamina, and, Kraus herself marveled at her strength during the New York series:

*How did I survive? I can only say, "God alone knows. I don't!" I worked at least eight hours a day, day in and day out, hardly having the time to gobble down my meals. And there were periods when there was nobody to cook for me, during which time I ate out of the icebox and lived on cold turkey and Sara Lee coffee cake—all of which nearly killed me, if you really want to know!*[35]

Actually, she was not alone during the New York residency. Fergus stayed with her for four months, doing for Kraus many of the things Mandl once took care of. He cooked, cleaned, and—most importantly—organized her practice schedule, seeing that she worked as hard as she needed to.

Harold Schonberg of the *New York Times* attended the first of the concerto evenings on October 4, 1966. In his review the next day, he attempted to capture the essence of Kraus's playing:

> *Miss Kraus played handsomely. She is an interesting pianist—always has been—and has some individual ideas about the music. She does not try to evoke a rococo style, what the Germans call "kleine Fingern." Quite the contrary. Both Miss Kraus's ideas and her playing were robust. She feels the drama of the music and is not afraid to build to a healthy climax.*
>
> *Thus there was throughout the evening a concentration on contrasts and dramatic values.*
>
> *The overriding impression was of a pianist with taste, skill and heart, one with a smoothly-working technique; and, also, one who does not worry too much about musicological niceties. There was, for instance, no way of determining how Miss Kraus would take a trill. It could be on the fundamental note, it could be a semitone up.*[36]

In a review of that same October concert, *Time* magazine reported:

> *It was impeccable Mozart throughout, original without being eccentric, introspective without being pedantic. At concert's end, the sellout crowd in Manhattan's Town*

*Hall applauded like baseball fans who had just shared in winning the first game of the World Series.*[37]

Alan Rich wrote in the *New York World Tribune* after the opening night of the concerto series, "The kind of playing she produced at this . . . was the kind that we remember from those legendary pre-war records that still make the rounds among collectors."[38] Ten days later, the review in *Billboard* was glowing:

> *Hearing Lili Kraus perform at Town Hall makes one realize what has been missing from the concert stage: Lili Kraus. As to Miss Kraus' stage performance, it can best be described as "impeccable." She excelled as a performer possessing vitality, strength and style. The sold-out performance was a tribute to an exciting, dedicated artist. Acclaimed highly in Europe for many years, she has at last been found in the United States.*[39]

The positive critical notices afforded the concerti project led Kraus to return to New York in the 1967–1968 season, when she presented five recitals, performing all of the Mozart piano sonatas. She also recorded the sonatas on the now-defunct Epic label. They later reappeared on the CBS Odyssey label.

Comparing Kraus's Mozart sonata recordings with Glenn Gould's version of the same pieces, reviewer Harris Goldsmith stated:

> *Kraus also goes in for a bit of dramatizing. Like Gould, she indulges in dynamic extremes that can verge on the*

*theatrical. Also like Gould, she abhors insipid Mozart playing and to preclude its possibility uses all sorts of devices—* caesuras, *vivid black-white contrasts, even laconic thrusts of downright plangent sound. The drama she creates, however, comes from an imaginative observance of the composer's own dynamic markings.*[40]

In contrasting the Wilhelm Backhaus and Kraus recordings of the sonatas, Goldsmith found interrelationships:

> *As it happens, to listen to Backhaus and Mme. Kraus in parallel literature proves highly instructive. I had always categorized these two artists in two distinctly different traditions, yet hearing them in immediate juxtaposition shows how similar they really are. They share, for example, a robust, explosively contoured approach: both tend to be dramatic and a bit overdrawn in terms of dynamic contrasts, and both can be very cavalier about ornamentation. Moreover, you find the playing of Kraus and the playing of Backhaus similarly tinged with certain romantic mannerisms, such as a just discernible breaking of hands in cantabile passages.*[41]

In a further consideration of the recordings of the Mozart sonatas, Goldsmith found Kraus to be "an expressionist, boldly reinforcing dramatic outbursts with stark, black outlines and vehement accents."[42]

*141*

Richard Freed, writing in *Stereo Review* in 1975, recognized that the passionate drama that Kraus brought to Mozart's music might invite criticism. He offered the following explanation:

> *As for the suggestion that Kraus' way with Mozart is too aggressive, I can only wonder if that attitude doesn't represent some sort of lingering sexual prejudice. Walter Susskind remarked, in a recent memoir, that Artur Schnabel "played with great understanding, but almost* against *the accepted concept of Mozart style; he emphasized the* masculine *element, and brought it off superbly." This, it seems to me, is exactly what Kraus does in these recordings: there is nothing "ladylike" in her playing, and a comparison of her version of the great A Minor Sonata (K. 310) with Schnabel's will show some astonishingly close parallels.*[43]

Freed went on to provide some additional analysis of Kraus's style. In comparing her recordings of the sonatas with those made by Artur Balsam, he summarized:

> *There is, without question, more drama in Kraus' playing, and more variety, both throughout the series and within each work. It is not simply a matter of brisker tempos (there is nothing here resembling Glenn Gould's drive to see how fast the allegros can be played), but of an almost mystically enlivening "aura"—a visionary approach without self-consciousness on Kraus' part. She takes some risks to achieve something like the improvisatory spirit we associate with Mozart-as-performer. Her phrasing is characterized by*

*subtle inflection, one is aware of a controlled undercur-
rent of nervous animation, and there are most effective
dynamic contrasts—but always within reasonable
approximation of the dynamic range of the late-eighteenth-
century instruments.*[44]

In December 1967, Riverside Radio, WRVR of New
York, paid tribute to Kraus's Mozart triumphs by broadcasting a
two-part "Mozart Marathon" program of her recordings of the
concertos. Kraus herself supplied commentary for the selections
played on Christmas and New Year's, giving a brief historical
background, musical analysis, and insight into her interpretative
approach. The month prior to the broadcasts she had to interrupt
her American tour to fly to London for concerts and telecasts
after being named the British Broadcasting Corporation's "Artist
of the Month." Back in the United States, she recorded a ninety-
minute television special, "Lili Kraus and the Mozart Piano
Concerti," for the Public Broadcasting System (then known as
National Educational Television); the program aired nationally
in 1968. In it, she performed the last movement of the E-flat
major Concerto, K. 271, the entire G major Concerto, K. 453,
and the entire D minor Concerto, K. 466, with the Mozart
Chamber Orchestra of New York. Between each concerto Kraus
discussed her career, life, and interpretation of Mozart.

On March 17, 1968, Kraus appeared on the television
program *Camera Three*, a feature of the Columbia Broadcasting
System. (For a transcription of her comments from that
program, see Appendix, no. 7) The medium of television was

*143*

a perfect vehicle for the projection of Kraus's magnetic style of speaking and performing. In fact, it served her better than recordings and did much to further her cause in America.

Later in 1968, Roosevelt University awarded Kraus an honorary doctor of music degree during ceremonies commemorating the hundredth anniversary of the founding of Chicago Musical College, now a part of Roosevelt. The degree citation paid homage to the pianist:

> . . . renowned pianist, teacher and scholar, who, by her great gifts of heart and mind, her keen perception, love and utter dedication to music has, with extraordinary sensitivity over several decades, communicated the music of Mozart to eager and receptive world-wide audiences.[45]

The arduous course piloted for Kraus by Alix Williamson had paid handsome dividends. Kraus had made her mark as a Mozart pianist, but her musical appetite was more eclectic than that. She said she would "kick and fight" if she continued to play works of only one composer. During the 1968–1969 season, she presented three all-Schubert recitals in New York. Also, on November 2, 1969, she again appeared on *Camera Three* playing the world premiere of Schubert's newly discovered *Grazer* Fantasy. Incidentally, she learned the *Grazer* Fantasy from the manuscript, an almost indecipherable score. She subsequently recorded this work for the Odyssey label. In 1970, at the Brazilian Beethoven Festival, Kraus played all five of the Beethoven piano concertos as well as his *Choral* Fantasy.

Without question, Kraus was at the height of her postwar popularity, and most of her acclaim was coming from America instead of Europe. Despite conflicted feelings about leaving her homeland behind, Kraus looked westward for the golden opportunities that awaited her. Unlike Moses, she not only got to see the Promised Land, but also she was about to cross over. ✿

# ACT VII~COMING TO AMERICA

Drawn by her growing success in America, Kraus, accompanied by the Popes, moved to the United States in February 1967. They stayed in New Jersey with Fergus's mother before arriving in Rochester, Minnesota, in March 1967 so that Fergus could take a position at the Mayo Clinic. That same year, Kraus became artist-in-residence at Texas Christian University in Fort Worth, where she had previously visited as an adjudicator at the first Van Cliburn International Piano Competition in 1962, returning for the same purpose in 1966.

Michael Winesanker, then chairman of the TCU music department, had met with Kraus at her London home in 1965 to propose that she become artist-in-residence. He outlined the following conditions of her employment:

> *She would have complete freedom to go and come, to spend some time teaching, to go off on tour or make recordings. We would have an assistant for her to help the students while she was away.*
>
> *I made it clear that we recognized the obligations she had to the world as a great artist and that we would take that into account and that her teaching would be fitted in, that first and foremost she is the great artist, Lili Kraus.*[1]

Such an extraordinary appeal did not go unheeded. Kraus, recognizing a welcome opportunity, accepted the appointment, effective February 1967. Just as Winesanker hoped, she managed to combine an active worldwide performing career and her teaching schedule, a difficult feat.

Her teaching duties at TCU began in July 1967 when she presented her first week-long master class at the university. These yearly events, continuing each summer until a culminating one-day master class in May 1981, had a great impact on those who attended. Kraus, ever beautiful and striking, appeared in a pants suit and white ruffled blouse—her standard teaching outfit. Performers, usually drawn from her class at TCU, played on the stage in Ed Landreth Auditorium while Kraus walked around and listened, hands behind her back. An audience of forty to fifty, many of whom returned yearly, watched Madame Kraus's every move as the young pianists took their turns at the piano. When the last note was released and the applause died, Kraus would usually move to the instrument and look her pupil in the eye. She might praise, frequently saying, "Good, but not good enough," or she might scold. Whichever tack she took, it was delivered with breathtaking metaphoric eloquence graced with that enchanting Hungarian accent, and the mood created was one of singular importance.

In a feature article in the *Dallas Morning News* in 1976, John Ardoin described Kraus's performance at the June 1976 master class:

*I have attended many such classes by a variety of*

*renowned artists and have often found them a platform more for ego than sharing. Not so with Kraus. She submerges herself and her ego deeply into that of her students, agonizing with them over memory slips, prodding them into fuller self-expression and verbally rapping their knuckles for an unmusical phrase.*

*Only from Maria Callas, when she taught at Juilliard, have I experienced such selfless, concentrated giving as Kraus gave last week at TCU.[2]*

The university, Fort Worth, and Texas fell in love with Kraus. Frank Hughes, dean of the TCU School of Fine Arts at the time of her hiring, remarked: "She is one of the select few in the United States of such international repute in the fields of both concert performance and pedagogy."[3] Musicians and non-musicians came to respect and admire the pianist. Her recitals at TCU were celebrated events with standing-room-only crowds. No advertising campaign was needed to attract an audience; people flocked to her, drawn by her playing and her personality. Kraus loved the attention accorded her and developed a genuine affection for her adopted "subjects." She developed enduring friendships in Fort Worth, and the city became the most permanent home of her adult life.

At TCU, a full-time faculty member assisted Kraus and taught her students during her concert tours; among her assistants were Luiz Carlos de Moura Castro, Yoko Kanno, Jo Boatright, and Donna Edwards. Kraus was away from the school about half of each semester, jetting in for a week or two

*149*

and then off again. Her personality, talent, and reputation awed her small class of students, who always called her "Madame Kraus." Most revered her, yet she was sometimes harsh with them during private lessons, direct to the point of insensitivity. She seemed often to be harshest with her most gifted students, probably because of frustration with their failure to fulfill her expectations; she never accepted that students had commitments other than practice, such as English papers and math homework. The result, sadly, was that many of her students were unnerved, and Kraus, in turn, resented those who showed their fear. She never respected meekness or suffered the untalented gladly.

Kraus's pedagogical tactics were akin to those of other great teachers of her generation who attempted to use intimidation as a method of motivation. She did not have any formal pedagogical training such as courses in learning theory and educational psychology, and history has demonstrated time and again that good performers do not necessarily make good teachers. Her primary pedagogical role model was Schnabel, her teacher from the 1930s who typically told his students, "Everything you've known until now is rubbish, and we're starting you from zero." Kraus said something similar to most of her students early on. Schnabel also tended to devote lesson after lesson to the first measure or so of a piece, a practice that Kraus adopted. Technical and musical specifics were analyzed in astounding detail, leaving little if any time for a discussion or hearing of the entire piece. Such teaching does engender a heightened awareness of how to work but can cause students

to lack confidence in their abilities. Despite Kraus's pedagogical shortcomings, many students, particularly those in master classes, found her teaching an epiphanic experience.

She also frequently showed compassion for her young charges. When she was in Fort Worth, she usually ate lunch and dinner with her students, and she loved learning about their lives, especially their personal relationships. On nice days, lunch might be a picnic on the lawn next to the music building. Students cooked for her, chauffeured her to and from the airport and around town, and ran to lessons whenever summoned. She relied on students for many things, including advice, though she was not always comfortable with it when given. For instance, she asked student Nancy Basmajian, "Who's the greatest woman pianist in the world?" Basmajian naively responded: "Alicia de Larrocha." Kraus sharply corrected the youthful indiscretion. Another student, Kit Bridges, told Kraus that he had recently been listening to recordings of Casals conducting some late Mozart symphonies. Kraus greeted this news with stony silence; two weeks later she gave Bridges a present—recordings of the Mozart sonatas played by Lili Kraus! One of the more revealing stories told of Kraus confronting student Louise Spain Gurganus, who had forgotten to pick her up the previous evening for a recital at TCU. After a brief but heated exchange on the front porch of her duplex, Kraus went inside and closed the door. Gurganus, who lived in the other half of the duplex, threw a glass of orange juice she had been holding at Kraus's door. Kraus came back out, saw what Gurganus had done, and said, "I hope you live long enough to regret this." To her credit,

*151*

Kraus held no grudge against her, eventually hosting a recital party for Gurganus at which she gave the girl a cherished heirloom broach. To Gurganus's credit, she continued to prepare breakfast most mornings for Kraus, waking her mentor when the food was ready. Evidencing the bond that developed between Kraus and her students, two of them came to her duplex one evening after Kraus had played with the Fort Worth Orchestra in a performance that had not gone particularly well for the pianist. The students brought with them a box of brownies from the bakery at the Buddies grocery a few blocks away.

Kraus's ability to demonstrate at the keyboard the repertoire students brought to the lessons was one of her most important pedagogical strengths. If she knew the piece, she played it so beautifully that students were inspired; she transformed the ordinary into the extraordinary through her voicing and phrasing. If she did not know the piece, she had difficulty because her sight-reading skills were relatively weak. Fortunately, if she had ever studied a piece, even if she had not played it for decades, she could perform it from memory. Though her recollection might have flaws, she played well enough to demonstrate and impress. Kraus also required students to articulate a drama or specify an emotion for each piece they studied; she would sometimes stop a student in midmeasure by suddenly grabbing his hands and asking, "What emotion do you have at this moment; what is the music saying?" Students learned quickly that a hesitant or vague response was not acceptable. She would often help by offering her vision— expressed, of course, in a dramatic and metaphoric fashion—of the

piece. Also, she would sometimes sketch action characters in the margin of the printed music, depicting a developing drama. The creation of a message to be communicated was essential to the way Kraus played and taught, and that message was often stalwart and occasionally sensual. In one lesson, for instance, in which the second movement of Schubert's A major Sonata, op. 120, was being discussed, she described, measure by measure, a scene involving a couple making love. She even found the spot in the music where they lit their cigarettes. The lessons were never tame or boring. She was always interested in the love life of her students, frequently encouraging them to explore all things physical.

In teaching technique, Kraus also drew heavily upon the notions of Rudolph Briethaupt, who in *Die natürliche Klaviertechnik* (1905) championed weight and relaxation. Though not mentioning him by name, she espoused his approach, as have the great majority of piano teachers throughout the century, despite significant evidence that his ideas are flawed. No one plays with complete relaxation, and weight rarely innervates physical activity at the piano. Kraus, though, did offer significant insights into some aspects of technique, such as the necessity to analyze every motion, a by-product of her study of the Alexander Technique, in which the minutest aspects of movement are scrutinized. This study of movement includes all physical actions, large and small. For instance, she taught students which muscles to use when squinting in the bright sun. One night on her front lawn she showed a group how to enter and exit the stage using correct posture. Another time she coached a couple of students on how to stand in line in a cafeteria, suggesting the apportionment

*153*

of weight between the feet and the correct bend of one knee. On another occasion, she gathered her students at the bottom of a flight of stairs in Ed Landreth; each student in turn had to ascend the steps while those below analyzed every move.

Her emphasis on developing strong, articulate finger action, allied with a loose wrist, was another hallmark of her pedagogy. She endorsed the teachings of fellow Hungarian József Gát, requiring many of her students to read his *The Technique of Piano Playing* (1965). On the rare occasions when Kraus visited her mother in Budapest in the 1950s and early 1960s, she had a few lessons with Gát, seeking to fill the void created by the absence of technical training in her youth. Importantly, she taught her students to do exactly what she had been required to do, starting when she was eight, and that is to embrace a methodology for technical self-improvement through slow practice and detailed review of the action of every muscle and movement.

Few of Kraus's students pursued performing careers after graduation, perhaps because many departed with bruised egos and diminished self-esteem. Successful performers require a high degree of confidence in their artistic vision and abilities, and most of Kraus's students left her without that. What she gave them instead were detailed insights into a dramatic performing style, one handed down to her from Schnabel and Bartók. Her students learned to analyze and question, attributes of teachers, not performers. Though Kraus said she had other job offers from American music schools, she chose to stay at TCU, partly because of the students she found there:

*I made up my mind that the sacrifice I will bring for music, among the million other sacrifices that you have to bring, is to forego the pleasure of teaching people who prepare to be performers, per se.*

*The fate of music depends, not on those people, but on the teachers who will teach them. Therefore I decided that I will teach at a university where there are talented people, at least not to the sole purpose of becoming performers, but they will become teachers. You see, we have excellent performers, we have jolly, jolly few excellent teachers. Those are needed, and that's why I'm teaching.[4]*

Kraus's colleagues at the university respected her artistry, but they were not always comfortable with the famous and assertive pianist. She sometimes made derisive comments to students about teachers she did not respect, which led naturally to resentment. For instance, she told TCU student Kent Grumbles that his piano teacher "knew as much about teaching the piano as she knew about roping cows." Despite such problems, for most of her years at TCU, Kraus was a valued member of the faculty. She was paid and treated handsomely, though her frequent absences dismayed key administrators who wanted her to devote more time to teaching. Kraus was often troubled by this dualism of demand.

Outside the university, Kraus became the darling of Fort Worth's social scene. She developed a close friendship with one of the city's most prominent socialites, Martha Hyder. Gala parties were frequently given in her honor, events

that took a toll in time away from practice. Kraus reflected, "When I come to Fort Worth I never have any time for myself." Her celebrity status was sustained in part by her annual concerts at TCU, appearances with the Fort Worth and Dallas orchestras, and at many other recital venues in the Metroplex. As was usual throughout her career, many of her recitals were prefaced and interspersed with commentary. While playing, she would look toward the heavens, as if seeking inspiration, much as her teacher Schnabel had done. No recording can ever do justice to Lili Kraus the Performer. One had to see her perform in person to know why she was so popular.

Such was Kraus's reputation as a Texas diva that even Lady Bird Johnson, widow of the former president, invited Kraus to spend a weekend at her Hill Country ranch. Kraus went but returned early due to a bout with flu.

At the Van Cliburn Competitions held every four years, Kraus was the reigning presence, serving as judge in 1962, 1966, 1969, 1973, 1977, and arriving for the conclusion of the one in 1981, her last Van Cliburn. She was also an adjudicator at other major international piano competitions, including the Maryland competition in 1972 and 1975, the Marguerite Long in 1973 and 1979, competitions in Athens in 1979 and Montreal in 1980, and the Paloma O'Shea in Santander, Spain, in 1982.

As much as Kraus enjoyed her new life in America, she was often critical of the popular attitudes. She thought Americans had not endured the suffering that had befallen other nations and consequently were spoiled. When the oil

embargo in the early 1970s prompted austerity programs in the United States, Kraus said she believed it was good for the country because hardship builds national character. She also believed that the rich in America were oppressing everyone else, and she spoke of the need for political revolution. She much admired President Jimmy Carter but said, "He is too good for the country—he will never be appreciated."

During Kraus's American period, her time away from Texas was spent mainly in the western North Carolina mountains near Asheville, where Thomas Wolfe, Carl Sandburg, Zelda and F. Scott Fitzgerald, O'Henry, George Vanderbilt, and even Kraus's mentor, Béla Bartók, had lived. In June 1969, Kraus, Fergus and Ruth Pope, and Kraus's three grandchildren—Clara, Daniel, and Frances—built a house, which they named Hill House, on a 600-acre farm in Celo Township, fifty miles north of Asheville. From that time, Hill House served as Kraus's home when she was not teaching or traveling. The house was big and comfortable. Its large music room, with a wall of glass over-looking the mountains and valleys, had a raised stage furnished with a Hamburg Steinway and a fortepiano. This was the one and only home she was to own, and she was justly proud of it. Displaying a recognition of her humble origins and great accom-plishments, she remarked of Hill House, "I built all this with these ten fingers." She had come a long way from the beginnings in Budapest and the devastation suffered in World War II. Hill House was a proud symbol of that success.

Hill House was also a working farm and wildlife sanctuary called the Lili Kraus Wildlife Foundation. Kraus was the

presiding matriarch, entertaining fellow musicians, prospective and current students, and local townspeople. In Burnsville, near Hill House, she began giving an annual benefit recital at a church to help fund the arts organization Music in the Mountains, of which she was named honorary chairman. These recitals, continuing for eleven years, created a bond between her and local residents, who liked having Lili Kraus as a Yancey County resident, recognizing a celebrity in their midst. Kraus, in turn, loved the attention.

Hill House was also a place for physical renewal. Kraus loved to swim in a stream down a path from her mountaintop home. The year-round icy waters seemed not to bother her. In fact, she was a four-season outdoor swimmer in all possible settings. When on tour, she sought the nearest pool. Once, in South Carolina, in the dead of winter she climbed a fence that enclosed the motel's pool, which had been shut for the season. The manager was shocked to find the seventy-plus-year-old Kraus in his pool swimming laps with the strength and vigor of an athlete. "Athlete," in fact, aptly describes Kraus, because she was quite fit, tanned, and in robust health until the end of her life. She took pride in her ability to touch her toes well into her seventies. (In Fort Worth, Kraus made herself at home at the pools of apartment complexes near the TCU campus. Allegedly, she liked to swim nude. Surprised residents of one apartment building [the one housing the seminarians] finally complained to TCU authorities, who arranged a diplomatic conference with their artist-in-residence. Thereafter, she wore a bathing suit, one that was usually hung up to dry in her studio window at TCU.)

Meanwhile, Kraus's career outside North Carolina and Texas continued in high gear. Typical of her schedule in the 1970s were long tours in Australia and New Zealand. In 1970 and 1973 she spent more than two months in those countries, not forgetting the kindness shown her there after the war. She also played often in Japan, France, and England. When in England, Kraus frequently visited her son, Michael, his wife, Gill, and their four sons, Paul, Christopher, Simon, and James. They lived in Essex, where Michael, whose collegiate major had been physics, worked as the marketing director of English Electric.

Highlights of her career in its last full decade included several appearances in New York's Mostly Mozart Festival. In August 1970, she also performed at the Tanglewood Festival with Seiji Ozawa, whose professionalism she adored. On August 15, 1971, she joined Beveridge Webster and Claude Frank, also Schnabel pupils, in playing Mozart's Three Piano Concerto, K. 242, at New York's Lincoln Center under the baton of Leon Fleisher, an event commemorating the twentieth anniversary of Schnabel's death. Interestingly, Kraus refused to record Mozart's Double and Triple Concertos with herself playing all piano parts, as other performers had done. To do so, she felt, sacrificed the natural tension that should exist between multiple performers. But she did record that composer's Sonata for Four Hands in D major, K. 381, playing both parts herself, on the Educo label in 1953 or 1954. Unfortunately, this disc was only briefly in the Educo catalog because of tuning problems. On that recording she also played both parts separately so that student pianists

could play the alternate part along with her.

In 1972, Mills Publishing Corporation (now Belwin-Mills) published Kraus's edition of the cadenzas and *Eingänge*, or lead-ins, for the Mozart piano concertos. The edition also included a preface on Mozart performance practices. Kraus wrote her own cadenzas for more than a third of the concertos and edited the Beethoven cadenzas for the D minor Concerto, K. 466. Though she used the original Mozart cadenzas when they existed, Kraus's cadenzas fill the void left by Mozart in Concertos K. 37, 39, 41, 175, 238, 467, 482, 491, 503, and 537. *Eingänge* and fillers were either written or edited by Kraus for Concertos K. 37, 238, 271, 414, 415, 449, 450, 453, 456, 459, 466, 467, 482, 491, 537, and 595. How she found time to work on this project is a puzzlement, particularly when one glances at her tour schedule for the 1972–73 season (see the Appendix, no. 8), which was typical of her activities throughout the decade.

In early 1973, Kraus was a guest on NBC's *Today* show. Two years later she appeared at the Albert Schweitzer Centenary celebrations, where she played Mozart and Weber concertos with Robert Shaw and the Atlanta Symphony Orchestra on April 12. Also in 1975, she played a special performance for the Haydn Festival and Conference on a 1795 fortepiano at the Smithsonian Institution in Washington, D.C. When she returned to TCU from Washington, Kraus delivered an informal lecture in which she made interesting comparisons between the modern piano and the fortepiano. Included in her remarks was a revealing insight regarding her lack of confidence in her Bach performances, finding herself lacking particularly when

compared with Glenn Gould, renowned Canadian pianist and
Bach specialist:

> *I don't know whether I told you that every Bach
> performance, of course including my own, with the one
> exception of the* Goldberg *Variations as recorded by
> Glenn Gould, is for me very unsatisfactory. Totally. But
> there is that kind of genius [in Gould] that transcended
> that instrument and created a new one. It is not a harpsi-
> chord; it is not a clavichord, but it is absolutely suitable for
> Bach's music. For that alone, [Gould] will sit in the bosom
> of the Lord forever.*[5]

The year 1975 also found Kraus on a tour in Holland,
where she collaborated with Szymon Goldberg, violinist now
turned conductor. That same European jaunt took her to
communist East Berlin, "a horrible place" for her in those days:
"Believe me, if any one had any Communist tendencies, all he
would have to do is visit the city and he would be cured forev-
er," she once said. She later told a friend: "I felt very uneasy in
my evening dress."[6]

In 1978, Kraus played again in Austria with the Vienna
Symphony Orchestra for the first time in ten years. That same
year she returned to New York's Mostly Mozart Festival and then
undertook an extensive and exhaustive six-week concert tour of
Japan. The real jewel in the crown in 1978 for Kraus was her
participation in November in Carnegie Hall's observance of
the 150th anniversary of Schubert's death. Every seat was sold,

*161*

and a long line formed prior to the recital in hopes of returned tickets. A sizable contingent of friends from TCU attended. The moment Kraus played the last note of that program, the audience roared instantaneously. She played several encores, each followed by another ovation. Backstage, manager Alix Williamson, trying to protect Kraus's aging hands, was turning away long lines of autograph-seekers.

After concerts with the Wichita (Kansas) Symphony Orchestra under the direction of Michael Palmer on March 11 and 12, she signed the harp of the Steinway piano on which she had played:

> *Happiness is playing Mozart with the incomparable Michael Palmer and his superb musician-virtuoso orchestra. May the listeners and players alike be blessed with such total fulfillment as was mine by the Lord's grace.*

> *Lili Kraus*
> *2 March 1979*

When James Clancy, director of community facilities, learned of the piano signing, he called it "high-class graffiti" and ordered it removed from the city-owned instrument. News of this furor elicited letters from over the world supporting Kraus and rebuking Clancy. He backed down, and Kraus's message remains on the Wichita piano.

Reviews of her playing in the last decade of her career continued to be mostly glowing. Harris Goldsmith, attempting

to describe Kraus's musical style in his review of her recording of the Schubert Sonatas in A major, D. 664, and A minor, D. 845, began by observing that rarely do "recorded performances capture the miraculous balance between classical poise and expressive fire that characterizes [Kraus's] best live work."[7] He found this record a fortunate exception, one that projected basic, inherent qualities of her artistry:

> *Kraus approaches the music in the manner of an expressionist painter. She works boldly and freely with large dabs of color, stressing the asymmetrical patterns in bar lines, shifting emphasis from one voice to another, and highlighting the strange harmonic turmoil. Her grasp of the over-all structure is so acute that it enables her to change tempo and bend the rhythm without forsaking forward continuity. Her brusque energy, I hasten to add, is counterbalanced here by an almost bejeweled grace and elegance.*[8]

As for Kraus's personalized interpretations, Peter G. Davies was insightful about the pianist's artistic vision. Reviewing her performance of Beethoven's Piano Concerto in C minor in 1970, he wrote in the *New York Times*:

> *Miss Kraus gave a highly unusual and individual performance, very far from the prevailing view that holds this work to be the first true romantic concerto. The first movement, taken at a much brisker tempo than one generally hears, was full of impetuous explosions, gruff accents*

*and stringent tone. The slow movement, which would seem to invite playing of lyrical repose, projected instead a mood of sullen impatience, while the finale bristled with snappish bad temper. In fact, the interpretation conveyed all the qualities one associates with Beethoven himself. A fascinating reading, and like it or not one must credit Miss Kraus with the courage and thoroughness of her convictions.[9]*

Paul Hume of the *Washington Post* described Kraus's magic in a review of a March 7, 1972, recital:

*If the Kennedy Center seems radiant this week, it is probably due to the presence there of one of the world's great, incandescent artists, Lili Kraus.*

*Playing Mozart with the National Symphony Orchestra, under the direction of Howard Mitchell, Mme. Kraus brings to the Center a singular resplendence, one which, since she has not played there until this week, it has not previously known.*

*For there is no one these days who plays the piano remotely like Lili Kraus. Her playing is by no means confined to the miracle that happens when she first touches the piano. Rather, it begins with the orchestral introduction, at which moment, she becomes one with the music. She enters totally into Mozart's conception, of which her part and that of her instrument are but one element.[10]*

In a 1976 review in the *New York Times*, Donal Henahan

wrote about Kraus's courage of conviction in breathing her aesthetic life into whatever she played:

> *Next to talent, the greatest gift nature can bestow on an artist is conviction. Lili Kraus, for one, oozes conviction when she performs Mozart . . . In the face of such confidence, which Miss Kraus has built up through many years of hard thought and hard work, even one who might prefer another Mozart style to hers could only sit in admiration.[11]*

The reviews also reflect an admiration for her sense of drama. Of her recording of the Schubert Sonata in B-flat major in 1979, Davies of the *New York Times* wrote:

> *A Schubert anniversary without a concert by Lili Kraus would be as unthinkable as a Mozart anniversary without a concert by Lili Kraus. The pianist has become so closely identified with these two composers, playing their music and speaking of them with such passionate commitment, that one sometimes feels that she must have known them personally.[12]*

About her recording of Bach, Haydn, Mozart, and Schubert fantasies released by Vanguard in 1980, Richard Freed wrote that "the playing is, as always, gutsy, involved, and urgently communicative."[13] Harris Goldsmith agreed:

> *She is not, and never has been, a colorist in the Myra*

*Hess tradition; yet in her own inimitable way, she conveys the tensions, mysteries, and grandeurs of these fantasies . . .*

*Kraus is a keyboard expressionist; the shaggy edges and heavy black Rouault outlines she gave the Bach impart a power and scope that will have purists up in arms but less prejudiced listeners enthralled. If memory serves, her mentor, Artur Schnabel, played this exceptional work in a similar manner.[14]*

Regarding Kraus's final recording of Bartók's smaller works, which she made for Vanguard in November 1980, Edward T. Canby, writing for *Audio*, said that her playing was similar to Bartók's own recorded examples.[15] Richard Freed's review of this issue remarks again on the pianist's visionary freedom:

*Her playing is characterized most of all by the sort of idiomatic freedom that suits the quasi-improvisatory nature of these works . . . and makes them not only effective display pieces but exceptionally communicative.[16]*

Perhaps Jacob Siskind of the *Gazette* of Montreal best summed up Kraus's musicianship when he asserted its ineffability:

*It would be possible to dilate at length on the masterful sense of form to Miss Kraus' playing, her ability to shape and reshape the music as she plays, to keep a performance moving along reaching for one emotional peak after another, but words cannot describe the elusive quality that is hers . . . .[17]*

Awards recognizing Kraus's accomplishments were many. On March 2, 1978, she received the Austrian government's Cross of Honor for Science and Art, First Class, during ceremonies at a concert played by the Pueblo (Colorado) Symphony Orchestra. In 1980, she added an honorary doctorate from TCU to the one she had received from Roosevelt University in 1968. She also held an honorary doctorate from Williams College.

At the conclusion of the 1970s, Kraus was one of the great personalities in the music world. She was riding a crest of popularity, public admiration, and adulation. Sadly, she was about to learn that nothing lasts forever. ❀

# ACT VIII~CODA AND REQUIEM

At age seventy-five and with her career in full bloom, Lili Kraus began a long, difficult physical decline. While on the tour of Japan in the summer of 1978, she signed autographs for up to two hours after every concert. Kraus recalled audiences in which there were many schoolchildren who formed long lines to seek her signature. She autographed her own records and little "good luck" tablets the children brought. From all the writing and shaking hands, Kraus began to experience severe pains, but she never turned away a single child:

> No it is not possible for Lili, this Lili Kraus, not to shake the hand of that kid with the glowing eyes and not to ask her name and write it there "for so and so," or "Sayonara, Lili Kraus.[1]

Despite pleas from Kraus's manager, she continued to greet all who came backstage. The result was that by the end of the Japanese tour she had terrific pains in both hands, the first symptoms of rheumatoid arthritis, a crippling affliction that usually manifests itself earlier in life. She knew she should take some time off to allow her hands to rest, but she already had bookings all over the world and pushed on:

*If I had been a decent, reasonable citizen, I would have laid off for four months, six months, a year. No way. The dear Lord had to beat me on the head and say, "My dear child, you can't go on like that. No way."[2]*

Attempting to ignore the pain, which came and went at first, she continued to play and to record, finding no time for the rest her body needed.

In December of 1979, Kraus was forced to the sidelines when she contracted pneumonia and was hospitalized in Fort Worth. Upon release she went home to Hill House to spend the holidays with her family. This vacation quickly turned horrible. An antibiotic she was taking for the pneumonia caused an unusual reaction, an auto-immune inflammation of the soft tissues and joints. Her entire body became swollen in a matter of hours. Fergus arranged for her to fly to the Mayo Clinic in Minnesota in January 1980. She spent five weeks recuperating, returning to Hill House on February 14, physically and emotionally scarred by this illness. At seventy-seven, her body was clearly starting to fail. Looking back on this experience, she marked it as a real turning point.

The arthritis was beginning to affect every joint in her body, though it was particularly devastating in her hands. Playing was possible some days and not others. In a life that had repeatedly found salvation through hard work at the piano, the encroaching theft was merciless, the ultimate tragedy for a musician. As Beethoven was overtaken by deafness, he lost his ability to hear what his soul felt, and it nearly drove him mad.

Now Kraus, increasingly unable to express what she heard, knew how he felt. As further insult, while her identity as performing musician began to fade, so did her legendary beauty. The cortisone prescribed for her arthritis caused swelling of her face, and her trademark high cheekbones were obscured by puffiness. Kraus was embarrassed and horrified.

She cancelled commitments for the spring of 1980 and remained in North Carolina. Despite adversity, she found, as she had somehow done during her wartime incarceration, a measure of solace even in her most desperate moments. In a letter to a friend she wrote:

> *. . . please don't think that this is an ultimately sad letter: I began to really feel victory in defeat as there is defeat in the most radiant victory. The two are one and the interplay is man's life until he is so free that he is not aiming at anything but the highest state: liberation in love.[3]*

Kraus returned to St. Mary's Hospital, part of the Mayo Clinic, in May 1981 for more tests and treatments. Cortisone injections in both knees completely remedied the pain in those joints for awhile. During this hospitalization, the Van Cliburn Competition was taking place in Fort Worth. On May 31, the final day of the competition, she flew from Minnesota to Texas to join the other judges on the stage of the Tarrant County Convention Center in Fort Worth for the announcement of the winners. At the end of the presentations, the warmest ovation was saved for Kraus, who was still wearing her hospital

*171*

identification bracelet when she walked on stage.

Afterward, Kraus tried to resume her career and played sporadically for the next several months. But, she saw the future all too clearly:

> *Indeed, time is passing and its passage both in the course of illness and age seems unaccountably fast.*
>
> *The pains come and go and there is no prophecy which could be considered valid; I, myself, know only that the slightest effort has to be paid for with a horrendous price and I indeed cannot see myself taking to the road once more.*[4]

She continued to teach at TCU. Her last master class was reduced to a one-day affair, in May 1981, thus concluding the fifteen-year tradition. Her second-floor studio was too difficult for her to reach, so she was given one on the ground floor in a portion of the space once occupied by the music library. She desperately wanted to continue teaching, believing she had more to offer than ever before. As during her imprisonment, she found new insights resulting from the forced internalization of music. Suffering brought wisdom, and she wanted to share it. Unfortunately, she tired easily and could teach only for brief periods.

On June 12, 1982, Kraus played in public for the last time. She closed her illustrious career at Swarthmore College in Pennsylvania with one of the most dramatic Mozart concertos, the D minor, K. 466. That week, she wrote to a friend a letter not of despair but of acceptance:

*At the end, in my present state, I don't feel disappointed,*
*betrayed, short-changed by adverse fate. . . .* weil nicht alle
blüten Traüme reiften *(Goethe) ["because not all dreams*
*come true"].*[5]

In January 1983, Kraus wrote another remarkable letter in
which she eloquently and sensitively articulated her credo. If
Iago railed, Kraus prevailed:

> *However, I think I have to confess to myself before I*
> *make it public knowledge, that my playing days are over. For*
> *one thing, the joints, especially the invisible knuckles, are so*
> *swollen that I cannot align the fingers in the direction of the*
> *keys and, secondly, for this same reason, the hand has*
> *narrowed, thus I cannot play chords as they exist in my head*
> *and heart and have always existed in actual sound. . . .*
>
> *Now, all the undiminished joys, wonders, fulfillments*
> *are referred to Him. Whilst I learned how to live, I now learn*
> *how to die, perceiving that my contribution to the timeless*
> *Mosaic of humanity's existence is but an infinitesimally small*
> *particle of the in-dwelling God and will be one link among*
> *millions of others, yet of a unique hue of eternal validity to*
> *serve the pattern of Creation, everlasting.*
>
> *Thanks to Him again, all perceptions remain undi-*
> *minished, worth living for. First and last, the sense of humor;*
> *the marvel of beauty; the multi-faceted nature of human*
> *relationships and, the splendor of all creation—all are alive*
> *within me and that poor, aching, slow body just pays the*

*173*

*price for all past, present, and future trespasses and necessities.*
*There is no bitterness, no sense of injustice, no jealousy*
*to mar the picture, just infinite gratitude . . .* [6]

In February 1983 Kraus had eye surgery. In April, there
were a few happy if bittersweet days. TCU honored her
retirement with a gala party on April 29. The black-tie event,
held at a downtown hotel, featured toasts to Kraus offered by
such dignitaries as the minister of the New Zealand embassy;
Eugene Fodor, the Hungarian-born editor-publisher of travel
books and former Kraus student; and both of her children.
Van Cliburn sent a huge bouquet of red roses. President
Ronald Reagan sent the following message:

> *April 25, 1983*
>
> *Dear Madame Kraus:*
>
> *I am pleased and happy to join the Texas Christian*
> *University School of Fine Arts in honoring you on this special*
> *occasion.*
> *For many years you have delighted audiences around*
> *the world with virtuoso performances as a leading concert*
> *pianist. Your talent and musical artistry have not only*
> *dazzled critics and fans, but also inspired the students and*
> *scholars of Texas Christian University.*
> *The passionate involvement and intense personal*
> *commitment that illuminate your performances encourage the*
> *artists of this generation to pursue their studies more devotedly.*

*Congratulations on this well-deserved tribute and good luck in the future.*

> *Sincerely,*
> *Ronald Reagan (signed)*[7]

A multimedia presentation of Kraus's life, accompanied by her own recordings, was presented as was a check for $100,000 raised by "Friends of Lili Kraus." That group was formed in 1979 to underwrite the Lili Kraus Artist Fund, a TCU scholarship endowment.

Though officially retired from the university, Kraus returned to Fort Worth six times during the 1983–84 academic year. On each visit of about a week, she continued to work with a few students finishing degrees.

As her physical and emotional suffering increased, her spiritual life assumed an increasing immediacy. In 1983, Kraus was baptized by a Catholic priest in Virginia, thus making her conversion official in the eyes of the Church.

In June 1983, Kraus returned to the Mayo Clinic for hydro- and physiotherapy. That fall, she was scheduled to assume the influential and prestigious position as hostess of a televised series called *Young Americans at the White House,* a showcase for gifted musicians embarking on their careers. Her health forced her to cancel. In April and May, she made yet more journeys to Mayo for surgeries on the knuckles in both hands. The bones were scraped or shaved and the tendons realigned. For a while she thought she might be able to play again, but that notion was quickly dispelled by recurring pain.

In December 1984, Kraus left Hill House for a trip to Fort Worth. A special premiere screening had been arranged for the thirty-minute biographical drama, *Lili*. Filmed in Fort Worth, New York, Budapest, and Vienna and produced by Fort Worth Productions, it was aired nationally on PBS stations on January 2 and 6, 1985. Kraus wanted very much to attend the advance showing in Fort Worth, so she ignored her growing pain and frailty to make the trip from North Carolina. Shortly after checking into a hotel, she collapsed, suffering a brief period of unconsciousness from the exhaustion of the trip. She returned home the next day, shaken from this experience, and never went back to Texas.

Kraus was not happy with the film, though she was proud it existed. First, she was offended at Ruth's comment regarding her alleged response to a Japanese camp commander's question, "Madame Kraus, what can I do for you?" Ruth quoted her mother as saying, "I would love a piano and to be reunited with my family—in that order."[8] Kraus denied having ranked the piano ahead of her family and told her daughter she was hurt. Ruth, though, stood by her recollection of her mother's stated priorities. Kraus's other reactions to *Lili* were summarized in a letter:

> As to the film, Lili, *it won all kinds of distinctions as you will see from the enclosed report. I, myself, am not very fond of it for several reasons. Firstly and chiefly, my vanity is pricked in that I look as ugly as the proverbial full-moon face of the people taking prednisone (at that period I was on twenty milligrams a day). Secondly, my two best pupils were*

*not available, playing at competitions at various places.*

*However, the message of my credo comes through clearly and, like all my attempts at guidance and dedication, it is clear that what we work for is, in fact, unattainable. All we can do is to cleanse the vessel as best as we are able to, so that the divine message doesn't fall short too badly of the Creator's message. Hence the last words of the film, after all the praise I am giving, are: "It's superb—but it is not good enough."*[9]

Back at Hill House, Kraus was alone. Ruth and Fergus had moved to Houston to tend to their son, Daniel, who had broken his spine in a diving accident. The octogenarian had to supervise the few employees who maintained the property and tree farm. A nurse came every morning to help her dress, a task Kraus was unable to perform alone. This great lady, who had conquered the musical world with her hands, now could not comb her hair or button her clothes. She spent every night alone on that dark, secluded mountaintop, far from the attention and glamour she had known.

During the Christmas holidays in 1984, Ruth came to North Carolina to visit her mother. She was alarmed at Kraus's decline, realizing she could not live alone any longer. Ruth contacted a retirement/nursing facility—Givens Estates—in Asheville. They went for an initial visit, looking at apartments and the full-care building. Kraus hoped to move to one of the apartments, but on Friday, January 4, 1985, when Ruth drove her mother to her new residence, she was assigned to a single room in the nursing-care unit.

At first, Kraus was depressed by her circumstances. Placement in a nursing home, no matter how pleasant the facility might be, is still an admission of compromised ability. For Kraus, such admissions came harder than for most. Fortunately, she was also more resilient than most, and as she had done before, she soon turned despair into fulfillment. Ruth quickly furnished her mother's room with personal effects, including a favorite desk, plants, and a remote control television. While Kraus was busy making her adjustments, the staff at Givens Estates learned that it, too, was expected to make concessions. Kraus presented the home's administrator with a list of demands, which he granted. For instance, breakfast was served in Kraus's room at a time later than would ordinarily have been possible. She quickly acquired celebrity status among the patients and staff. A secretary spent time with her most afternoons taking dictation for countless letters. Her favorite evening pastime was talking on the telephone with friends throughout the world. When she found she could no longer hold the receiver for long periods, Martha Hyder, her longtime Fort Worth friend, sent her a lightweight headset to free her hands.

Of course, she had to forgo the 1985 Van Cliburn International Piano Competition. Just before the competition, she went again to the Mayo Clinic for more hand surgery. The four large knuckles in her left hand were replaced, a procedure that freed her from the tremendous pain. Friends from Fort Worth called her daily at the hospital with news of the competition, and she followed the proceedings through radio broadcasts. In her room was a huge floral arrangement from Van

Cliburn. At the awards ceremony, F. Murray Abraham, recipient of a 1985 Academy Award for his portrayal of Salieri in the motion picture, *Amadeus*, made the following comments from the stage of the Tarrant County Convention Center in Fort Worth:

> *This competition has had a marvelous jury, and I know they would have picked a Mozart over a Salieri every time! But before I introduce those who are here I must talk about one particular lady who unfortunately could not be with us. She has been a juror for every Van Cliburn Competition since the first in 1962, and both she and we were terribly unhappy that an operation on her hands prevented her being with us this year. We have talked to her by phone frequently, and she is certainly here with us this evening in spirit. Madame Lili Kraus, we miss you!* [10]

In June 1985, Kraus returned to Givens Estates, the home she called the "well-run jail." Despite her suffering, she was able to write words of encouragement to her friends. When a former student confessed that she might not want to play the piano again, Kraus responded:

> *Don't you say that you are not sure that you will ever again take up the piano. The grades of difficulty vary with everybody, but all heartbreak, all frustration, all setbacks in one's progress are worth the fulfillment of the rare moments when you are identified with what you want to express.* [11]

Kraus spent the rest of 1985 quietly, writing letters, taking short walks, talking with friends, and reminiscing. Remarkably, she summoned the strength to go to New York on October 13 to introduce Albert Schweitzer's daughter, Rhena, onstage at Avery Fisher Hall in the Albert Schweitzer Music Award ceremonies.

But the dawning of the New Year brought more bad news. On January 4, 1986, Kraus underwent emergency surgery at the Mayo Clinic just days after a second hand operation, this time to replace the joints in her right hand. Suddenly, she developed a painful intestinal blockage, a result of medication she had taken for years to fight her arthritis. Twelve inches of her colon were removed. After recuperating, she returned to Asheville, where on April 21, she developed another blockage, this one prompted by the scar tissue from the first operation. A colostomy was performed at Asheville's Memorial Mission Hospital. Kraus tried to adjust to the problems accompanying that procedure, but she found them too great an indignity. Against strong and urgent medical advice not to undo the colostomy, Kraus insisted. On July 31, a surgeon at Memorial Mission Hospital reconnected Kraus's intestines.

On August 23, Eugenia Zuckerman, wife of the violinist Pinchas Zuckerman, interviewed Kraus for CBS-TV's *Sunday Morning*. The interview, nationally broadcast on September 21, 1986, showed a very frail Kraus walking around the grounds at Givens Estates, feeding the ducks, having dinner, and chatting with Zuckerman in a private parlor. The pianist's hands were gnarled, her face thin, her hearing severely compromised, her hair frayed and brittle. But her eyes retained their old sparkle,

her voice was strong, her smile was broad, and her intellect was intact. Kraus was still there in all her glory for those who had eyes to perceive her true essence. Asked if she missed the stage, Kraus replied, "I miss it terribly." As to what music meant to her at that point in her life, Kraus said, "What it always has: nostalgia, happiness, infinite flight of imagination." Zuckerman concluded the interview by asking Kraus if she thought it was important for a great musician to suffer:

> *Yes, of course. You must know hell and paradise to all their depths and heights. Of course I believe that, because but for that you didn't live.*[12]

On August 24, the day after the CBS interview was taped, the problem that the surgeon predicted occurred when Kraus's colostomy was reversed. A new intestinal blockage required yet another operation. So weakened was Kraus that she knew recovery was unlikely. Friends who spoke with her in September and October of 1986 said she was resigned to her fate and even welcomed death. She wrote to a former student on October 18, "I am weak as a beetle on his back, in the fall, trying to move his impotent legs."[13] Perhaps most tragically of all, Ruth remembered that her mother admitted to having lost the solace of inner music during those last days:

> *When Lili got so sick, one of the saddest things that she ever told me was, "You know, I have no more music in me now. When I am sitting somewhere, or thinking, or walking,*

*I don't hear the music anymore." I said, "But Lili, how's that possible?" And she said, "Well, when I was in prison camp, I heard the music. It was written, it was in me, every waking moment; if I wanted to, I could recall any music. I can't do that any longer."*[14]

On October 25, Kraus underwent her fifth major surgery in ten months, again to correct an intestinal blockage. Kraus's eighty-three-year-old body had no strength left. Kraus never again left Memorial Mission Hospital, the site of her final two operations, lapsing into a coma with her breathing sustained by a respirator.

On Friday, October 31, Ruth, who was then living in Chapel Hill, North Carolina, was summoned to her mother's bedside and told that she could not survive the day. Ruth sat there all day, talking, and Kraus seemed to understand at times. The next day, November 1, Kraus rallied, to the amazement of her physicians. Though still on the respirator, she communicated by squeezing Ruth's hand. She also summoned the strength to form the word "Miessi," her son Michael's nickname; fortunately, Ruth was able to read Kraus's lips and sent for her brother. Michael arrived from England on Monday, November 3, an event that Kraus seemed to have been waiting for. She suddenly had more strength. However, despite removal of the respirator, she could not speak to either of her children because her throat was too sore. She never spoke again.

On Tuesday, November 4, Kraus declined throughout the day and that evening lapsed into a final coma. Ruth spent some time with her mother that night, bidding her farewell, as

Michael did the next morning. Kraus died at 2:30 A.M. on November 6, 1986. With her was Susannah Jones, a family friend of many years. The death certificate listed the cause of death as "Overwhelming Sepsis as a consequence of Peritonitis and small bowel obstruction." Within a few hours, Kraus's body, which weighed just eighty-eight pounds, was cremated. Lili Kraus—beloved musician, actress, teacher, wife, mother, grandmother, friend—was gone.

The news of her death spread rapidly. Newspapers throughout the world printed obituaries, many on front pages. Notices of condolence poured into her family. In Texas, on November 8, a concert featuring the Chester String Quartet and Stephen de Groote, the late Van Cliburn Competition gold medalist and then TCU's artist-in-residence, was held at the university. The concert, originally planned to honor Kraus, was transformed into a memorial for her. On Sunday, November 16, a private memorial service for family and invited friends was held at the Celo Inn near Hill House, and Kraus's ashes were buried at the farm. A public memorial service for Kraus was held in New York City at the Church of St. Francis Xavier on December 15, 1986. That service included the playing of Kraus's recording of Mozart's D minor Concerto, K. 466, and concluded with a performance of the *Aria* Sonata of Scarlatti by Alexander Toradze, 1977 Van Cliburn Competition silver medalist. As he approached the piano that evening, Toradze brought with him a picture of Kraus which he placed on the music desk while he played. When he finished, he took the picture, kissed it, and closed the key cover.

Others continued to pay tribute to the pianist. Swarthmore College, where Kraus made her final public appearance, dedicated a performance of Mozart's *Requiem* to her. In England, the BBC's *Radio 3* broadcast six memorial programs on Sunday mornings from November 22 to December 27, 1987, featuring various Kraus recordings. For a radio station in Amsterdam, Frans Schreuder of Holland, personal friend of the pianist and expert on her life and recordings, devoted four Monday evenings (April 9 and 23, May 7 and 21, 1990) to retrospective programs focusing on Kraus's life and musicianship. On October 17, 1990, he also presented a lecture at the International Piano Archives at Maryland entitled, "Lili Kraus, Pioneer on 78 Records." Just five days before that, on October 12, Swarthmore College presented the "Lili Kraus Memorial Concert" introducing the new Lili Kraus concert grand piano. National Public Radio in the United States presented a program about Kraus on October 25, 1995, and a conference devoted to her memory was held in New Zealand on July 27, 1996. In 1997, James Newcomer, vice chancellor emeritus of TCU and close friend of Kraus, published his movingly eloquent *Lili Kraus and the Van Cliburn International Piano Competition: A Memoir of the TCU Years.*

One of the most beautiful tributes to the late pianist was written by John Ardoin, music critic of the *Dallas Morning News:*

> *When I remember Lili, I remember her light-giving smile, her boundless enthusiasm for everything, her kindness to everyone, her extraordinary articulateness (especially for*

*one whose native language was not English) and her ripe
sense of humor.*

*Though there was a regal quality about her—the
sweep with which she entered a stage and possessed it—she
was the most approachable of artists. Everyone in music,
whatever his age or experience, was treated like a colleague,
and you felt taller and more important after an evening
spent with her.*[15]

Kraus left a powerful and enduring legacy. She was one of
the most interesting musicians of the century, and the sheer
force of her charismatic personality knew no equal. Perhaps
Shakespeare himself would have approved of the following
paraphrase of his moving lines from *Romeo and Juliet* in
describing Kraus's place in the hearts of those who knew her:

*Take her and cut her out in little stars,
And she will make the face of heaven so fine
That all the world will be in love with night,
And pay no worship to the garish sun.*[16]

# *F*INAL NOTES

She is a quick observer, seeing and perceiving everything. Independent of her moods, her perceptions are sharp and emotional. She is very attentive to everyone and everything around her but can control these reactions when necessary. Under all circumstances, Lili remains herself. She has respect for others and in that regard, has shed inhibition of the past. The values of the past she has carefully preserved in an aristocratic manner. In relation to forty years ago, she has become more aware and cautious. For her own sense of identity, she does not need others, but she does want to share her spiritual wealth with others. She is a very strong woman, resisting all external influences in fundamental matters. She knows what she wants and how to accomplish it. Sometimes this brings considerable tension, resulting in emotional outbursts, and occasionally, fits of temper. This she herself accepts.

Lili is obstinate and ambitious, driven to more and more achievements. She is persistent and pugnacious; also sensual, pragmatic, and very sensitive to form and colour. In both internals and externals, she is inclined to extravagance. She is a human with many facets, a rich inner life, and a tendency to be theatrical, letting people wonder what she is thinking at a given moment but keeping that secret.

*Memories are dear to her and maintained with care. She has a good instinct, recognizing situations and experiences from her past, and is creative with them. She is alert, considerate, but not obliging, respecting her own worth and that of another. Actually she lives a solitary life, withdrawn into herself. For intimate relationships she takes little time. Her work is her life. Because of her great need for achievement, her perfectionism, and the high demands she makes of herself, she cannot tolerate people around her for long, though perhaps in the background. She is the center.[1]*

The preceding portrait of Lili Kraus's personality was drawn in 1986 by a professional graphologist who never knew Kraus personally but studied samples of the pianist's handwriting from various periods in her life. Amazingly, this description captured the essence of Kraus with startling clarity and validity. Although many regard graphology skeptically, Kraus herself would likely have approved.

Kraus was passionate about all her beliefs, including religion. She described her faith as "the one and only real force. It's as strong in me as the necessity for survival. I cannot imagine myself outside of God even for an instant."[2] Although her spirituality was exceptionally strong, it was not what most would consider orthodox; her theology was universal, embracing eastern religions. She also believed in astrology, reincarnation, and karma. She knew her astrological chart, which indicated she was a Pisces with a Leo ascendant. This, she explained, made her life

difficult because, "The water of Pisces is always putting the fire of Leo out." She practiced transcendental meditation and yoga, which she learned in the early 1950s from violinist Yehudi Menuhin's guru, the renowned B. K. S. Iyengar. She professed that she was a medium through which God spoke: "When I play well, I'm not playing—I'm just a channel."

Kraus was an open and warm person. Never shy and always gregarious, she professed and demonstrated love for most everyone and everything, including animals and nature:

> . . . I am really looking forward to the time when I can be in nature again . . . . my happiest memories go back to my childhood when I used to swim in a lake. I would float on my back, and the sky would be pink and the water reflected it, and I absolutely dissolved in nature.[3]

Once when Kraus was in St. Paul, Minnesota, to play a Mozart concerto with the Chamber Orchestra, she went for a walk after a rehearsal session. Dressed in one of her all-white outfits, she reclined on the green grass, enjoying the warm sun. She suddenly spied a bird feather, which she picked up and studied in silence. After a while, she said to her companion, "Isn't this incredible that God would make such gorgeous things to be thrown away."[4] Kraus never lost her childlike sense of wonder. Nor did she ever meet a dog or cat she did not like. For example, on a hot August night in 1984, Kraus locked herself out of her house in North Carolina. Remembering that her secretary had a key, she went to look for her. Unfortunately, she

went first to the wrong house, one guarded by a large, fierce dog. Kraus walked straight to the barking, snarling animal and embraced it, and the dog licked her face in return.

Exuberant and confident though she was, Kraus could also be vulnerable. She frequently asked those around her how she had played, looking for reassurance. She agonized over bad performances and unflattering reviews. When she performed for her students, she felt the greatest pressure of all. On the occasion of her recitals at TCU, for instance, she typically sat alone in her studio all day, refusing to answer the phone or the door. She was particularly nervous about her technical abilities, and more than once she also expressed concern about her pedagogical skills.

Despite this innate fear of failure, Kraus exhibited a penchant for risk-taking and challenges. She liked to live dangerously, to take chances, particularly on stage. Ruth recalled that Kraus said before practically every concert: "*Wenn ich auf Nummer sicher spiele, ist es immer schlecht*" ("If I try to play safe, it's always bad").[5] She sometimes changed what she was going to play—and how to play it—just prior to walking out. She might switch fingerings at the last moment or conduct "request" recitals in which the audience, by calling out names of favorite pieces from her repertoire, would dictate what was played. Her unusual way of memorizing music was also adventurous. For a professional musician, this sort of risk taking can be dangerous, but Kraus willingly traded security for artistry:

> *Spontaneity is the very essence of a performance. You should not let on that you know what the next note or bar is*

*or that you have worked on the piece to the point of being sick and tired of it. I want to hear your one-time experience: you have never before seen this music, never known it; you invent it now, as you go along. Now how will you do this? By trying to imagine the ineffable beauty of the piece, by trying to imagine everything that happens in it, by being utterly identified with it—body, soul, and spirit.*[6]

When asked to describe herself, Kraus responded, "I am terribly passionate, irrational, and the most undiplomatic person God ever made."[7] Following is Ruth's attempt to describe her mother:

*The song from* The Sound of Music—*"How Can You Catch a Moonbeam and Hold It Down?"—that is how you catch the life that is in Lili and describe it. How can you catch the overwhelming love that she has in her heart for the music, nature, animals, human beings, how can you describe that in a word?*[8]

An interviewer, Russ Rymer, attempted to define the special quality that elevated Kraus to the top of her profession:

*Passion has made Lili Kraus great in a field where greatness is something larger than perfection, where cold technique alone will not suffice. In music, a bird in the bush is worth a thousand in the hand: it is not the things that can be held or defined that raise a performance above the ordinary, but the fleeting and ineffable qualities, the intensity of*

*understanding that a musician must discover in some internal reservoir of experience and personality. And it is that understanding that Mme. Kraus has in spades.*[9]

Kraus related what a stagehand wrote to her:

*During a Scandinavian tour, when playing in Stockholm, I left [a box of cigarettes] in the artist's dressing room handy for between numbers. This particular box happened to be almost completely full. Thus I had moved on to another city before I arrived at the last layer of cigarettes. There I found a note: "Among all the pianists of the world, there are but two real artists—Arthur Rubinstein and Lili Kraus." Signed: "The backstage hand."*[10]

The linkage of Lili Kraus's name with that of another great pianist personality of the century underscores the esteem she enjoyed through most of her career, especially from listeners whose lives she so magically touched. (For Kraus's views of Rubinstein and other contemporary pianists, see the Appendix, no. 9).

Kraus was enchanting, and she knew it. People worshipped and adored "Madame Kraus," and she loved that. Life brought her opportunities and challenges, which she turned into gold. Success was hers because she won it the old-fashioned way—through hard work, indefatigable stamina, talent, force of personality, and her uncanny ability to turn adversity into victory. She refused to succumb to defeat, an alien concept.

Her favorite quote was by Goethe: "With fresh eyes, joyfully

see." Kraus lived that philosophy, experiencing amazement in simple things, relishing both the ordinary and the extraordinary. Many people do not begin to appreciate life until they have come close to losing it, but Kraus conducted her entire existence at that threshold of enlightened awareness. She lived with enthusiasm, with inquisitiveness, with boundless energy, with total involvement. She also was intimately in the service of the composer whose name became forever entwined with hers—Mozart. She is widely regarded as the foremost Mozart pianist of the century, and her recordings were and continue to be treasured. Indeed, her interpretations of the Viennese master became the standard for many people. Of her relationship with Mozart, Kraus wrote:

> *If I could go back to times past . . . I would most assuredly bow low and kneel in the presence of Mozart. And if I may see him someday in the hereafter, I hope that he will confide in me, saying that I have not altogether displeased him with my interpretations of his works.*[11]

If that meeting took place, Mozart probably returned the bow. Kraus earned such honor as she earned the love, respect, and gratitude of thousands who heard her music and delighted in her engulfing charm.

Kraus was a great figure of the twentieth century. She lived her life with tremendous zest, and her passing brought twilight to an era of personal grandeur that was more a product of the century before her birth. She was remarkable, unique and dazzling. She richly deserves her place in history. ❊

# Appendix

1. Following is a list of Kraus's solo repertoire from the 1920s:

| | |
|---|---|
| Mozart | Sonata in B-flat major, K. 281 |
| | Sonata in G major, K. 283 |
| | Sonata in A major, K. 331 |
| | Sonata in B-flat major, K. 333 |

| | |
|---|---|
| Beethoven | Sonata in F minor, op. 2, no. 1 |
| | Sonata in F major, op. 10, no. 2 |
| | Sonata in C minor, op. 13 (*Pathétique*) |
| | Sonata in A-flat major, op. 26 |
| | Sonata in E-flat major, op. 31, no. 3 |
| | Sonata in G minor, op. 49, no. 1 |
| | Sonata in C major, op. 53 (*Waldstein*) |
| | Sonata in F-sharp major, op. 78 |
| | Sonata in E major, op. 109 |
| | *Eroica* Variations, op. 35 |
| | Rondos in C major and G major, op. 51, nos. 1 and 2 |

| | |
|---|---|
| Haydn | Variations in F minor |

| | |
|---|---|
| Schumann | Sonata in G minor, op. 22 |
| | *Symphonic Etudes*, op. 13 |
| | *Scenes from Childhood*, op. 15 |
| | *Fantastücke*, op. 12 |
| | *Papillons*, op. 2 |

| | |
|---|---|
| Brahms | Rhapsody in E-flat major, op. 119, no. 4 |
| | Capriccio in B minor, op. 76, no. 2 |
| | Intermezzo in B-flat minor, op. 117, no. 2 |
| | *Schumann* Variations, op. 9 |
| | |
| Chopin | Etudes (selections) |
| | Ballades in G minor, op. 23, and A-flat major, op. 47 |
| | Fantasy in F minor, op. 49 |
| | Scherzos in B-flat minor, op. 31, and B minor, op. 20 |
| | Impromptus in F-sharp major, op. 36, A-flat major, op. 29, and in C-sharp minor, op. 66, etc. |
| | |
| Liszt | Etudes (selections) |
| | *Tarantella* |
| | Chopin-Liszt arrangements |
| | |
| Bartók | *15 Hungarian Peasant Songs* |
| | |
| Franck | *Prelude, Chorale, and Fugue* |
| Bach | *Capriccio on the Departure of a Beloved Brother* |
| | Preludes and fugues (selections) |
| | |
| Scarlatti | Sonatas (selections) |
| | |
| Géza Frid | *Piano-Toccata* |
| | |
| Also | unidentified works by Kodály, Albéniz, Debussy, and Mussorgsky [1] |

2. Following are remarks Kraus made during a London recital in 1972:

>Perhaps in no other medium is the Hungarian genius as strongly manifest as in their folklore. I had the inestimable good fortune and privilege having been taught by Bartók, and I remember as if today, when I played these pieces for him, how he never ceased to marvel at the beauty of the texts and the unity they formed with the tunes. For your better enjoyment, I will try to translate some of these songs. I can't translate them all. For one thing, some of them are dances and don't have texts. Also, it would be too long; and also some of them are terribly naughty. For instance, some say, "texts unprintable."
>
>The first four are lamenting songs—bitter songs—and read: "I tie my horse to the weeping willow and bend down my head to its forelegs. I bend down my head into the apron of my sweetheart, thus mourning our parting." The second says (a girl speaking): "The flowers that my lover gave me are not yet withered, and he has forsaken me already." The third says, "The corn is ripe; it wants to be cut. My heart is so full of woe, it wants to burst." And the fourth . . . says, "The blue forget-me-not blossoms along the river. My mother has chased me out of the house, I know not why. And now I am more orphaned than all the orphans in the world."
>
>Then comes a piece which Bartók calls a "Scherzo," and it is sung by a man, evidently unhappily married. If you listen well, you will hear in the bass how he grunts and grinds and gnashes his teeth. And he says, "My wife is so clean she washes once or twice every month. For as long as I live I will regret that I have married." He goes on: "She's also a wonderful cook: bakes bread beautifully. Heats up the oven five or six times, out comes the bread, not baked." And again the refrain, "I will forever regret that I have married."
>
>Then comes a beautiful theme with variations. Now this text is a "border" case, but I can translate it if I am careful. A mother speaking to the daughter saying, "My daughter, my daughter, . . . what kind of a funny dress are you wearing. Getting shorter and shorter by day in front and longer and longer in the back." And she answers, "That seamstress cut it wrongly and put it on me wrongly. And the silly girl put the back to front, that's why." And so on and so forth.
>
>And I would like you to recognize a particularly beautiful one, easy to recognize, big chords, and the theme plays only *unisono*.[1] A girl

sings this, and saying, "you are not a real lad . . . . You don't dare to kiss me in the presence of my parents. Do you think I am afraid to reciprocate your kiss? Well will I kiss you no matter who is present when the rosy-fingered dawn is approaching."

And finally, the last piece is not a song but a dance, accompanied by an instrument which we call "duda," which is exactly like your bagpipe—that is to say it is anchored on a bass. And this piece then brings the whole set to a triumphant end. Thank you.[2]

3. Following are compilations of Kraus's views on playing Mozart:

Actually, the performance of Mozart is somewhat special because there is a golden rule which must be followed when it comes to playing his piano music. We must remember that his writing was framed by the narrow dynamic range of the instrument he played. I own a piano of his day, and know first-hand that neither real *forte* nor a real *pianissimo* are possible on it. If you play too loudly, you will break a hammer. If you play too softly, the note simply does not speak. So, a real culminating *forte* or a whispered *piano* can be had only in a relative sense. This knowledge is what must guide us in performing Mozart's music. But I have always thought that his manner of speech tended toward a wonderful restraint anyway. I have found that even his most passionate outbursts, his darker sides, are tempered by grace.

As to tempos, there are in Mozart's music, as there are in the music of any composer, very precise indications in its character, in the notes of the music itself. For example, "*con brio*" in Haydn or Beethoven means something quite different than it does in Mozart. With Haydn, it brings an earthy lustiness, about of the beer hall. In Beethoven, it is a titanic outburst. But with Mozart there is a driven quality, something almost breathless.

There is a superstition that the less pedal used in Mozart the better. This is nonsense; it fits in with the distorted picture of Mozart as a pretty, Rococo composer in silk breeches and powdered wig. I prefer Mozart in riding pants and boots![3]

To say that Mozart should be played delicately is to say that life should only have pink pastel and blue pastel colors—no ups and downs; that it should be white, serene, not too happy, please, but just nice, comfortable, pleasant, charming. As we all know, there are no depths of

unhappiness, tragedy, frustration, anger that haven't touched Mozart to the core—likewise no bliss that he has not experienced. Any musician worth his salt speaks his life—the greater the master, the more economical the means; he doesn't have to put his heart on his sleeve. The past master of such understatement was Mozart, always with the understanding that what he had to say was glowing inside and shines through the seemingly restricted and almost childishly simple—close to the line between childish and childlike. Anybody who is not conversant through personal experience with the dynamic range will not be able to discern the difference between the pretense of loud playing and the bodily *forte*. Now, when I play Mozart I don't ever really play loud—I would not play a single *forte* in Mozart as I play one in Beethoven—but by comparison the *piano*, which is never a Chopinesque *pianissimo*, already affects the listener as if it were loud. Through vitality, tension, imagination, I create the illusion that it is very loud, whereas it is never a *forte* per se.

Only people who are conventionally and superficially acquainted with Mozart can ever come to the idea that he should be played delicately or lifelessly—prettily. Never, never, never! Always he has to have that wonderful incision that he is capable of creating whether he is *dolcissimo* or in despair. Certainly it has to be subtle and to contain, like life itself, all the surprises from tragedy to comedy, and it does; but if you always play that through a veil it can never possibly show its true vigor and impressiveness. Contrasts only seem extreme to someone who expects blandness.[4]

In the beginning it seemed as if my own temperament—tending towards passionate outbursts, effusive utterances and unbridled rhythmical impulses—was ill-fitted for Mozart's way of speech. Also, it appeared that I would have to forego the pagan joy of bodily release in the virtuoso pieces which had dominated my repertoire in early years. It was only a burning love for Mozart that finally enabled me to qualify as his interpreter, spurring me on through long years of "agony and ecstasy" during which I was obliged to submit to a self-imposed, uncompromising discipline until the channels of communication could be freed and cleansed.[5]

Now, I am quite sure that there are any number of my colleagues who play Chopin, Schumann, Brahms, Rachmaninoff, and Shostakovich and the rest infinitely better than I do. I do not think that that is the case in Mozart. So I find it my God-given duty, privilege, and if you like, cross, to consecrate my life to this music.[6]

Mozart has given this gift of sweetness, which is so extraordinary because it is born out of tragedy. I feel an affinity to Mozart because he, like myself, had an almost unbearable sensitivity for all suffering around him, if I dare to speak of myself in the same breath with his name. Now, to be able to bear the pain, the dear Lord gave us as an antidote a capacity for tremendous serenity, humor and gaiety which leads to happiness; otherwise one couldn't bear the suffering. There's an old saying that the sea is as deep as the mountain is high on its shore. Thus, if you know these extremes of happiness and unhappiness, you are able to face whatever comes your way. Mozart's music is so irresistibly lovable because he didn't, like Beethoven, fight for perfection of expression; his perfection was in implying the totality of life, the good and the bad of it.

In his diary, Leonardo da Vinci said that the true experience of the artist at times is so terrifying that, if the artistic vision were presented in full truth to the layman, he would be so shocked that he would flee in terror. Therefore, according to Leonardo, it is the duty and sacred privilege of the creative artist to cloak his experience in the garb of love and perfection. Now this is precisely what Mozart has done, and his music has become so much a part of me that I agonize when the music turns to the minor, and I'm redeemed when it reverts to the major.[7]

The following comments were made during a radio interview in 1983:

**Interviewer:** Schnabel said that Mozart is too easy for children and too difficult for great artists. Do you agree?

Yes. The [difficulty] in playing Mozart is between "doing" and "being." You cannot bring Mozart to life unless you are what is in his music which is living that life of that piece.

**Interviewer:** Should Eighteenth Century music be performed on instruments of that period?

I am not entirely against that. But it is silly, though. Although I am not against it, it is silly all the same. (A) The biggest hall they played in was tiny. If you coughed, it stifled the sound. The smaller instrument was appropriate. (B) Alas, our musical palates have been coarsened

through so much noise, so much exhibitionism, etc. Nobody would notice what one does on a harpsichord. (C) If you take Wanda Landowska—she was a harpsichord player par excellence—she couldn't play on the piano. The crossover is difficult. There is such a beautiful sentence in one of Goethe's writings: "You notice the purpose and become displeased."

I am not on principle against Mozart being played on an original instrument—I possess such an instrument, incidentally—but it depends on who does it and why they do it. Now, Glenn Gould, who, alas, we lost, was one of the few geniuses who indeed while working on the piano conjured up a sound that for the first time you felt, "Bach is alive! That is Bach." That is the greatest thrill, the greatest convincing power you can imagine. On the other hand—may he rest in peace— when [Gould] plays the Beethoven Second Piano Concerto, it is like an old spinster with no guts and no heart. In Bach, he was able to make the piano sound something like a harpsichord, but he never pretended it was a harpsichord.

**Interviewer:** Is there a work of music by Mozart or another composer that you are still trying to understand more deeply?

Every work—every work. According to my age and stage of evolution, I was in turns called "The Beethoven Player," "The Chopin Player," "The Liszt Player." Schnabel told me that he never heard anyone play Haydn as I played it. He said, "Not even myself."

It is so funny that an affinity like one has should be so terribly one-sided. It is not possible. If you are that much in love with music, the better the music the more you are in love, and that's a blissful circle for ever after.[8]

4. Following is a review of Kraus's recital at the Auckland Town Hall on June 20, 1946:

On June 20 Lili Kraus played at the Auckland Town Hall in a concert directed by the National Broadcasting Service. In the week before she had broadcast three times from IYA, and had played a lunch-hour concert, and at the Auckland University College and the Teachers' Training College. This was her first public performance in New Zealand.

I had heard all of these other recitals. They were generous programmes, played the only way she seems to know how to play—that is, generously, withholding nothing. If the halls and the pianos were by no means what her audience thought she should have had, she seemed unaware of it herself. The evening before the Town Hall concert she played at the Training College: Mozart's Sonata in A minor, Schumann's *Carnaval*, and a posthumous sonata of Schubert. There is still discussion in Auckland as to whether anything she played at the Town Hall outshone her Schubert sonata in the University Hall, or the Beethoven op. 109 at the Tower Studio. In all these places I had seen her dwarfing other people who had played there. At the Town Hall, I knew I could see her in perspective against other pianists who had played there in the last twenty years.

Lili Kraus opened her Town Hall concert by playing *God Save the King* as if it were a prayer and not a call to arms. Before she could continue, she had to leave the platform to borrow a large handkerchief to clean the piano because the keys were damp. The applause for this, which may have bewildered people listening in, was for the way she did it. This was not the fidgeting and flicking of how to clean a piano.

When she began to play Bach's *Chromatic Fantasy and Fugue* in D minor, I think the first impression—something that comes fresh and startling every time she begins a concert—was of vitality of tone. This brings a sudden awareness of the strings of the piano, of the structure of the instrument and its purpose. The dynamic range of the *Fantasy* showed at once that this quality is in every note she plays, in the swift and gentle ones as much as the solitary, powerful ones. The *Fantasy* was rich and warm and coherent, perfectly played. The *Fugue* was constructed on a subject with a marked diminuendo towards the end, so that in the inner parts it melted into the whole rather before the end of the phrase. The whole *Fugue* was faster and less rhetorical than I have thought of it before. There are probably at least twenty grand ways of playing this *Fugue*—Bach is the most arguable of composers—and this was certainly one of them. I didn't feel, as I do when Lili Kraus plays Mozart or Schubert, that there is no other possible way but the one she is revealing. What I did feel was that there was no other possible way of playing the piano but the way she played it. She doesn't play on her instrument, she plays with it; there isn't a bar where the music is diverted from its own shape into pianism. It is the same with her technique—it is used for the music, and if one watches to see how she

will manage a passage of known technical difficulty, all that one learns is that one was quite mistaken in thinking it a difficult passage. Long before the Bach was finished, I had forgotten my irritation at the fitful and ill-adjusted spotlight which was being thrown down on the pianist, and my fears of the large, malignant cellophane flowers that were glowering from pots on either side of the stage.

Lili Kraus then played a Mozart Piano Sonata, K. 333, in B-flat. She took the first and third movements with that almost reckless brilliance that I feel Mozart is often asking for, though it is no use offering it to him without this sureness and clarity as well as speed; the second movement, too, was perfect, and I still cannot understand how the tone she gave to this could be so gently lyrical in effect and yet so rich in a large hall. Mozart's piano sonatas have not, I think, been played in the Town Hall before, though they are widely known and devotedly studied in humbler places; and in the applause for K. 333 there was a welcome for Mozart as well as for this interpretation.

The Brahms that followed reaffirmed what the Mozart had revealed—the clarity of their transitions from movement to movement, from phrase to phrase, from *forte* to *piano*. There are no aimless or perfunctory bars and she is never caught resting in that no-man's-land of *mezzo-forte*. If she is there she is on her way somewhere else, the path clear in her mind. In the same way she can make a lightning transition from one composer to another without bringing anything of one to the next, or trailing even a wisp of that purely personal quality by which some pianists make one almost more conscious of who plays the music than who has written it. Hard on the heels of the Mozart came a Brahms Rhapsody, an emotional and technical *volte face*, which was grandly dramatic. When the Town Hall clock failed to check the Brahms, two fire engines were called out, but even then the pianist seemed to stop more for her audience's sake than for her own. She replayed the Intermezzo and then dealt with the defiant Rhapsody in E-flat major in such a way as to send these disturbances from our minds, utterly routed.

When the interval came I began to regret that I had undertaken to write about Lili Kraus' playing. I had seen in the past few days what happened to people when they tried to find words for it—the seasoned concert-goers of Auckland had been going round saying that they were walking on air, that they had drunk the milk of Paradise, and so on; and indeed that is what they looked like. They had started out to write to friends on the south to tell them why they must on no account miss

*203*

hearing Lili Kraus, and found that in the end they had a page of truly wonderful adjectives in front of them, and a literary effort unfit even for a school magazine. It is easy enough to say what is wrong with a person's playing, but when it is right—in the complete sense that hers is—there are no words.

Some explanation had to be found to satisfy the people who hadn't heard Lili Kraus and were wondering what was wrong with us all—and some explanation to those of us who had been hearing her play and wondering why everything seemed suddenly to have come right. It might be this way—people who work with music daily, either listening or playing, find a great deal of pleasure in it, but they are looking beyond this all the time and working towards those moments where there is joy of quite a different quality, a conviction that the composer's music has been recreated as he heard it and wrote it down. This conviction is unqualified when it comes, but in ordinary musical life it comes only in short, rare moments—just enough to keep people working hard hoping for more. What Lili Kraus does is simply to deliver such moments nearly all the time she is playing far more continuously than any other musician I have heard. When she plays Mozart, Beethoven and Schubert—the three to whom her understanding has perhaps brought her closest—they seem to reach us through the clearest channel a human being could make for them. These Auckland audiences have been put into this state of exhilaration and amazement by the full force of the music itself.

Great musicians do not often come to New Zealand while they are in their best years. When they do, when we know that we are having an evening that might make us the envy of any city in the world, it is strangely exciting. Nobody who had heard all that Lili Kraus played in Auckland in one week could imagine that her vitality, her technique, her repertoire—those things that her internment might have taken from her—are less than they were before. As a human being, as a musician, she cannot have stood still during this time. The excitement of the Town Hall was unique—perhaps we heard a new Lili Kraus, one that the other side of the world does not know yet.

After the interval the audience returned with a look of hope that I have never seen before at a piano recital. Usually by this time there is a feeling that the main dishes have been carried out and that there is nothing to look forward to but a few saucers of nuts and raisins. This evening there was still a lordly dish to come—the *Waldstein* Sonata.

Chopin had been remembered in the way he himself is said to have asked to be—by the playing of Mozart's music instead of his own.

As the lights went out after the interval, I began to think about the *Waldstein* Sonata. I had often wondered what might be heard in the last movement, the *Rondo*, if it were played by a pianist whose technique was equal to it but not an end in itself, by a musician who had noted Beethoven's suggestion *Allegretto Moderato* and had thought about the full possibilities of the relationship of those first few bars to the final *Prestissimo*. Now I thought I might know. As Lili Kraus slowly explored the depths of the *Molto Adagio*, she seemed to be in the very closest touch with Beethoven's intentions. As she moved up to the *Rondo* there was a pause—and then it was like seeing a seaplane taking off from the water almost out of earshot, watching it and now hearing it, too, coming closer, gathering speed without haste, the sound coming in louder gusts until with a sudden roar it was right overhead. When I came to myself, I marshalled up other performances I had heard of the *Waldstein*. Beside this they were like the noise of a motor-cycle when a young man starts it up and rides it round and round the block. Wrapping them all up in this simile, I threw them overboard for ever.[9]

5. Following is the transcription of Kraus's comments made at a 1954 master class in Long Beach, California, and recorded by Educo Records:

**Mozart: Sonata in G major, K. 283 (*Allegro*)**

We are always excited when we play, and I think that if we are at all to succeed in overcoming this excitement, it is only possible when you put yourself inside the music. For that it is necessary that you speak it as a language. Thinking alone doesn't do it. The Holy Trinity is the thinking (which is the knowing), the feeling, and the prophecy, namely to know what is to come and to feel what has been. When you start with this Sonata, the whole picture of it must be in your head.

It is unthinkable to perform just one movement of a sonata. How can you break it off when the first movement finishes with a G major chord and goes on to heavenly modulation to C major? If you only play one movement, what I recommend is to at least play the first few bars of the subsequent movement and then stop. Then everyone knows what is supposed to come next.

Technically, the most important consideration is to keep the fingers so fixed and firm at the knuckle joint that all the rest is free to move. But if the knuckles are soft, you have to resort to other sources for power; you try to get that power from elbow, shoulder, back—wherever you possibly can. The fingers must also have all the support you can get from the entirety of your body. For instance, for the last month, I've studied yoga with a teacher (I had done them many years prior to that without a teacher). Yehudi Menuhin and I brought his yoga instructor (Menuhin has worked with him for six years) to London, and we worked with him on the spot. I learned, among other things that if I really am firm on my buttocks and hold the shoulder blades well apart away from the spine, my fingers operate as independently as if they would have no resistance whatsoever. Please remember that the root and only strong point of the finger is the knuckle; therefore, the finger should move always from there with a real active movement. Also, the finger must be firm at the two lower joints. At neither point must the finger break. This becomes more difficult if you must play for a stretch of time loud and fast. The way to ease this is to understand that the optimum point of depressing the key is not at the very bottom but a little before. Therefore, please don't descend with all your might into the key when you want to play loudest. Also, for loud playing, you must reach that point very fast with a firm finger. As to the wrist, it must always be in a position to be flexible. This is indeed easy if the finger is firm. For octaves, the wrist wants to be firm—not rigid.

It is very important to discipline the hand so that all fingers are ready to play without tension. The greatest difficulty in this is the thumb and the fifth. They will tense. When, though, you play chords, or octaves, or arpeggios, these outer two fingers should be held firm, but without tension.

When you have to play quick and long-lasting passages, try to hold the shoulder down and away from your spine. It is quite incredible what release that brings.

### Bach: Prelude and Fugue in C-sharp major, Bk. I

How much you interpret Bach's music by *agogic* (that means playing more with the time than with the colors), or rhythmic or phrasing means, that is up to the individual player. For instance, Rosalyn Tureck, who is regarded as one of the most outstanding

Bach interpreters, treats Bach exactly with the full means of expression as the modern piano will allow. This produces a lovely and quite satisfactory result. But for me, it is not that Bach that I imagined it should be.

When you teach Bach, bear in mind two important points. First, Bach is live music like everything else. It should be heartfelt and not regarded as a mathematic equation. Second, Bach's fingers must not be sacrificed to the theme. The interest of a fugue is by no means the recurring theme but what happens round and with the theme in the course of its development.

### Kabalevsky: Sonata op. 46 (*Allegro con molto*)

Contemporary music is no different from any other music except that it is made now. I call it contemporary and not modern because I don't think there is anything under the earth which, for instance, wouldn't occur in the organ fugues by the way of discord, originality, daring, and fantastic harmony by Bach.

A mechanically steady rhythm is very characteristic of modern music. The playing must be steady like a machine, but one that is flexibly alive.

### Mendelssohn: *Rondo Capriccioso*, op. 14

He [the student] has a lovely voice, and the voice is always conditioned by the soul of the player. As your personal voice is, so is your voice in your music.

The best proof of the musicality of this chap was the sensitiveness of the bass he provided for the music to lift, breathe, and move on.

Schnabel told me that once when he was playing in the U.S., a woman came up to him and asked, "To which school of thought do you belong?" Schnabel said, "What do you mean?" "I mean," she said, "do you play on time or do you just play as you feel?" Upon which Schnabel answered, "But madame, is it entirely impossible to feel on time?"

Unless you have a special purpose, do not inject a pause within or before a phrase.

### Debussy: *Dr. Gradus ad Parnassum* from *Children's Corner*

This thing about "style" is such an extraordinary business. I am very much against tagging and restricting and labelling, but there is some truth in the matter. French music moves on quite different levels and in different ways than German music, especially Debussy. This fluid elegance, this lucid precision is very much the reflection of the Latin spirit which is more brilliant than profound, more witty than spiritual, more playful than passionate, and certainly more rarely and less frequently holy than the classical Austrian-German old music.

This little piece has to be frivolous in as much as it is mocking the student, mocking feeling, mocking everything. Generally I am dead against speed as such, but this has to have a certain speed, because otherwise it doesn't come off. It must be glib and not profound in any way.

### Brahms: Rhapsody in B minor, op. 79, no. 1

This is playing after my own heart because it goes to the heart of the music.

If you press, you keep the felt too long on the strings, and therefore, you prevent it from freely vibrating and including all the harmonics which it can have.

Brahms had a beard and a big belly, and he was a heavy man, but full of longing, perhaps never quite redeemed. But this very longing makes him so lovable. But the heaviness must also be there. His music is not graceful like Mozart, and it is also not like Beethoven because it doesn't have that sort of pensive strength.

### Summary

Music performed is not merely a means to achieve a glamorous position nor only a livelihood, nor self-expression. It's all that. We should emphasize to our students again and again that this divine thing which we call music exists as all the other benedictions of God (whether it is the wing of the butterfly or the snow on the mountains or the wind in the tree) and has to be received with that humble joy. When you then want to transform and convey them through that vehicle which is called music, you must always bear in mind that it is not you who is important in the process, but the thing. When you work on it, it is much more important that you watch what it does with you than what you do with

it. Therefore, if you want to really ever arrive at that benediction, you must question again and again how much of what you are doing is really consecrated to the sense of that music which you are studying or performing or showing and how much in your wish to cut a good figure. Now this wish is of course there and should be there; it cannot ever by eliminated to its fullness. But it should be put on the second level, and the focus of interest should be conducted toward the music on hand, towards its meaning, and its ineffable joy. So when we sweat blood and cry tears, do let's remember that these are temporary phases and it doesn't matter: we are always infinitely far away from perfection. The other day I read that beautiful phrase, "Only fools expect perfection from other fools." So please remember that it does not matter if you fail as long as you really strive to understand and to convey. Then nothing bad can ever befall you.[10]

6. Following is a list of Kraus's repertoire from the late 1950s:

SOLO REPERTOIRE

| Bach | Preludes and Fugues |
| | *Chromatic Fantasy and Fugue* |
| | *Capriccio on the Departure of a Beloved Brother* |

| Haydn | Variations in F minor |
| | Fantasy in C major |
| | Sonatas: |

E-flat major *(à Mme Kurzbock)*

E minor *(à Mlle Genzinger)*

D major *(à Mlle Auenbrugger)*

| Mozart | Fantasy in D minor, K. 397 |
| | Adagio in B minor, K. 540 |
| | Fantasy and Sonata in C minor, K. 475/457 |
| | All sonatas |
| | Variations: |

*La Belle Françoise*, K. 353

*Unser dummer Pöbel mein,* K. 455
*Come un agnello,* K. 460
*Salve tu, Domine,* K. 398

| Beethoven | Sonatas: | opus 2, no. 3 |
| | | opus 13 |
| | | opus 31, nos. 1, 2, 3 |
| | | opus 53 |
| | | opus 78 |
| | | opus 90 |
| | | opus 109 |
| | *Eroica* Variations, op. 35 | |

| Schubert | Impromptus: | op. 90, nos. 1, 2, 3, 4 |
| | | op. 142, nos. 3, 4 |
| | *Moments Musicaux,* op. 94 | |
| | Sonatas: | op. 42 |
| | | op. 143 |
| | | A major, op. posth. |
| | *Wanderer* Fantasy, op. 15 | |

| Schumann | *Papillons,* op. 2 |
| | *Carnaval,* op. 9 |
| | *Etudes Symphoniques,* op. 13 |

| Brahms | *Schumann* Variations, op. 9 |
| | Intermezzos |
| | Rhapsodies |

Chopin

Waltzes

Etudes

Preludes

Ballades:    G minor, op. 23

A-flat major, op. 47

Scherzo in B-flat minor, op. 20

Fantasy in F minor, op. 49

Bartók

*15 Hungarian Peasant Songs*

3 Rondos

2 *Romanian Dances*

Stravinsky

Sonata (1924)

## Concerto Repertoire

Mozart

E-flat major (*Jeunehomme*), K. 271

A major, K. 414

B-flat major, K. 456

A major, K. 488

C minor, K. 491

D minor, K. 466

B-flat major, K. 450

D major (*Coronation*), K. 537

F major, K. 459

C major (*Lützow*), K. 246

Beethoven

C major, op. 15

*211*

B-flat major, op. 19

C minor, op. 37

G major, op. 58

E-flat major, op. 73

Schumann          A minor, op. 54

Liszt             E-flat major

Weber             *Konzertstück* in F minor, op. 79 [11]

7. Following is the transcription of Kraus's comments made on *Camera Three*, CBS's television broadcast of March 17, 1968:

> There is a great difference in the interpretation and the mode of playing between the modern piano and that of Mozart which I am fortunate enough to possess. [Work on the Mozart piano] taught me more truth about Mozart than anything else.
>
> The circumstances of playing [the Mozart piano versus the modern piano] are quite different. The keyboard there [on the Mozart piano] differs in all ways. Here the surface of touching is tiny—a little square. Not only are the keys narrower—one has to have very slender fingers which luckily I do have. Also, contrary to the modern Steinway or any other piano, when you touch these [keys] they already sound. On a normal piano we are constantly in touch with those keys which we do not play. Here we may not do that because it is only too easy that they give a sound. Of course, wrong notes then ensue.
>
> [The Mozart piano] restricted the dynamic phrase, but also it was more colorful. The fact that it is so immensely difficult to play Mozart—quite apart from its spiritual, emotional, and intellectual content—is chiefly the reason that the dynamic phrase is infinitely smaller. When your heart is fuller you have to express what you feel, yet you have to restrict it so that the contrasts don't become too bland or too stark.
>
> There is no aspect of human feeling, of human spirit, that is not contained in Mozart's music. It has to be now tempestuous, now

tormented, now turbulent, now tender, now *amoroso* even as he calls one or two of his sonata movements. But at all times it has to be tempered by his chastity, modesty, and grace.

[Mozart's music] is easy to read because there are times when one finger alone plays. But this is the very touchstone of a great artist—what he can do with such a melody. For instance, there is a movement called *Romanza* in the D minor Concerto, K. 466 [Kraus then performed a few measures of the movement with its simple melodic line and quiet accompaniment]. In the middle section of this movement, there comes a melody which is actually played by one finger and the orchestra accompanies. Unless this is played with all the simplicity, tenderness, but heartfelt intimacy, and contains all that it implies, it remains empty. This is an immense task. It takes all the dedication, God-given ability, and great knowledge to be able to play it.

[On Mozart's piano] I cannot pedalize like on a normal piano with my feet. I have to do that with my knees because there is a knee pedal. Instead of pressing down my foot, I have to lift my knee. It is a very unuseful feature. I've already spent eight hours learning it.

[Next, Kraus performed the first movement of Mozart's Concerto in A, K. 414, with the CBS Chamber Orchestra.]

I consider my experiences [in World War II] one of the greatest benedictions the Lord ever awarded me because I understood—and it is quite extraordinary right while it lasted—what a terrific privilege it was to learn what I have learned there which I couldn't have learned any other place ever in my life. That is to say to learn that all that matters is within you. We were all in the same boat, and how differently people reacted.

It is one thing to hear about hunger and forced labor and beating and cruelty. It is another thing to live through it. Especially difficult it was to keep the children—our children—free from hatred, resentment both toward the Japanese and toward the Dutch prisoners, some of whom had a lot of food reserves yet wouldn't share it with the children.

My life can never—not for one second—exist without music, just as little as it can exist without God. Although I had no instrument, the music, along with the longing for my family, was present in my heart and mind all the time. And in fact, after one year, when everything came

*213*

back to me—family, and the piano, of course not food—everything became riper, sweeter, profounder than it ever has been. You see, since I could not materialize the music on an instrument, it all had to take place within. Therefore, the imagination had to become much clearer and much more concentrated. It happened that compositions came back to me of which I haven't thought even let alone which I have played for years and years. This was my salvation.[12]

8. Following is Kraus's itinerary during the 1972-73 season:

| Date | Place | Engagement |
| --- | --- | --- |
| Nov. 5 | New York, N.Y. | Recital at Hunter College |
| Nov. 8 | Dallas, Tex. | Recital |
| Nov. 10 | Laguna Beach, Calif. | Recital |
| Nov. 12 | Whittier, Calif. | Recital |
| Nov. 13–17 | Fort Worth, Tex. | Soloist with TCU Orchestra |
| Nov. 19 | Montreal, Quebec | Rehearsal |
| Nov. 20 | Montreal, Quebec | Soloist with McGill Chamber Orchestra |
| Nov. 28–29 | Holland, Mich. | Recital |
| Dec. 1–Jan. 10 | Europe | Recital in Queen Elizabeth Hall, BBC telecast, etc. |
| Jan. 13 | Waynesboro, Va. | Recital |
| Jan. 15 | Gastonia, N.C. | Recital |
| Jan. 17 | Fayetteville, Ark. | Recital |
| Jan. 19 | Clarksdale, Miss. | Recital |
| Jan. 21 | Jackson, Miss. | Rehearsal |
| Jan. 22–23 | Jackson, Miss. | Soloist with Jackson Symphony |
| Jan. 25 | Oxford, Miss. | Recital |
| Jan. 27 | Clearwater, Fla. | Recital |

| | | |
|---|---|---|
| Jan. 29 | Modesto, Calif. | Recital |
| Feb. 2 | Roseburg, Ore. | Recital |
| Feb. 4 | Wenatchee, Wash. | Recital |
| Feb. 6 | Minot, N. Dak. | Recital |
| Feb. 8 | Mt. Clemens, Mich. | Recital |
| Feb. 10 | Ft. Lauderdale, Fla. | Rehearsal |
| Feb. 12–13 | Ft. Lauderdale, Fla. | Soloist with Ft. Lauderdale Symphony |
| Feb. 14 | Daytona, Fla. | Rehearsal |
| Feb. 15 | Daytona, Fla. | Soloist with Florida Symphony |
| Feb. 16 | Orlando, Fla. | Soloist with Florida Symphony |
| Feb. 23 | Brookville, N.Y. | Rehearsal |
| Feb. 24 | Brookville, N.Y. | Soloist with Mozarteum Orchestra of Salzburg |
| Feb. 25 | Boston, Mass. | Soloist with Mozarteum Orchestra of Salzburg |
| Feb. 26 | Princeton, N.J. | Soloist with Mozarteum Orchestra of Salzburg |
| Mar. 5 | Minneapolis, Minn. | Rehearsal |
| Mar. 6 | Minneapolis, Minn. | Soloist with Mozarteum Orchestra of Salzburg |
| Mar. 8 | Marquette, Mich. | Recital |
| Mar. 14 | Joplin, Mo. | Recital |
| Mar. 17 | Evansville, Ind. | Rehearsal |
| Mar. 18-19 | Evansville, Ind. | Soloist with Evansville Philharmonic |
| Mar. 28–May 23 | Australia | Tour |
| May 26–June 9 | New Zealand | Tour |
| June 16–24 | Paris | Judge in Marguerite Long Competition[13] |

9. For Kraus's views on other pianists, see the following:

> It is so beautiful that one admires pianists for different reasons. Of course, my immortal deity is Schnabel, and will forever remain so. On the same level, there is Bartók, for so different reasons. My most recent amour is Murray Perahia whom I never heard in the flesh, but what I heard on the radio was unforgettable, incomparable. When Pollini plays Chopin Studies I think that nothing as shiny and perfect has existed; when he plays the *Wanderer* Fantasy, I find him boring and lifeless. Ashkenazy I admire no end, but he does not play in the way I wish to hear the respective composition. I bow to his fabulous talent. He has everything but genius. I love Firkusny beyond words and Fleisher, when he still played. Of the Van Cliburn contestants, Radu Lupu was one of my favorites, but somehow he has trapped himself into a mannered way, but he is a wonderful talent. I adore Alicia de Larrocha on my knees when she plays Spanish music, but when she plays Mozart, though she plays it beautifully, it's not really Mozart. Gilels, whose playing I haven't heard much of, played the *Emperor* Concerto; it was so totally different—in every fiber of me lives the memory of Schnabel's *Emperor*—but it didn't matter because of the integrity and the fabulous pianism. Clifford Curzon I love. I adore Glenn Gould's Bach, but not his Mozart. His Bach is infinitely preferable to Rosalyn Tureck's.[14]

Kraus really admired Artur Rubinstein, saying that "he could play everything." She was very proud that he had inscribed a copy of his autobiography for her. On the other hand, she did not like the playing of Sviatoslov Richter, Rudolf Serkin, Wanda Landowska (this opinion applies only to Landowska at the piano, not the harpsichord), Myra Hess, or the renowned accompanist, Gerald Moore. She thought his playing lacked color. Regarding Annie Fischer, another great champion of Mozart, she once remarked upon hearing her perform the Schumann Concerto that the playing was uninteresting: *Weil sie nicht von der Liebe durchglüht ist.* (Because it is not permeated with love).[15] As for Horowitz, Kraus was in the audience when he made his debut in Vienna in the 1920s. In 1932 she heard him again in Berlin. Her stepson, who was with her, remembered Kraus's reaction:

> She shook with horror at the way he interpreted what he was playing. I asked her afterwards about it, and she said, "One can't

shamelessly bare one's soul when what then is bared is not worth looking at.[16]

However, in 1986, when Horowitz presented his return recital in Russia on television after many years of absence from that country, Kraus found that she was quite overwhelmed by his playing. *

# DISCOGRAPHY

Bach, Johann Sebastian. *Notenbuch Für Anna Magdalena* Bach (BWV.Anh. nos. in brackets): Marches in D [122] and in E-flat [127]; Minuets in G [114] and in G [116]; Musette in D [126]; and Polonaises in g [119] and in g [123]. Little Preludes (BWV. nos. in brackets): C [933]; C [939]; d [940]; c [934]; C [943]; and in c [999; orig. lute]. Two Part Inventions: f [780]; F [779]; a [784]; and in B-flat [785]. Bourrée from the Suite in E [996; orig. lute]. Minuet from the Suite in G [822]. Polonaise from the French Suite, no. 6, in E [817]. Gavotte and Musette from the English Suite, no. 3, in g [808]. Capriccio in B-flat (*Sopra la lontananza del suo fratello dilettissimo*)[992]. W.T.C. Book I: Prelude in C [846]. Educo 3001.

Bach, Johann Sebastian; Haydn, Franz Joseph; Mozart, Wolfgang Amadeus; and Schubert, Franz. *Chromatic Fantasy and Fugue in D* (Bach); Fantasy in C, Hob. XVII/4 (Haydn); Fantasy in d, K. 397 (Mozart); and *Wanderer* Fantasy in C, op. 15 (Schubert). Vanguard VA 25003. Reissued on CD by Vanguard CD VBD 25003.

Bartók, Béla. *Six Romanian Folk Dances. Fifteen Hungarian Peasant Songs. Three Hungarian Folksongs. Three Rondos on Folk Tunes.* Sonatina in D. *For Children,* vol. 1, nos. 1, 2, 3, 5, 6, 9, 12, 17, 18, 19, 20, and 21. *Evening in the Country* from *Ten Easy Pieces.* Vanguard VSD 71249. Reissued on CD by Vanguard Classics OVC 8087.

Bartók, Béla. Sonatina in D. *Fifteen Hungarian Peasant Songs. For Children,* vol. 1, nos. 1–21 (nos. 1, 4, 6, 10, 12, 14, 15, 17, and 18 are played in two versions—as originally composed and taught to Kraus and as revised in 1945). Educo 3008.

Bartók, Béla. *Three Rondos on Folk Tunes. Romanian Folk Dances.* Parlophone R20434-5.

Beethoven, Ludwig van. Concerto no. 3 in c, op. 37, and Fantasy for
Piano, Chorus, and Orchestra in C, op. 80. With the Chorus and
Orchestra of the Amsterdam Philharmonic Society conducted by
Gianfranco Rivoli. Musical Masterpiece Society M 2236. The
Fantasy was also issued by 1st Component Series C-50070 on
cassette.

Beethoven, Ludwig van. Concerto no. 3 in c, op. 37, and Rondo in B-
flat. With the Vienna State Opera Orchestra conducted by Victor
Desarzens. Monitor MCS 2092. Also issued by Audiofidelity
Enterprises FCS 50071 on cassette.

Beethoven, Ludwig van. Concerto no. 3 in c, op. 37. With the Vienna
Symphony Orchestra conducted by Rudolf Moralt.
VOX PL 7270.

Beethoven, Ludwig van. Concerto no. 4 in G, op. 58, and Rondo in
B-flat. With the Vienna State Opera Orchestra conducted by
Victor Desarzens. Musical Masterpiece Society MMS 2192.
Reissued on Vanguard SRV 252 SD.

Beethoven, Ludwig van. *Eroica* Variations in E-flat, op. 35.
Parlophone R20470-2.

Beethoven, Ludwig van. Sonatas in c, op. 13, in C, op. 53, and in g,
op. 49, no. 1. Musical Masterpiece Society MMS 2221. Reissued
on Festival Classique 403.

Beethoven, Ludwig van. Sonata in d, op. 31, no. 2. *Eroica* Variations in E-
flat, op. 35. Selmer 320.C.017.

Beethoven, Ludwig van. Sonatas in g and G, op. 49, nos. 1 and 2,
Sonata in c, op. 13, *Für Elise*, Minuet in G, and Bagatelles op.
119, nos. 1, 2, 3, 4, 9, 10, and 11. Educo 3006.

Beethoven, Ludwig van. Sonatas in C, op. 53, and in E, op. 109.
Selmer 320.C.008.

*219*

Beethoven, Ludwig van; Schubert, Franz; and Mozart, Wolfgang
Amadeus. Sonatas for Violin and Piano: Sonata in G, op. 30, no.
3 (Beethoven); Sonatina in g, D. 408 (Schubert); and Sonata in
F, K. 376 (Mozart). With Norbert Brainin. BBC-22313.

Beethoven, Ludwig van. Violin-Piano Sonatas (Complete). With Willi
Boskovsky. Les Discophiles Français DF 167, 168, 169, and 170.

Beethoven, Ludwig van. Violin-Piano Sonata in A, op. 12, no. 2. With
Szymon Goldberg. Odeon 8385-6.

Beethoven, Ludwig van. Violin-Piano Sonata in F, *Spring*, op. 24. With
Szymon Goldberg. Odeon 123839-41. Reissued on CD by
Music and Arts 665.

Beethoven, Ludwig van. Violin-Piano Sonata in A, op. 30, no. 1. With
Szymon Goldberg. Odeon 177253-5.

Beethoven, Ludwig van. Violin-Piano Sonata in A, *Kreutzer*, op. 47. With
Szymon Goldberg. Odeon 123828-31. Reissued on CD by
Music and Arts 665.

Beethoven, Ludwig van. Violin-Piano Sonata in G, op. 96. With Szymon
Goldberg. Odeon 123825-7. Reissued on CD by Music and
Arts 665.

Brahms, Johannes. *Schumann* Variations, op. 9. Rhapsody in g, op. 79,
no. 2. Intermezzo in E-flat, op. 117, no. 1. Capriccio in b, op.
76, no. 2. Intermezzo in d, op. 116, no. 4. Intermezzo in b-flat,
op. 117, no. 2. Rhapsody in E-flat, op. 119, no. 4. Ducretet
Thomson 300 C 041.

Chopin, Frederic. Prelude in e, op. 28, no. 4, and Impromptu in F-sharp,
op. 36, no. 2. Parlophone R20451.

Chopin, Frederic; and Mozart, Wolfgang Amadeus. Waltz in e (Chopin).
Sonata in A, K. 331, *Alla Turca* movement (Mozart).
Odeon O-11880.

Debussy, Claude; Mozart, Wolfgang Amadeus; and Schubert, Franz. Music for Flute and Piano: *Syrinx* for Flute Solo (Debussy); Sonata in B-flat, K. 454 (Mozart); and Sonatina in g, op. 137 (Schubert). With Jean Pierre Rampal. Educo 3076.

Haydn, Franz Joseph. Variations in f. Parlophone 20347-8.

Haydn, Franz Joseph. Andante grazioso and Finale—Allegro from the String Quartet in F, op. 74, no. 2 (arr.), Arietta in A, Minuet in C, and Sonatas in D, Hob. XVI/19, and in C, Hob. XVI/35. Educo 3005.

Haydn, Franz Joseph; and Mozart, Wolfgang Amadeus. Sonata in D, no. 9 (Haydn); and Sonata in B-flat, K. 281 (Mozart). Educo 3050.

Haydn, Franz Joseph. Sonatas in e, Hob. XVI/34, and in E-flat, Hob. XVI/49. Selmer 270.C.012.

Haydn, Franz Joseph. Sonatas in E-flat, Hob. XVI/52, and in D, Hob. XVI/37. VOX PL 1740. The Sonata in D reissued on CD by Vox Box CD CDX2 5516.

Haydn, Franz Joseph. Sonatas in g, Hob. XVI/44, in A-flat, Hob. XVI/46, and in E-flat, Hob. XVI/52. Les Discophiles Français DF-194. Reissued on EMI C 051-73088.

Haydn, Franz Joseph; Mozart, Wolfgang Amadeus; and Schubert, Franz. Sonata in E-flat, Hob. XVI/49 (Haydn); Sonata in F, K. 322, and *Unser dummer Pöbel meint* Variations, K. 455 (Mozart); and Sonata in a, op. 143 (Schubert). Issued from earlier recordings on Vogue CD 672012.

Haydn, Franz Joseph. Trio for Piano, Violin, and Cello in f-sharp, op. 73, no. 3. With Anthony Pini, cello, and Szymon Goldberg, violin. Parlophone SW 21-2. Reissued on CD by Lys 450.

Haydn, Franz Joseph. Trio for Piano, Violin and Cello in C, op. 75, no. 1. With Anthony Pini, cello, and Szymon Goldberg, violin. Parlophone SW 23-4. Reissued on CD by Lys 450.

Haydn, Franz Joseph. Trio for Piano, Violin, and Cello in E-flat, op. 75, no. 3. With Anthony Pini, cello, and Szymon Goldberg, violin. Parlophone SW 25-6. Reissued on CD by Lys 450.

Haydn, Franz Joseph; Bach, Johann Sebastian; Mozart, Wolfgang Amadeus; and Schubert, Franz. Fantasy in C, Hob. XVII/4 (Haydn); *Chromatic Fantasy and Fugue* in d (Bach); *Fantasy* in d, K. 397 (Mozart); and *Wanderer* Fantasy in C, op. 15 (Schubert). Vanguard VA 25003. Reissued on CD by Vanguard VBD 25003.

Haydn, Franz Joseph; and Mozart, Wolfgang Amadeus. Arietta in A, Allegro in F, Minuet in C, Andante grazioso in B-flat from the String Quartet in F, op. 74, no. 2 (arr.), and Sonata in C, Hob. XVI/35 (Haydn); Minuet in F, K. 2, Allegro in B-flat, K. 3, Sonata in C, K. 545, Allegro from the unfinished Sonata in g, K. 312, Adagio in C, K. 356, and Fantasy in d, K. 397 (Mozart). Educo 3014.

Kraus, Lili. "Lili Kraus Teaches a Master Lesson." Mozart Sonata in G, K. 283 (Allegro); Bach Prelude and Fugue in C-sharp, Bk. I; Kabalevsky Sonata, op. 46 (Allegro con molto); Mendelssohn *Rondo Capriccioso*; Debussy *Dr. Gradus ad Parnassum*; and Brahms Rhapsody in b, op. 79, no. 1. Educo 5010 and 5011.

Mozart, Wolfgang Amadeus. Adagio in C, K. 356, Allegro in B-flat, K. 3, Allegro from the unfinished Sonata in g, K. 312, Andantino in E-flat, K. 236, Minuet in F, K. 2, Fantasy in d, K. 397, and Sonatas in B-flat, K. 281, and in C, K. 545. Educo 3004.

Mozart, Wolfgang Amadeus. Adagio in b, K. 540. Parlophone R20445.

Mozart, Wolfgang Amadeus. Adagio in b, K. 540. Rondo in D, K. 485. Musical Masterpiece Society MMS-947. The Adagio reissued on CD by Vox Box CDX2 5516.

Mozart, Wolfgang Amadeus. Adagio in b, K. 540. Minuet in D,
K. 355, Sonatas in C, K. 309, and a, K. 310. *Eine Kleine* Gigue
in G, K. 574. Les Discophiles Français DF 95. Reissued on EMI
30131.* Reissued on CD by Music & Arts MUA 1001. The
Minuet in D also reissued on CD by Vox Box CDX2 5510.

Mozart, Wolfgang Amadeus. Concertos (complete). Twelve-record set.
With the Vienna Festival Orchestra conducted by Stephen
Simon. EPIC BSC 154, 156, 161, and 162. Reissued on
Columbia P12 11806 (complete set) and Columbia P12 11806-
11818 (single records).

Mozart, Wolfgang Amadeus. Concerto in E-flat *Jeunehomme*, K. 271. With
the London Philharmonic Orchestra conducted by Walter
Susskind. Parlophone R20570-3.

Mozart, Wolfgang Amadeus. Concertos in E-flat *Jeunehomme*, K. 271, and
in d, K. 466. With the Chamber Orchestra of the Wiener
Konzerthaus conducted by Willi Boskowsky. Les Discophiles
Français DF 730.045.

Mozart, Wolfgang Amadeus. Concerto in E-flat *Jeunehomme*, K. 271.
Sonata in A, K. 331. With the Vienna State Opera Orchestra
conducted by Victor Desarzens. Festival Classique FC 423.
Reissued on Monitor MCS 2105. Concerto reissued on CD by
Preludio, PHC 1131. Concerto and Sonata reissued on CD by
Denon COCO-6605.

Mozart, Wolfgang Amadeus. Concertos in A, K. 414, and in B-flat,
K. 456. With the Boston Symphony Orchestra conducted by
Pierre Monteux. RCA Vic.LM 1783.

---

*All Mozart solo piano works recorded by Les Discophiles Français
reissued on five CDs on EMI WWCC-7101/5

Mozart, Wolfgang Amadeus. Concerto in B-flat, K. 456. With the London Philharmonic Orchestra conducted by Walter Goehr. Unfinished Violin-Piano Sonata in C, K. 404, Szymon Goldberg, violin. Parlophone R20404-7.

Mozart, Wolfgang Amadeus. Concerto in F, K. 459. With the Pro Musica Orchestra of Vienna conducted by Mari. Rondo in a, K. 511. VOX PL 6890.

Mozart, Wolfgang Amadeus. Concertos in F, K. 459, and in D, K. 537. With the Amsterdam Philharmonic Society conducted by Gianfranco Rivoli. Monitor MCS 2089. Concerto in D, K. 537, reissued on CD by Preludio, PHC 1131.

Mozart, Wolfgang Amadeus. Concertos in F, K. 459, and in A, K. 488. With the Vienna Symphony Orchestra conducted by Rudolf Moralt. VOX PL 6890. Reissued on CD by Vox Box CDX2 5510.

Mozart, Wolfgang Amadeus. Concerto in d, K. 466. With the Pro Musica Orchestra of Vienna conducted by Enrique Jorda. Minuet in D, K. 355. Rondo in D, K. 485. Polydor A 6350/3. Reissued by VOX PL 6290. Concerto in d reissued on CD by Vox Box CDX2 5510.

Mozart, Wolfgang Amadeus. Concerto in E-flat, K. 482. Rondo in D, K. 382. With the Pro Musica Orchestra of Vienna conducted by Rudolf Moralt. VOX PL 7290. Reissued on CD by Vox Box CDX2 5516. Rondo reissued on CD by Vox Box CDX2 5510.

Mozart, Wolfgang Amadeus. Concerto in d, K. 466. With the Pro Musica Orchestra of Vienna conducted by Enrique Jorda. Concerto in F, K. 459. With the Vienna Symphony Orchestra conducted by Rudolf Moralt. Sonatas in A, K. 331, and in F, K. 332. Reissue of various recordings on Vox Box CDX2 5510.

Mozart, Wolfgang Amadeus. Concerto in c, K. 491. Sonata in C, K. 545. With the Vienna Symphony Orchestra conducted by Rudolf Moralt. VOX PL 6880.

Mozart, Wolfgang Amadeus. Concerto in D *Coronation*, K. 537. Adagio in b, K. 540. With the Vienna Symphony Orchestra conducted by Rudolf Moralt. VOX PL 7 7300. Reissued on CD by Vox Box CDX2 5516.

Mozart, Wolfgang Amadeus. Concerto in D *Coronation*, K. 537. Adagio in b, K. 540. Rondo in D, K. 485. With the Orchestra of the Amsterdam Philharmonic Society conducted by Gianfranco Rivoli. Festival Classique FC 455. Concerto reissued on CD by Preludio PHC 1131.

Mozart, Wolfgang Amadeus. Fantasy in c, K. 396. Sonatas in F, K. 332, and in D, K. 576. Eight Variations *Come Un'Angello* in A, K.460. Les Discophiles Français DF 93. Reissued on EMI 30129.* Fantasy and Variations reissued on CD by Music & Arts MUA 1001.

Mozart, Wolfgang Amadeus; Bach, Johann Sebastian; Haydn, Franz Joseph; and Schubert, Franz. Fantasy in d, K. 397 (Mozart); *Chromatic Fantasy and Fugue* in d (Bach); Fantasy in C, Hob. XVII/4 (Haydn); and *Wanderer* Fantasy in C, op. 15 (Schubert). Vanguard VA 25003. Reissued on CD by Vanguard VBD 25003.

Mozart, Wolfgang Amadeus. Fantasy in c, K. 475. Sonata in c, K. 457. Parlophone R20438-41.

Mozart, Wolfgang Amadeus. Fantasy in c, K. 475. Sonata in c, K. 457. Les Discophiles Français DF 94.*

Mozart, Wolfgang Amadeus. Fantasy in c, K. 475. Sonatas in D, K. 284, and in c, K. 457. Les Discophiles Français DF 94. Reissued on EMI 30130.* Fantasy in c, reissued by Music & Arts MUA 1001.

Mozart, Wolfgang Amadeus; and Schubert, Franz. Fantasies in c, K. 475, and in d, K. 397 (Mozart); *Grazer* Fantasy and Laendler from D. 366 and D. 974 (Schubert). Columbia Odyssey 32 16 0380.

*225*

Mozart, Wolfgang Amadeus; and Haydn, Franz Joseph. Minuet in F, K. 2, Allegro in B-flat, K. 3, Sonata in C, K. 545, Allegro from the unfinished Sonata in g, K. 312, Adagio in C, K. 356, and Fantasy in d, K. 397 (Mozart); Arietta in A, Allegro in F, Minuet in C, Andante grazioso from the String Quartet in F, op. 74, no. 2 (arr.), and Sonata in C, Hob. XVI/35 (Haydn). Educo 3014.

Mozart, Wolfgang Amadeus; Schubert, Franz; and Debussy, Claude. Music for Flute and Piano: Sonata in B-flat, K. 454 (Mozart); Sonatina in g, op. 137 (Schubert); and *Syrinx* for Flute Solo (Debussy). With Jean Pierre Rampal. Educo 3076.

Mozart, Wolfgang Amadeus. Piano-Violin Sonatas in C, K. 296, in G, K. 379, and in E-flat, K. 481. With Szymon Goldberg. Parlophone SW 7-13. Sonatas K. 296 and K. 379 reissued on CD by Pearl 9454 and by Music and Artists MUA 665.

Mozart, Wolfgang Amadeus. Piano-Violin Sonatas in F, K. 377, in B-flat, K. 378, and in E-flat, K. 380. With Szymon Goldberg. Parlophone SW 14-20. Sonatas K. 377 and K. 378 reissued on CD by Pearl 9454, and Sonatas K. 377, K. 378, and K. 380 by Music and Artists MUA 665 and by Lys 402.

Mozart, Wolfgang Amadeus. Piano-Violin Sonatas. With Willi Boskovsky. Vols. 1-2. Les Discophiles Français. Reissued by EMI C 151-73111/4 and C 151-73052/4 and on 6 CDs by EMI Classics CDHF 63873.

Mozart, Wolfgang Amadeus. Quintet for Piano and Winds in B-flat, K. 452. With P. Pierlot, J. Lancelot, P. Hongne, and G. Coursier. Adagio and Rondo for Glass-harmonica [celesta], Flute, Oboe, Viola, and Cello in c, K. 617. With Jean Pierre Rampal, P. Pierlot, E. Pasquier, and P. Pasquier. Trio for Piano, Clarinet, and Viola in E-flat, K. 498. With F. Etienne and P. Pasquier. Les Discophiles Français DF 164.

Mozart, Wolfgang Amadeus. Rondo in D, K. 485, and Ten Variations *Unser dummer Pöbel meint* in G, K. 455. Parlophone R20397-8.

Mozart, Wolfgang Amadeus. Sonatas (complete). Fantasy in d, K. 397. Fantasy in c, K. 475. Rondo in D, K. 485. Vols. 1–2. Columbia Odyssey Y3 33220 and Y3 33224. The Sonatas complete reissued on 5 CDs by Sony Classical SM4K 47222 and by Music & Arts MUA 1001.

Mozart, Wolfgang Amadeus. Sonatas in C, K. 279, in F, K. 280, and in B-flat, K. 570. Rondo in a, K. 511. Les Discophiles Français DF 97. Reissued on EMI 30133.* Sonata in B-flat reissued on CD by Vox Box CDX2 5516.

Mozart, Wolfgang Amadeus; and Haydn, Franz Joseph. Sonata in B-flat, K. 281 (Mozart); and Sonata in D, no. 9 (Haydn). Educo 3050.

Mozart, Wolfgang Amadeus. Sonatas in B-flat, K. 281, in D, K. 311, and in A, K. 331. Fantasy in d, K. 397. The Haydn Society HS 9013. Reissued on Les Discophiles Français DF 96. Reissued on EMI 30132.* The Fantasy reissued on CD by Music & Arts MUA 1001. The Sonata in D reissued on CD by Vox Box CDX2 5516.

Mozart, Wolfgang Amadeus. Sonatas in E-flat, K. 282, in G, K. 283, and in C, K. 330. Six Variations *Salve Tu, Domine* in F, K. 398. Les Discophiles Français DF 91. Reissued on EMI 30127.* Reissued on CD by Haydn Society HSCD 9013. The Variations reissued on CD by Music & Arts MUA 1001.

Mozart, Wolfgang Amadeus. Sonatas in a, K. 310, and in A, K. 331. VOX PL 6310.

Mozart, Wolfgang Amadeus. Sonata Movement in g, K. 312. Sonatas in B-flat, K. 333, and in C, K. 545. Twelve Variations *La Belle Françoise* in E-flat, K. 353. The Haydn Society HS 9037. Reissued on Les Discophiles Français DF 92. Reissued on EMI 30128.* The Variations reissued on CD by Music & Arts MUA 1001.

Mozart, Wolfgang Amadeus; and Chopin, Frederic. Sonata in A, K. 331, *Alla Turca* movement (Mozart); Waltz in e (Chopin). Odeon O-11880.

*227*

Mozart, Wolfgang Amadeus. Sonatas in F, K. 332, and in D, K. 576. VOX PL 7040. Sonata in F reissued on CD by Vox Box CDX2 5510.

Mozart, Wolfgang Amadeus; Haydn, Franz Joseph; and Schubert, Franz. Sonata in F, K. 332, and *Unser dummer Pöbel meint* Variations, K. 455 (Mozart); Sonata in E-flat, Hob. XVI/49 (Haydn); and Sonata in a, op. 143 (Schubert). Issued from earlier recordings on Vogue CD 672012.

Mozart, Wolfgang Amadeus. Sonata in B-flat, K. 333. Parlophone 20566-7.

Mozart, Wolfgang Amadeus. Sonata for Four Hands in D, K. 381. Kraus plays both parts. Educo 3002.

Mozart, Wolfgang Amadeus. Trios for Piano, Violin, and Cello. With Willi Boskovsky, violin, and Nikolaus Hubner, cello. Les Discophiles Français DF 97-99. Reissued on EMI C 151-73052/4. Reissued on 2 CDs by EMI Références, CHS7 697962. *Grand Prix du Disque* in 1956.

Mozart, Wolfgang Amadeus; Beethoven, Ludwig van; and Schubert, Franz. Sonatas for Violin and Piano: Sonata in F, K. 376 (Mozart); Sonatina in g, D. 408 (Schubert); and Sonata in G, op. 30, no. 3 (Beethoven). With Norbert Brainin. BBC-22313.

Schubert, Franz; and Mozart, Wolfgang Amadeus. *Grazer* Fantasy and Laendler from D. 366 and D. 974 (Schubert); Fantasies in c, K. 475, and in d, K. 397 (Mozart). Columbia Odyssey 32 16 0380.

Schubert, Franz. Impromptu in c, op. 90, no. 1. *Moments Musicaux* in A-flat, op. 94, no. 2. International Guilde du Disque M-946.

Schubert, Franz. Impromptus in c, op. 90, no. 1, in G-flat, op. 90, no. 3, and in A-flat, op. 142, no. 2. Scherzo in B-flat. *Moments Musicaux*, op. 94, nos. 1, 2, and 3. Laendler op. 18, nos. 1-9 and 11. Educo 3007.

Schubert, Franz. Impromptus in E-flat, op. 90, no. 2, and in B-flat, op. 142, no. 3. Parlophone 20561-62.

Schubert, Franz. Impromptus (complete), op. 90 and op. 142. Vanguard
Cardinal VCS 10031. Reissued on CD by Vanguard Classics
OVC 4068 and OVC 8200.

Schubert, Franz; Debussy, Claude; and Mozart, Wolfgang Amadeus. Music
for Flute and Piano: Sonatina in g, op. 137 (Schubert); *Syrinx* for
Flute Solo (Debussy); and Sonata in B-flat, K. 454 (Mozart).
With Jean Pierre Rampal. Educo 3076.

Schubert, Franz. Piano Pieces for Four Hands. Variations op. 82. Polonaises
op. 61, nos. 1, 3, and 4. *Divertissement a la Hongroise* in g, op.54.
With Homero de Magalhaes. Disques Alpha DB 66.

Schubert, Franz. Sonata in a, op. 42. Parlophone SW 2111-4.

Schubert, Franz. Sonatas in a, op. 42, and in A, op. 120. Vanguard
Cardinal VCS 10074. Reissued on CD on Vanguard Classics
OVC 8200 and on Vanguard VAN 8098.

Schubert, Franz. Sonata in a, op. 143. Laendler, op. 18, nos. 1–9 and 11.
Parlophone R20388-90.

Schubert, Franz; Haydn, Franz Joseph; and Mozart, Wolfgang Amadeus.
Sonata in a, op. 143 (Schubert); Sonata in E-flat, Hob. XVI/49
(Haydn); and Sonata in F, K. 332, and Unser dummer Pöbel
meint Variations, K. 455 (Mozart). Issued from earlier recordings
on Vogue CD 672012.

Schubert, Franz. Sonata in A, op. posth. VOX PL 6940.

Schubert, Franz. Sonata in A, op. posth. *Valses Sentimentales* from D. 779.
*Moments Musicaux* no. 2 in A-flat and no. 3 in g. Laendler from
D. 790. Ecossaises from D. 145 and D. 783. Musical
Masterpiece Society MMS 2178. Reissued on Festival Classique
FC 458 and on CD by FNAC Music 642328.

Schubert, Franz. Sonata in B-flat, op. posth. Vanguard VSD 71267.
Reissued along with the *Wanderer* Fantasy in C, Op. 15, on CD
on Vanguard Classics OVC 8200 and on Vanguard VAN 8099.

Schubert, Franz; Beethoven, Ludwig van; and Mozart, Wolfgang Amadeus. Sonatas for Violin and Piano: Sonatina in g, D. 408 (Schubert); Sonata in G, op. 30, no. 3 (Beethoven); and Sonata in F, K. 376 (Mozart). With Norbert Brainin. BBC-22313.

Schubert, Franz. *Valses Nobles*, op. 77, nos. 1–12. Parlophone R20429.

Schubert, Franz; Bach, Johann Sebastian; Haydn, Franz Joseph; and Mozart, Wolfgang Amadeus. *Wanderer* Fantasy in C, Op. 15 (Schubert); *Chromatic Fantasy and Fugue* in d (Bach); Fantasy in C, Hob. XVII/4 (Haydn); and Fantasy in d, K. 397 (Mozart). Vanguard VA 25003. Reissued on CD by Vanguard VBD 25003. The *Wanderer* reissued on CD by Vanguard VAN 8099 and Vanguard Classics OVC 8200.

Schubert, Franz. *Winterreise.* With Doda Conrad, bass. VOX PL 6090.

Schumann, Robert; and Weber, Carl Maria von. Concerto in a, op. 54 (Schumann); *Konzertstuck* in f, op. 79 (Weber). With the Vienna State Opera Orchestra conducted by Victor Desarzens. Musical Masterpiece Society MMS-2327. Reissued by Vanguard SRV 293 SD.

Weber, Carl Maria von; and Schumann, Robert. *Konzertstuck* in f, op. 79 (Weber); Concerto in a, op. 54 (Schumann). With the Vienna State Opera Orchestra conducted by Victor Desarzens. Musical Masterpiece Society MMS-2327. Reissued by Vanguard SRV 293 SD.

# Notes

## Act i: the debut

1   Interview with Lili Kraus, conducted by Steve Roberson, 21 January 1984.
2   Interview with Lili Kraus, conducted by Fort Worth Productions, 1983.
3   Ibid.
4   Ibid.
5   Ibid.
6   Ibid.
7   Ibid.
8   Ibid.
9   Ibid.
10  Kraus interview, Roberson, 21 January 1984.
11  Kraus interview, Fort Worth Productions.
12  Kraus interview, Roberson, 21 January 1984.
13  Kraus interview, Fort Worth Productions.
14  Kraus interview, Roberson, 21 January 1984.
15  Kraus interview, Fort Worth Productions.
16  Ibid.
17  Ibid.
18  Ibid.
19  Ibid.
20  Ibid.
21  Kraus interview, conducted by Steve Roberson, 13 August 1984.
22  Kraus interview, Fort Worth Productions.
23  Kraus interview, conducted by Steve Roberson, 22 November 1984.

## Act ii: tales from vienna

1   Kraus interview, conducted by Steve Roberson, 8 January 1985.
2   Kraus interview, Roberson, 22 November 1984.
3   Ibid.
4   Kraus interview, Roberson, 8 January 1985.
5   Kraus interview, Fort Worth Productions.
6   Richard Freed, "Lili Kraus: Mozartean," *Stereo Review*, February 1975, p. 77.

7   Promotional flyer published by Ibbs & Tillett, Kraus's management representatives, in the late 1920s.

8   Ibid.

9   Ibid.

10  Kraus interview, Roberson, 8 January 1985.

11  Dean Elder, "Lili Kraus . . . Regal Lady of the Keyboard," *Clavier* 19 (September 1980): 24.

12  Interview with William Otto Mandl, conducted by Steve Roberson, 1 July 1987.

13  Kraus interview, Fort Worth Productions.

14  Ibid.

15  Interview with William Otto Mandl, conducted by Fort Worth Productions, 1983.

16  Kraus interview, Fort Worth Productions.

17  David Ewen, editor, *Musicians Since 1900* (New York: H. W. Wilson, Co., 1978), p. 418.

18  Ibid.

19  Mandl interview, Roberson.

20  Kraus interview, Fort Worth Productions.

21  Mandl interview, Roberson.

22  Ibid.

23  Joseph Roth, *Juden auf Wanderschaft* (Berlin: Die Schmiede, 1927), quoted in his *Romanze-Erzahlunger-Augsatze* (Cologne, 1964), pp. 559ff.

24  Lili Kraus, "Of Teachers and Husbands," *The Piano Quarterly* 84 (Winter 1973–74): 34.

ACT III: THIRTY-SOMETHING

1   Kraus, "Of Teachers and Husbands," p. 34.

2   Kraus interview, Roberson, 21 January 1984.

3   Kraus interview, Fort Worth Productions.

4   Kraus, "Of Teachers and Husbands," p. 35.

5   Kraus interview, Roberson, 13 August 1984.

6   Interview with Claude Frank, conducted by Fort Worth Productions, 1983.

7   Kraus interview, Roberson, 13 August 1984.

8   Ibid.

9   Ibid.

10  Patsy Swank, "Lili by Lili," *Vision*, October 1980, p. 28.
11  Interview with Marius Flothuis, conducted by David Morely, November 1993.
12  Interview with Ruth Mandl Pope, conducted by Fort Worth Productions, 1983.
13  Recital review, *Times* (London), 9 January 1931, p. 16.
14  Ibid.
15  Mandl interview, Roberson.
16  Ibid.
17  Ibid.
18  Ibid.
19  Kraus interview, Fort Worth Productions.
20  Recital review, *Times* (London), 24 May 1935, p. 14.
21  Recital review, *Times* (London), 30 November 1936, p. 19.
22  Kraus interview, Roberson, 8 January 1985.
23  Ibid.
24  Marion Stone, "Interview with Lili Kraus," *Clavier* 12 (September 1968): 24.
25  Sjoerd de Witte, recital review, *Bataviasch Nieuwsblad*, 13 June 1936.
26  Recital review, *Times* (London), 15 November 1937, p. 21.
27  Ibid.
28  Recital review, *Times* (London), 30 December 1938, p. 8.
29  Interview with Ruth Mandl Pope, conducted by David Morely, October 1993.
30  Frans Schreuder, "Lili Kraus, Pioneer on 78 Records: A Survey of the Pianist's Historic Phonograph Records," pamphlet distributed at a lecture at the International Piano Archives at Maryland, 17 October 1990.
31  "Lili Kraus En Haar Werk Voor De Grammofoon," translated by Frans Schreuder, *Het Volk* (The Netherlands), 27 July 1939.

ACT IV: STURM UND DRANG

1  "Kraus-Conrad Farewell Concert," *De Telegraaf* (Amsterdam), 12 March 1940. Translated from the Dutch.
2  Pope interview, Morely.
3  Ibid.
4  Interview with Kichiro Tago, conducted by David Morely, October 1993.

5 "Bezettingskroniek 1942–1945," *Moesson,* translated by Frans Schreuder, 1 February 1980, p. 16.

6 Tago interview, Morely.

7 Freed, "Lili Kraus: Mozartean," p. 77.

8 Kraus interview, Fort Worth Productions.

9 Elyse Mach, *Great Pianists Speak for Themselves* (New York: Dodd, Mead & Company, 1980), p. 149.

10 Kraus interview, Fort Worth Productions.

11 Olin Chism, "Pianist Lili Kraus Triumphs Over Horrors of Past," *The Dallas Times Herald,* 27 February 1977, pp. D1 and D10.

12 Russ Rymer, "The Greatness of Lili Kraus," *Atlanta Weekly* magazine of *Atlanta Journal and Atlanta Constitution,* 16 January 1983, p. 8.

13 "The Legend of Lili Kraus," *This Is TCU,* Spring 1968, p. 21.

14 Kraus interview, Roberson, 8 January 1985.

15 "The Legend of Lili Kraus," p. 21.

16 Rymer, p. 21.

17 Kraus interview, Fort Worth Productions.

18 Louis Snyder, "Applause from Four Continents," *Christian Science Monitor,* 20 August 1970, p. 19.

19 Kraus interview, Roberson, 8 January 1985.

20 Ibid.

21 Ibid.

22 Kraus interview, Fort Worth Productions.

23 Rymer, p. 14.

24 Swank, p. 29.

25 Freed, "Lili Kraus: Mozartean," p. 77.

26 Mach, p. 150.

27 "The Legend of Lili Kraus," p. 21.

28 Daphne Jackson, *Java Nightmare.* Cornwall: Tabb House Padstow, 1979.

29 Ibid.

30 Murray Tonkin, "Lili Kraus Likes Music, Movies, and Mountain Climbing," *Radio Call's,* 27 February 1946.

31 Flothuis interview, Morely.

32 "Philosophy and the World View," *New Zealand Listener,* 2 August 1946, p. 6.

33 Pope interview, Morely.

34 Ibid.

35 Chism, "Pianist Lili Kraus Triumphs," pp. D1 and D10.

36  Tago interview, Morely.
37  Ibid.
38  Ibid.
39  Kraus interview, Roberson, 8 January 1985.

ACT V: LE RETOUR

1   Kraus interview, Fort Worth Productions.
2   Chism, "Pianist Lili Kraus triumphs over horrors of past," p. D10.
3   Kenneth Wilkinson, "Vivid Recital by Lili Kraus," recital review, *Daily Telegraph* (Sydney, Australia), 29 November 1945.
4   Recital review, *Daily Telegraph* (Sydney, Australia), 4 December 1945.
5   Recital preview, *Radio Call's*, 20 February 1946.
6   Interview with Michael Mandl, conducted by Fort Worth Productions, 1983.
7   Owen Jensen, "Lili Kraus Remembered," New Zealand radio broadcast, 1986 or 1987.
8   Bob Doerschuk, "Lili Kraus: Spirited Doyenne of Mozart and Bartok," *Keyboard*, October 1983, p. 54.
9   Interview with Lili Kraus, conducted by Vivian Perles for the Yale University Oral History Steinway Project, 25 June 1979.
10  Jensen, "Lili Kraus Remembered."
11  Pope interview, Morely.
12  Recital review, unidentified paper, translated by Frans Schreuder, Amsterdam, 24 March 1948.
13  Recital review, unidentified paper, translated by Frans Schreuder, Amsterdam, 31 March 1948.
14  Matthijs Vermeulen, recital review, translated by Frans Schreuder, *De Groene Amsterdammer* (Amsterdam), 6 November 1948, p. 8.
15  Kraus interview, Fort Worth Productions.
16  A. Kettielarij, "Piano-recital: Lili Kraus," recital review, unidentified paper, translated by Frans Schreuder.

ACT VI: ECSTASY AND AGONY

1   Robert Sabin, recital review, *Musical America*, 15 November 1949, p. 36.
2   Paul Hume, "Comments on the Arts," radio broadcast on WGMS (Rockville, Maryland), 27 November 1986.
3   Educo Records promotional material.

4  R. H. Hagan, record review, *Chronicle's This World* (San Francisco), 29 August 1954.

5  Interview with Jean Pierre Rampal, conducted by Steve Roberson, 20 February 1987.

6  Max Loppert, CD review, *International Classical Record Collector*, Spring 1998.

7  Alice Myers Winther, *Christian Science Monitor*, 7 August 1956.

8  Kraus interview, Fort Worth Productions.

9  Ibid.

10  Ruth Pope interview, Fort Worth Productions.

11  Mach, pp. 145–155.

12  Julius Franz Simek, recital review, *Musical America*, 1 November 1958, p. 26.

13  Recital review, *Times* (London), 10 February 1958, p. 3.

14  "Miss Lili Kraus' Superb Musicianship," recital review, *Times* (London), 9 February 1959, p. 12.

15  Undated issue of *La Tribune* as quoted in record jacket notes of Franz Schubert, *Sonata in A major*. Lili Kraus, pianist. Festival Records, MU 314.

16  Kraus interview, Fort Worth Productions.

17  Interview with Fergus Pope, conducted by Fort Worth Productions, 1983.

18  Recital review, *Music Courier*, January 1961, p. 25.

19  Wriston Locklair, recital review, *Musical America*, January 1961, p. 81.

20  Recital review, *Times* (London), 10 December 1962, p. 5.

21  Ross Parmenter, "Music: Sharply Personal," recital review, *New York Times*, 19 November 1963, p. 46.

22  Ibid.

23  Ibid.

24  Ibid.

25  Peter Davis, recital review, *Musical America*, December 1963, p. 262.

26  Frederick Page, recital review, *The Musical Times*, December 1963, p. 887.

27  Interview with Lili Kraus, unidentified Dutch source from The Hague, 1961, translated by Frans Schreuder.

28  Fergus Pope interview, Fort Worth Productions.

29  Interview with Alix Williamson, conducted by Fort Worth Productions, 1983.

30  Interview with Stephen Simon, conducted by Fort Worth Productions, 1983.

31 Raymond Ericson, "Six Down—More to Come," record review, *New York Times*, 27 February 1966, p. 19.

32 Stephen Sell, record review, *American Record Guide*, March 1966.

33 David Dubal, *The Art of the Piano* (New York: Harcourt, Brace & Company, 1995), p. 145.

34 Simon interview, Fort Worth Productions.

35 Stone, p. 24.

36 Harold C. Schonberg, "Music: Mozart Complete," concert review, *New York Times*, 5 October 1966, p. 39.

37 "View from the Inside," *Time* magazine, 14 October 1966, p. 50.

38 Alan Rich, concert review, *New York World Tribune*, 5 October 1966.

39 "An Impeccable Reading Is Achieved by Lili Kraus," concert review, *Billboard*, 15 October 1966.

40 Harris Goldsmith, "From Five Artists: Five Essays on Mozart's Piano Sonatas," record review, *High Fidelity*, July 1968, p. 72.

41 Harris Goldsmith, *Records in Review* (Great Barrington, Mass.: Wyeth Press, 1970), p. 239.

42 Harris Goldsmith, *Records in Review* (Great Barrington, Mass.: Wyeth Press, 1976), p. 211.

43 Richard Freed, "The Mozart Solo Sonatas: Two Integral Sets," *Stereo Review*, October 1975, p. 112.

44 Ibid.

45 "The Legend of Lili Kraus," p. 19.

ACT VII: COMING TO AMERICA

1 Interview with Michael Winesanker, conducted by Fort Worth Productions, 1983.

2 John Ardoin, "Learning with Lili," *Dallas Morning News*, 20 June 1976, p. 7C.

3 "The Legend of Lili Kraus," p. 19.

4 Swank, p. 29.

5 Lecture delivered by Lili Kraus, Texas Christian University, 1975.

6 Leonard Eureka, "Lili Kraus Conducts Master Classes," *Fort Worth Star-Telegram*, 13 June 1976.

7 Harris Goldsmith, *Records in Review* (Great Barrington, Mass.: Wyeth Press, 1972), p. 321.

8 Ibid., p. 322.

9 Peter G. Davies, "Lili Kraus Plays Beethoven Concerto," concert

review, *New York Times*, 11 May 1970, p. 48.
10  Paul Hume, "Lili Kraus: One With the Music," concert review, *Washington Post*, 7 March 1972.
11  Donal Henahan, "Lili Kraus Has Vigor, Conviction, Confidence," concert review, *New York Times*, 4 August 1976, p. 14.
12  Franz Schubert, *Sonata in B-flat Major.* Lili Kraus, pianist. Vanguard Records, VSD 71267. Record jacket notes unsigned.
13  Richard Freed, record review, *Stereo Review*, June 1982, p. 113.
14  Harris Goldsmith, record review, *High Fidelity*, January 1982, p. 75.
15  Edward T. Canby, record review, *Audio*, July 1982, p. 70.
16  Richard Freed, "Keyboard Bartok: Three Views," record review, *Stereo Review*, May 1982, p. 70.
17  Jacob Siskind, "Lili Kraus Sparks Concert by McGill Chamber Orchestra," concert review, *Gazette* (Montreal), 21 November 1972.

ACT VIII: CODA AND REQUIEM

1  Kraus interview, Fort Worth Productions.
2  Ibid.
3  Letter from Lili Kraus to Frans Schreuder, 30 March 1980.
4  Letter from Lili Kraus to Frans Schreuder, 13 June 1981.
5  Letter from Lili Kraus to Lineke Havermans-van den Berg, 6 June 1982.
6  Letter from Lili Kraus to Frans Schreuder, 31 January 1983.
7  Letter from President Ronald Reagan to Lili Kraus, 25 April 1983.
8  Ruth Pope interview, Fort Worth Productions.
9  Letter from Lili Kraus to Frans Schreuder, 4 November 1985.
10  Information provided by the Van Cliburn Foundation, Inc., Fort Worth, Texas, 1985.
11  Letter from Lili Kraus to Lineke Havermans-van den Berg, 20 June 1985.
12  Interview with Lili Kraus, conducted by Eugenia Zuckerman for CBS-TV's *Sunday Morning*, 23 August 1986.
13  Letter from Lili Kraus to Kathie Faricy, 18 October 1986.
14  Pope interview, Morely.
15  John Ardoin, "Lili Kraus Lived Her Love of Music," *Dallas Morning News*, 30 November 1986, p. 2C.
16  Paraphrase by the author of Shakespeare's *Romeo and Juliet*, Act 3, Scene 2, Lines 22–25.

## FINAL NOTES

1   Graphological analysis by Joca van der Leest of Lili Kraus's handwriting, 1986.
2   Enid Nemy, unidentified article, *New York Times*, 6 April 1971
3   Jensen, "Lili Kraus Remembered."
4   Interview with Kathie Faricy, conducted by Steve Roberson, 18 July 1987.
5   Pope interview, Morely.
6   Elder, "Making Mozart Live," p. 14.
7   Kraus interview, Roberson, 8 January 1985.
8   Ruth Pope interview, Fort Worth Productions.
9   Rymer, p. 6.
10  Dean Elder, "Making Mozart Live," *Clavier* 10 (May–June 1971): 16.
11  Mach, p. 155.

## APPENDIX

1   Promotional flyer, Ibbs & Tillett.
2   Lili Kraus, Piano Recital, Queen Elizabeth Hall, London, England, 12 December 1972.
3   Adroin, "A Lesson in Musical Love," p. 15.
4   Freed, "Lili Kraus, Mozartean," p. 76.
5   Lili Kraus, "Marriage to Mozart," *Music Journal* 24 (December 1966): 24.
6   Stone, p. 24.
7   Mach, p. 155.
8   Interview with Lili Kraus, aired by an unidentified Washington, D.C., radio station in spring 1983.
9   "Part of the Music Itself," interview with Lili Kraus, unidentified source and interviewer, New Zealand, 1946.
10  Lili Kraus, "Lili Kraus Teaches a Master Lesson," Educo 5010 and 5011.
11  Promotional flyer issued by Maurice Werner, Kraus's manager, in the late 1950s.
12  Interview with Lili Kraus, Columbia Broadcasting System's *Camera Three* television program, aired 17 March 1968.
13  Itinerary prepared by Alix Williamson, Kraus's manager.
14  Kraus interview, Roberson, 13 August 1984.

15  Flothuis interview, Morely.
16  Mandl interview, Roberson.

# BIBLIOGRAPHY

## BOOKS

Chagoll, Lydia. *buigen in jappenkampen: Herinneringen van een kind dat aan de nazi's is ontsnapt maar in Japanse kampen terecht is gekomen [bowing in japanese camps: Remembrances of youth that escaped the nazis but came into Japanese camps].* Leuven, Belgium: Infodok, 1986.

Colijn, Helen. *Song of Survival: Women Interned.* Ashland, Ore.: White Cloud Press, 1996.

Dean, Elder. *Pianists at Play.* Evanston, Ill.: Instrumentalist Co., 1982.

Jackson, Daphne. *Java Nightmare.* Cornwall, England: Tabb House Padstow, 1979.

Kehler, George, editor. *The Piano in Concert.* 2 vols. Metuchen, N.J.: The Scarecrow Press, Inc., 1982. Vol. 1, pp. 693–694.

Kolodin, Irving. *In Quest of Music: A Journey In Time.* Garden City, N.Y.: Doubleday & Company, Inc., 1980, p. 39.

Kop, Dr. G. C. *De vertolker in de muziek [Interpretation of Music].* Utrecht, the Netherlands: Bohn, Scheltema & Holkema, 1982.

Krummer, Corby. *Talking about Pianos.* New York: Steinway & Sons, 1982.

Mach, Elyse. *Great Pianists Speak for Themselves.* New York: Dodd, Mead & Company, 1980, pp. 145–155.

Newcomer, James. *Lili Kraus and the Van Cliburn International Piano Competition: A Memoir of the TCU Years.* Fort Worth: Texas Christian University, 1997.

Parlophone and Odeon Record Catalog, 1939–1940. Hayes, Middlesex: The Parlophone Co. Ltd.

Röntgen, Joachim. *Muziek is mign leven [Music is my life]*. Published privately in 1986 in the Netherlands.

Shapiro, Nat, editor. *An Encyclopedia of Quotations about Music*. London: Newton Abbot, 1980.

Uszler, Marienne; Stewart Gordon; and Elyse Mach. *The Well-Tempered Keyboard Teacher*. New York: Schirmer Books, 1991.

Velden, Dr. D. Van. *De Japanse Interneringskampen noor burgers gedurende de Tweede Wereldoorlog [The Japanese Civil Internment Camps During the Second World War]*. The Netherlands: Uitgeverijt Wever B.V., 1977.

Wiener, Hilda. *Pencil Portraits of Concert Celebrities*. London: Sir Isaac Pitman & Sons, Ltd., 1937.

DICTIONARIES AND ENCYCLOPEDIAS

Clough, Francis F. and G. J.Cuming. *The World's Encyclopaedia of Recorded Music*. Westport, Conn.: Greenwood Press, 1970.

Creighton, James. *Discopaedia of the Violin: 1889–1971*. Toronto: University of Toronto Press, 1974.

*Current Biography*, 1975, S.v. "Lili Kraus."

Dubal, David. *The Art of the Piano: Its Performers, Literature, and Recordings*. New York: Summit Books, 1989 and 1995, S.v. "Lili Kraus."

Ewen, David, editor. *Musicians since 1900*. New York: H. W. Wilson Co., 1978.

*International Who's Who in Music and Musicians' Directory*, 8th ed., S.v. "Lili Kraus."

Jacobs, Arthur, editor. *The Penguin Dictionary of Musical Performers.* New York: Viking Penguin, 1990, S.v. "Lili Kraus."

Lyle, Wilson. *A Dictionary of Pianists.* London: Robert Hale, 1985, S.v. "Lili Kraus."

*The New Grove Dictionary of Music and Musicians*, S.v. "Lili Kraus," by Dominic Gill.

Pâris, Alain. *Dictionnaire des Interprètes.* Paris: Robert Laffont, 1982, S.v. "Lili Kraus."

Roth, Joseph. *Romanze-Erzahlunger-Augsatze.* Cologne: 1964.

JOURNALS

Dumm, Robert. "Luncheon with Lili." *Piano Review* 8 (Spring 1981).

Elder, Dean. "Lili Kraus: Regal Lady of the Keyboard." *Clavier* 19 (September 1980): 21–27.

_____. "Making Mozart Live." *Clavier* 10 (May–June 1971): 12–18.

_____. "Master Class." *Clavier* 19 (September 1980): 26–27.

_____. "On Mastering Mozart." *Clavier* 10 (April 1971): 10–16.

Kraus, Lili. "Marriage to Mozart." *Music Journal* 24 (December 1966): 24, 53.

_____. "Of Teachers and Husbands." *Piano Quarterly* 84 (Winter 1973–74): 34–35.

"Lili Kraus." *Piano Quarterly* 110 (Summer 1980): 48.

"Lili Kraus, Pianist to Tour U.S." *Musical Courier* 139 (1 March 1949): 15.

Mach, Elyse. "Practice Notes." *Clavier* 36 (May–June 1997): 46.

Rendleman, Ruth. "A Reference Guide to the Cadenzas for the Mozart Piano Concertos." *Piano Quarterly* 114 (Summer 1981): 35–37.

Schreuder, Frans. "Remembering Lili Kraus—A Vanishing Tradition." *Piano Journal* (London) 23 (June 1987): 11–12.

_____. "Lili Kraus . . . Schubert, Haydn, Mozart Pioneer." EPTA *Piano Bulletin* (London) 3 (1991): 54–61.

Simon, Stephen. "Salami, Schlagobers and Mozart." *Music Journal* 25 (October 1967): 22, 23, 60, 61.

Stone, Marion. "Interview with Lili Kraus Who Studied with Kodály and Bartók." *Clavier* 12 (September 1968): 22–24, 36.

MAGAZINES

"Bezettingskroniek 1942–45." Translated by Frans Schreuder. *Moesson* (the Netherlands), 1 February 1980, p. 16.

"Disappointment for W. A. Music Lovers." *The Broadcaster* (Australia), 30 January 1946.

Doerschuk, Bob. "Lili Kraus: Spirited Doyenne of Mozart and Bartók." *Keyboard*, October 1983, pp. 52, 54, 66, 75.

"Famous Pianist Designs Her Own Frocks: Exotic Lili Kraus Creations." *Radio Call's* (Australia), 3 March 1946.

"Film on Lili Kraus Being Completed for Fall PBS Showing." *This Is TCU*, Spring 1984, pp. 42–43.

Freed, Richard. "Lili Kraus, Mozartean." *Stereo Review*, February 1975, pp. 76–78.

Kraus, Lili. "Master Class: Mozart's Fantasie in D Minor." *Keyboard Classics*, July–August 1982, p. 41.

"Lili: Virtuoso of the Keyboard." *Dial*, January 1985, pp. 9, 18.

Maag, Melanie. "Lili Kraus . . . the Teacher." *Fort Worth Magazine*, August 1979, pp. 12–15, 33.

"Mme. Lili Kraus: She Graced Our Campus and the Globe." *This Is TCU*, December 1986, p. 37.

Newcomer, James. "Dramatic, Imperious Lili Kraus: Exuberance enlivened the campus." *This Is TCU*, May 1989, p. 15.

Ohendalski, Latryl. "Lili Kraus." *This Is TCU*, June 1983, pp. 3–6.

"Philosophy and the World View." *New Zealand Listener*, 2 August 1946, p. 6.

Rymer, Russ. "The Greatness of Lili Kraus." *Atlanta Weekly* magazine of *Atlanta Journal and The Atlanta Constitution*, 16 January 1983, pp. 6–7, 14.

Swank, Patsy. "Lili by Lili." *Vision*, October 1980, pp. 26–29.

"The Filming of Lili." *This Is TCU*, Fall 1984, pp. 40–43.

"The Legend of Lili Kraus." *This Is TCU*, Spring 1968, pp. 17–21.

Tonkin, Murray. "Lili Kraus Likes Music, Movies, and Mountain Climbing." *Radio Call's* (Australia), 27 February 1946.

NEWSPAPER ARTICLES

Ardoin, John. "A Lesson in Musical Love with Lili Kraus." *New York Times*, 1 August 1976, p. 15.

_____. "Learning with Lili." *Dallas Morning News*, 20 June 1976, p. 7C.

_____. "Lili Kraus Lived Her Love of Music." *Dallas Morning News*, 30 November 1986, p. 2C.

Blyth, Alan. "Pianist with the Secret of Simplicity." *Daily Telegraph* (London), 28 December 1987.

"Bravo, Kraus and Kruger." *Fort Worth Star-Telegram*, 24 April 1983.

Burnett, W. C. "Lili Kraus: Keyboard Magician." *Atlanta Journal and The Atlanta Constitution*, 18 February 1979, pp. 1E, 14E.

Chism, Olin. "Pianist Lili Kraus Triumphs over Horrors of Past," *Dallas Times Herald*, 27 February 1977, pp. D1, D10.

Ericson, Raymond. "A Cross and a Privilege." *New York Times*, 25 October 1970, p. 19.

Eureka, Leonard. "Lili Kraus Conducts Master Classes." *Fort Worth Star-Telegram*, 13 June 1976.

_____. "Lili Kraus Indefatigable." *Fort Worth Star-Telegram*, 15 June 1969, p. 6F.

Eyrich, Claire. "'Lili: The Legend Lives On." *Fort Worth Star-Telegram*, 22 April 1984, pp. 1F–2F.

_____. "Madame Kraus Turns 70 at Allegro Tempo." *Fort Worth Star-Telegram*, 15 March 1978.

"Famed pianist Lili Kraus Dies in Asheville at 83." *The News and Observer* (Raleigh, N.C.), 7 November 1986.

"A Farewell to Madame Lili." *Fort Worth Star-Telegram*, 9 November 1986.

Fleming, Michael. "Pianist Impressed Both Students, Fans." *Fort Worth Star-Telegram*, 24 April 1983, pp. 1E, 4E.

Folkart, Burt A. "Stellar Pianist Lili Kraus, 83, Dies." *Los Angeles Times*, 8 November 1986, part 1, p. 32.

"Friends of Lili Kraus to Help Young Pianists." *New York Times*, 28 October 1979, p. 67.

Garrison, D. Max. "Kraus Class: A High Note for Young Pianists." *News-Times* (Ridgefield, Conn.), 28 January 1975.

"Graffiti or an Honor?" *New York Times*, 17 March 1979, p. 9.

Granger, Don. "Kraus to Revisit Scene of Crime.'" *Wichita Beacon* (Kansas), 1982.

Heaton, Bob. "Pianist's Rare Tribute Starts Uproar." *Wichita Beacon* (Kansas), 15 March 1979.

"Internationally Known Pianist, Music Teacher Lili Kraus, 83." *The Charlotte Observer* (Charlotte, N.C.), 7 November 1986.

Interview with Lili Kraus. *The Washington Star*, 15 April 1978.

Jarvis, Janice. "Film Will Portray Kraus' Life." *Fort Worth Star-Telegram*, 4 July 1984, pp. 1–2.

Jones, Robert. "A Very Rare Lili." *Sunday News* (city unknown), 14 March 1976.

"Kraus, Kruger Honored." *Fort Worth Star-Telegram*, 2 May 1983.

"La pianiste Lili Kraus." *Le Monde* (Paris), 12 November 1986.

"Lili Kraus: *grammofoonplaat is gevaar voor podiumconcert*" ["recordings are a danger for concerts on the stage"]. Translated by Frans Schreuder. *Algemeen Dagblad* (The Netherlands), 11 October 1961.

"Lili Kraus Is Fine Interpreter of Mozart." *Radio Call's* (Australia), 20 February 1946.

"Lili Kraus Is Profiled in PBS Special." *News Leader* (Fort Worth, Tex.), 29 December 1984.

Nemy, Enid. *New York Times*, 6 April 1971.

Phillips, McCandlish. "Casals Dedicates Schweitzer Library." *New York Times*, 28 June 1971, p. 36.

Reinthaler, Joan. "Lili Kraus Helps Students Find 'Elusive Musicality.'" *Washington Post,* 12 August 1969.

"Renowned Pianist Lili Kraus, 83, Dies." *Fort Worth Star-Telegram,* 6 November 1986.

Rockwell, John. "Lili Kraus, Hungarian Pianist." *New York Times,* 7 November 1986.

Rosenfeld, Jay C. "Schweitzer Legacy Extolled." *The Berkshire Eagle* (Pittsfield, Mass.), 28 June 1971.

Snyder, Louis. "Applause from Four Continents." *Christian Science Monitor,* 20 August 1970, p. 19.

Stewart, Lloyd. "Even in Darkness, Music Shone Through." *Fort Worth Star-Telegram,* 7 November 1986, pp. 1, 18.

_____. "Lili Kraus Is Honored." *Fort Worth Star-Telegram,* 3 May 1983.

_____. "Star Pianist Brightened Music World." *Fort Worth Star-Telegram,* 7 November 1986, pp. 17H, 20H.

Trinkle, Jim. "Kraus Made 'Em Love Her in Florida." *Fort Worth Star-Telegram,* 20 April 1983.

"West Pointer Learns Discipline at TCU." *The Downtown News-Tribune* (Fort Worth, Tex.), 25 April 1983.

"World-Renowned Pianist Lili Kraus Dies." *News-Journal* (Burnsville, N.C.), 13 November 1986, p. 13.

RECORD JACKET NOTES
(selected examples)

Bach, Johann Sebastian; Haydn, Franz Joseph; Mozart, Wolfgang Amadeus; and Schubert, Franz. *Lili Kraus Plays Fantasies.* Vanguard Records, VA 25003. Record jacket notes unsigned.

Bartók, Béla. *Six Romanian Folk Dances. Fifteen Hungarian Peasant Songs. Three Hungarian Folksongs. Three Rondos on Folk Tunes.* Sonatina in D. *For Children,* vol. 1, nos. 1, 2, 3, 5, 6, 9, 12, 17, 18, 19, 20, and 21. *Evening in the Country from Ten Easy Pieces.* Vanguard VSD 71249.

Mozart, Wolfgang Amadeus. *The Complete Piano Concerti.* Lili Kraus, pianist. Columbia Records, P12 11806. Record booklet notes unsigned.

Schubert, Franz. *Sonata in A Major.* Lili Kraus, pianist. Festival Classique Records, MU 314. Record jacket notes unsigned.

Schubert, Franz. *Sonata in B-flat Major.* Lili Kraus, pianist. Vanguard Records, VSD 71267. Record jacket notes unsigned.

## MUSIC

Kraus, Lili, editor. *The Complete Original Cadenzas by W. A. Mozart for His Solo Piano Concertos with Supplementary Cadenzas by Beethoven and Kraus.* Melville, N.Y.: Belwin-Mills Publishing Corporation, 1972.

## RECITAL AND CONCERT REVIEWS

"A Pianist out of the Ordinary." *Times* (London), 10 December 1962, p. 5.

Ardoin, John. "Lili Kraus Excels in Intricate Work." *Dallas Morning News,* 10 November 1972.

Arntzenius, L. M. G. "Kraus-Conrad Farewell Concert." *De Telegraaf* (Amsterdam), 12 March 1940.

_____. "Lili Kraus and Doda Conrad." *De Telegraaf* (Amsterdam), 25 January 1940.

Ashley, Patricia. *High Fidelity,* February 1969, pp. 19-20.

*The Birmingham Post* (Birmingham, England), 16 December 1972.

Blanks, Fred R. *The Musical Times* 104 (July 1963): 498–499.

*Bulletin* (Sydney, Australia), 4 December 1945.

Chism, Olin. "Pianist Kraus Plays Beethoven Concerto." *Dallas Times Herald*, 9 November 1972.

Cooper, Martin. "Lili Kraus's Perfection in Mozart." *Daily Telegraph* (London), 25 March 1960.

*Daily Telegraph* (Sydney, Australia), 4 December 1945.

Davis, Peter G. "Lili Kraus Plays Beethoven Concerto." *New York Times*, 11 May 1970, p. 48.

Davis, Peter G. *Musical America* 83 (December 1963): 262.

de Witte, Sjoerd. *Bataviasch Niewsblad*, 13 June 1936.

Ericson, Raymond. "Lili Kraus in Town Hall Piano Recital." *New York Times*, 26 November 1960.

"Fine Playing of Mozart by Lili Kraus." *Daily Telegraph* (London), 13 December 1972.

Frankenstein, Alfred. "Pianist Breathes Life Into Beethoven's 2nd Concerto." *San Francisco Chronicle*, 13 January 1961, p. 32.

Fried, Alexander. "Lili Kraus Plays a Sparkling Solo." *San Francisco Examiner*, 12 January 1961.

Goldsmith, Harris. *Musical Courier* 163 (January 1961): 25.

_____. "Mozart: Sonatas for Piano." Source unknown.

Goth, Trude. "'Mozart Marathon' Part of N.Y. Music Season; Lili Kraus Shows How." *Variety*, 19 October 1966, p. 47.

Harrison, Max. *Times* (London), 13 December 1972, p. 11.

Henahan, Donal. "Lili Kraus Begins a Mozart Cycle." *New York Times,* 2 November 1967, p. 59.

_____. "Lili Kraus Has Vigor, Conviction, Confidence." *New York Times,* 4 August 1976, p. 14.

Henderson. Robert. *The Musical Times* 103 (May 1962): 323.

*High Fidelity Magazine,* August 1970. Reviews of Beethoven Piano Concertos nos. 3 and 4. Reviewer unknown.

Hughes, Allen. "Lili Kraus Plays Three Mozart Works." *New York Times,* 1 February 1967, p. 26.

_____. "Music: Mixed Elements." *New York Times,* 21 July 1970, p. 31.

Hume, Paul. "Lili Kraus: One with the Music." *The Washington Post,* 7 March 1972.

_____. "Lili Kraus: 'One of the World's Great Incandescent Artists.'" *The Washington Post,* 9 March 1972.

_____. "Busted Flat in College Park." *The Washington Post,* 31 July 1972.

"An Impeccable Reading Is Achieved by Lili Kraus." *Billboard,* 15 October 1966.

"Impressive Piano Playing." *Times* (London), 4 April 1960, p. 6.

Johnson, Harriett. *New York Post,* 5 October 1966.

Kolodin, Irving. *Saturday Review,* 22 October 1966.

"Lili Kraus's Marathon." *Times* (London), 18 November 1967, p. 19.

"Lili Kraus Recital." *Times* (Canberra, Australia), 1946.

Locklair, Wriston. *Musical America* 81 (January 1961): 81–82.

"London Mozart Players Shine." *Times* (London), 1 February 1962, p. 5.

Loughner, Jack. "Lili Kraus' Playing Vigorous, Delicate." *San Francisco News Bulletin*, 13 January 1961.

McLean, Eric. "Lili Kraus Offers Recital at McGill." *The Montreal Star*, 12 January 1961.

"Miss Lili Kraus's Superb Musicianship." *Times* (London), 9 February 1959, p. 12.

"Mozart and Haydn in Varied Moods." *Times* (London), 25 March 1960, p. 16.

*Musical America* 78 (November 1958): 26.

*Musical Courier* 140 (1 December 1949): 24.

*Musical Courier* 158 (December 1959): 36.

*Musical Courier*, January 1961, p. 25.

*Newsday*, 26 October 1966.

*The New York Post*, 2 August 1976.

*The New Yorker*, 15 October 1966.

Page, Frederick. *The Musical Times* 104 (December 1963): 887.

Parmenter, Ross. "Music: Sharply Personal." *New York Times*, 19 November 1963, p. 46.

Perkins, Francis D. "Lili Kraus Gives Recital of Piano Music at Town Hall." *New York Herald Tribune*, 26 November 1960.

*Radio Call's* (Australia), 20 February 1946.

Rich, Alan. *New York World Tribune*, 5 October 1966.

Sabin, Robert. *Musical America* 69 (15 November 1949): 36.

*The San Francisco Chronicle*, 26 July 1976.

Schonberg, Harold. "Lili Kraus, Pianist, Back at Town Hall." *New York Times*, 18 October 1958.

_____. "Music: Mozart Complete." *New York Times*, 5 October 1966, p. 39.

Simek, Julius Franz. *Musical America*, 1 November 1958, p. 26.

Siskind, Jacob. "Lili Kraus Sparks Concert by McGill Chamber Orchestra." *Gazette* (Montreal), 21 November 1972.

_____. "Lili Kraus Superb at McGill." *The Montreal Star*, 24 January 1961.

Strongin, Theodore. "Lili Kraus Displays Boldness in Recital." *New York Times*, 30 October 1970, p. 33.

*Times* (London), 9 January 1931, p. 10.

_____, 29 January 1934, p. 10.

_____, 24 May 1935, p. 14.

_____, 30 November 1936, p. 19.

_____, 15 November 1937, p. 21.

_____, 13 December 1937, p. 8.

_____, 30 December 1938, p. 8.

_____, 16 June 1939, p. 12.

_____, 23 June 1939, p. 12.

————, 1 December 1952, p. 3.

————, 5 February 1958, p. 3.

————, 10 February 1958, p. 3.

————, 10 December 1962, p. 5.

————, 21 February 1966, p. 5.

————, 17 December 1972.

Unidentified reviewer and source. New Zealand, 1946.

Unidentified reviewer and source (Amsterdam), 24 March 1948. Translated by Frans Schreuder.

*Variety*, 31 March 1976, p. 112.

Vermeulen, Matthijs. Translated by Frans Schreuder. *De Groene Amsterdammer* (Amsterdam), 6 November 1948. p. 8.

"View from the Inside." *Time Magazine*, 14 October 1966, pp. 50–51.

*The Washington Post*, 17 July 1976.

Wilkinson, Kenneth. "Vivid Recital by Lili Kraus," *Daily Telegraph* (Sydney, Australia), 29 November 1945.

Winther, Alice Myers. *Christian Science Monitor*, 7 August 1956.

## RECORD/CD REVIEWS

*Audio*, October 1980, p. 136.

Canby, Edward Tatnall. *Audio*, July 1982, p. 70.

Ericson, Raymond. "Six Down—More to Come." *New York Times*, 27 February 1966, p. 19.

Freed, Richard. "Keyboard Bartók: Three Views." *Stereo Review*, May 1982, p. 70.

_____. *Stereo Review*, June 1982, p. 113.

_____. "The Mozart Solo Sonatas: Two Integral Sets." *Stereo Review*, October 1975, pp. 112–113.

Goldsmith, Harris. "From Five Artists Five Essays on Mozart's Piano Sonatas." *High Fidelity*, July 1968, pp. 72–73.

_____. *High Fidelity*, April 1980, p. 95.

_____. "Lili Kraus Plays Keyboard Fantasies." *High Fidelity*, January 1982, p. 75.

_____. *Records In Review*, pp. 238–240. Barrington, Mass.: Wyeth Press, 1970.

_____. *Records In Review*, pp. 321–322. Barrington, Mass.: Wyeth Press, 1972.

_____. *Records In Review*, pp. 211–212. Barrington, Mass.: Wyeth Press, 1976.

_____. *Records In Review*, p. 285. Barrington, Mass.: Wyeth Press, 1981.

_____. "Viennese Sonatas for Violin and Piano." *High Fidelity*, July 1982, pp. 62–63.

Hagan, R. H. *Chronicle's This World* (San Francisco), 29 August 1954.

Loppert, Max. *International Classical Record Collector*, Spring 1998.

"Lili Kraus: *En Haar Werk Voor De Grammofoon*." Translated by Frans Schreuder. *Het Volk* (The Netherlands), 27 July 1939.

Mathews, Bertrand. "Listening to Music: Mozart on Record." *Keyboard Classics*, July–August 1982.

Salzman, Eric. *Stereo Review,* April 1980, p. 138.

Sell, Stephen. *American Record Guide,* March 1966.

Wiser, John D. *Association for Recorded Sound Collections* 14 (1982): 93.

INTERVIEWS

Basmajian, John and Dora. Conducted by Steve Roberson, 19 July 1987.

Basmajian, Nancy. Conducted by Steve Roberson, 18 July 1987.

Bawcombe, Candy. Conducted by Steve Roberson, 11 July 1987.

Boatright, Jo. Conducted by Steve Roberson, 24 November 1984, and 5 July 1987.

Bridges, Kit. Conducted by Steve Roberson, 12 July 1987.

Donath, Anni. Conducted by Steve Roberson, 6 June 1987.

Edwards, Donna. Conducted by Steve Roberson, 6 July 1987.

Faricy, Kathie. Conducted by Steve Roberson, 9 November 1986, and 12 and 18 July 1987.

Fodor, Eugene. Conducted by Fort Worth Productions, 1983.

_____. Conducted by Steve Roberson, 25 September 1989.

Frank, Claude. Conducted by Fort Worth Productions, 1983.

Grossmann, Agnes. Conducted by Steve Roberson, 19 August 1991.

Gurganus, Louise Spain. Conducted by Steve Roberson, 7 July 1987.

Kraus, Lili. Conducted by Fort Worth Productions, 1983.

_____. Conducted by Steve Roberson, 21 January, 13 August, and 22

November 1984, and 8 January 1985.

_____. Conducted by Vivian Perlis for the Yale University Oral History Steinway Project, 25 June 1979.

_____; and Mandl, Otto. Conducted by unidentified interviewer in New Zealand in June 1946.

Mandl, Michael. Conducted by Fort Worth Productions, 1983.

Mandl, William Otto. Conducted by Fort Worth Productions, 1983.

_____. Conducted by Steve Roberson, 1 July 1987.

Pope, Fergus. Conducted by Fort Worth Productions, 1983.

Pope, Ruth. Conducted by Fort Worth Productions, 1983.

_____. Conducted by Steve Roberson, 14 April 1985, 9 November 1986, and 22–24 June 1987.

_____. Conducted by David Morely, October 1993.

Rampal, Jean Pierre. Conducted by Steve Roberson, 20 February 1987.

Rietveld-Eskes, Bep. Conducted by David Morely, November 1993.

Schreuder, Frans. Conducted by Steve Roberson, 1 August 1987, 1–5 January 1988, and 19 July 1989.

_____, and other Dutch friends and former students of Lili Kraus from the Japanese internment camps and prior to the war. Conducted by Steve Roberson, 3 January 1988.

Silverman, Robert. Conducted by Steve Roberson, 15 December 1984.

Simon, Stephen. Conducted by Fort Worth Productions in 1983.

Tago, Kichiro. Conducted by David Morely, October 1993.

Williamson, Alix. Conducted by Fort Worth Productions, 1983.

Winesanker, Michael. Conducted by Fort Worth Productions, 1983.

## Radio and Television Broadcasts

Farlow, Allan. Interview with Lili Kraus conducted in Palo Alto, California, on 21 July 1977, and broadcast on a local public radio station sometime after that.

Hume, Paul. "Comments on the Arts." WGMS (Rockville, Maryland), 27 November 1986.

Jensen, Owen. "Lili Kraus Remembered." New Zealand radio broadcast, 1986 or 1987.

Kraus, Lili. Interview aired on *Camera Three*, CBS television, 17 March 1968.

_____. Performance of Schubert's *Grazer* Fantasy aired on *Camera Three*, 2 November 1969.

_____. Interview conducted by Eugenia Zuckerman. Aired on *CBS Sunday Morning*, 21 September 1986.

_____. Interview aired on an unidentified Washington, D.C., radio station in Spring 1983.

*Lili.* Docudrama of Lili Kraus produced by Fort Worth Productions. Aired nationally on PBS television stations, 2 and 6 January 1985.

## Unpublished Materials

Black, Leo, executive producer, *Radio 3* Music Department, British Broadcasting Corporation. Letter to Frans Schreuder, 12 May 1988.

Boatright, Jo. "Kraus's Technique." Journal based on observations of Kraus's lessons from 1973 to 1982.

_____. Personal letter to Steve Roberson, 12 February 1987.

Clark, Hattie, vice president, Columbia Artists Management, Inc. Letter to Cecil Cole, manager, Richmond (Virginia) Symphony Orchestra.

Columbia Artists Management files. Information supplied by Alix Williamson. New York, 1985.

Cooperman, Dorothy, Program Department, San Francisco Symphony. Letter to Steve Roberson, 22 March 1985.

Educo Records promotional material.

Ford, Emmett M. Personal letter to Steve Roberson, 10 April 1987.

"Gala Will Celebrate Artist's Distinguished Career." Bulletin issued by the Division of University Relations, Texas Christian University, Fort Worth, 1983.

Ibbs & Tillett Management files, 1926–1930.

Jones, Susannah Coolidge. Tribute to Lili Kraus, 15 December 1986.

Kraus, Lili. Comments made at a piano recital, Queen Elizabeth Hall, London, England, 12 December 1972.

_____. Personal letter written to Lineke Havermans-van den Berg, 4 January 1942.

_____. Personal letter written to Lineke Havermans-van den Berg, 20 September 1961.

_____. Personal letter written to Lineke Havermans-van den Berg, 29 July 1971.

_____. Personal letter written to Frans Schreuder, 5 September 1978.

_____. Personal letter written to Frans Schreuder, 30 March 1980.

_____. Personal letter written to Frans Schreuder, 13 June 1981.

_____. Personal letter written to Lineke Havermans-van den Berg, 6 June 1982.

_____. Personal letter written to Frans Schreuder, 31 January 1983.

_____. Personal letter written to Géza Frid, 13 June 1983.

_____. Personal letter written to Frans Schreuder, 25 June 1983.

_____. Personal letter written to Géza Frid, 18 April 1984.

_____. Personal letter written to Géza Frid, 21 May 1984.

_____. Personal letter written to Frans Schreuder, 17 June 1985.

_____. Personal letter written to Lineke Havermans-van den Berg, 20 June 1985.

_____. Personal letter written to Frans Schreuder, 4 November 1985.

_____. Personal letter written to Kathie Faricy, 18 October 1986.

_____. Taped recording of lecture presented at Texas Christian University, 1975.

Lord, Judy, Swarthmore Music and Dance Festival, Swarthmore College. Letter to Steve Roberson, 20 January 1987.

Mandl, William. Personal letter to Ruth and Fergus Pope, 3 December 1986.

Maurice Werner Management files, circa 1956.

National Educational Television press release, 10 November 1967.

"Part of the Music Itself." Interview with Lili Kraus. Unidentified source and interviewer. New Zealand, 1946.

Passenger list and itinerary for the ship, *Sibajak*, 24 June 1936.

Pope, Ruth. Eulogy: Memorial Mass for Lili Kraus. Delivered at the Church of St. Francis Xavier, 15 December 1986.

Questionnaires regarding Lili Kraus's teaching were designed, disseminated, collected, and analyzed by Steve Roberson in 1985. Fourteen completed questionnaires from Kraus's former students and six completed questionnaires from Kraus's former colleagues at Texas Christian University were received.

Recital program, benefit concert by Lili Kraus, Batavia, Dutch East Indies, 26 June 1943.

Recital/concert (1973–74) schedule for Lili Kraus. Provided by Alix Williamson.

*Rijksinstituut voor Oorlogsdocumentatie* [Government Institute for War Documentation—Amsterdam, the Netherlands]. Variety of information about Lili Kraus's World War II experiences shared with Frans Schreuder.

Schreuder, Frans. "Lili Kraus, Pioneer on 78 Records." Pamphlet distributed at a lecture presented at the International Piano Archives at Maryland, 17 October 1990.

Ship's itinerary for the *Johan van Oldenbarnevelt*, 13 March–11 April 1940.

Squire, Eric, Educo Records. Letter to Steve Roberson, 3 March 1985.

"The Pianist's Label." Information sheet printed by Educo Records. Ventura, California.

Van Cliburn Foundation, Inc. Statement about Kraus read during the awards ceremony of the 1985 Van Cliburn International Piano Competition. Information received in a letter written to Steve Roberson by the Van Cliburn Foundation on 13 June 1985.

*261*

Williamson, Alix. Publicity information about Lili Kraus.

Winkler, Bruce. executive vice president, Belwin-Mills Publishing
Corporation. Personal letter written to Steve Roberson, 26
December 1984.

# Index

*263*

Mandl, William (stepson), 25, 28, 30-31, 45-48
Marguerite Long International Piano Competition, 156, 216
Mari, Yascai, 4
marriage, 26-27, 29
Martinon, Jean, 112
Maryland International Piano Competition, 156
master classes, xi, 15, 101, 111, 113, 148, 244, 247; comments during, 205-209
Mayo Clinic, 147, 170, 175, 178, 180
Medan (Sumatra), 69
Melbourne (Australia), 97
memorials *see* tributes
memory slips while playing, xiii, 137-38
Mendelssohn, master class comments on, 207
Mengelberg, Willem, 44
metronome, 38
Michael Otto (son) *see* Mandl, Michael Otto
"Miessi" *see* Mandl, Michael Otto
Mills Publishing Corporation, 160
Minnesota, 189
Mitchell, Howard, 164
Monteux, Pierre, 48, 63, 114
Montreal International Piano Competition, 156
Moore, Gerald, 216
Moralt, Rudolf, 113
Mörike, Eduard, 18
*Morning Post* (London), 61
Mostly Mozart Festival, 159, 161
mother *see* Kraus, Irene Bak
mountain-climbing, 28, 46, 98
Mozart, Wolfgang Amadeus: 44, 51-54, 56, 193; edition authenticity, 52; interpretation, 52-54; Kraus's introduction to, 15; master class

comments on, 205-6; period pianos, 53, 212-13; recorded repertoire, 51, 54, 56, 58, 60, 63, 113-16, 140; repertoire, 19, 43-44, 50-53, 55, 62-63, 68, 72, 96, 103, 106-7, 109, 112-14, 122, 128, 172; stage commentary, 198-200; works studied, 37
Mozart Chamber Music Society, 60
Mozart Chamber Orchestra of New York, 143
Mozart Festival, 49
Mozart Festival Orchestra, 133
Mozart Orchestra, 62-63
Mozart Saal, 133
Music and Arts Institute (San Francisco), 113
Music in the Mountains, 158
*Musical America*, 109, 125, 127
musical beginnings, 4-8
*Musical Courier*, 125
musical influences, 12, 37-40
Musical Masterpiece Society, 124
musicianship, 8, 105, 166-67

Nash, Walter, 57
National Educational Television, 143
National Public Radio, 184
National Symphony Orchestra, 164
Nazi Germany, 1, 44, 55-57, 64-65, 67; annexation of Austria, 56
NBC-TV's *Today* show, 160
Netherlands, 17, 62-63, 69, 106
*Neue Freie Presse*, 20
*Neuer Wiener Tageblatt*, 21
Neumark, Ignaz, 18, 21
*New Grove*, 117
New Jersey, 130
New South Wales (Australia), 99
New Vienna Conservatory, 15-17
New York, 109, 111, 122, 126, 136, 159, 161, 180, 183